D1341694

crylic artist's guide to eptional colour

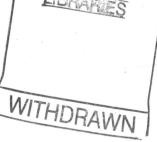

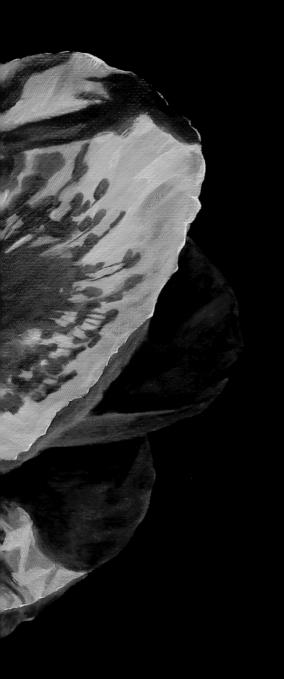

the acrylic artist's guide to exceptional colour

Lexi Sundell

A QUARTO BOOK

Published in 2012 by Search Press Ltd Wellwood North Farm Road Tunbridge Wells Kent TN2 3DR

Copyright © 2012 Quarto Inc.

All rights reserved. No part of this book may be reproduced, stored in a retrieval system or transmitted in any form or by any means, electronic, mechanical, photocopying, recording or otherwise, without the written permission of the copyright owner.

ISBN: 978-1-84448-807-0

QUAR.CPCA

Conceived, designed and produced by Quarto Publishing plc The Old Brewery 6 Blundell Street London N7 9BH

Senior Editor: Ruth Patrick Designer: Karin Skånberg Design Assistant: Kate Bramley Picture Researcher: Sarah Bell Copyeditor: Ruth Patrick Proofreader: Liz Jones Indexer: Helen Snaith Art Director: Caroline Guest

Creative Director: Moira Clinch Publisher: Paul Carslake

Colour separation by Pica Digital Pte Ltd, Singapore

Printed in China by 1010 Printing International Ltd

10987654321

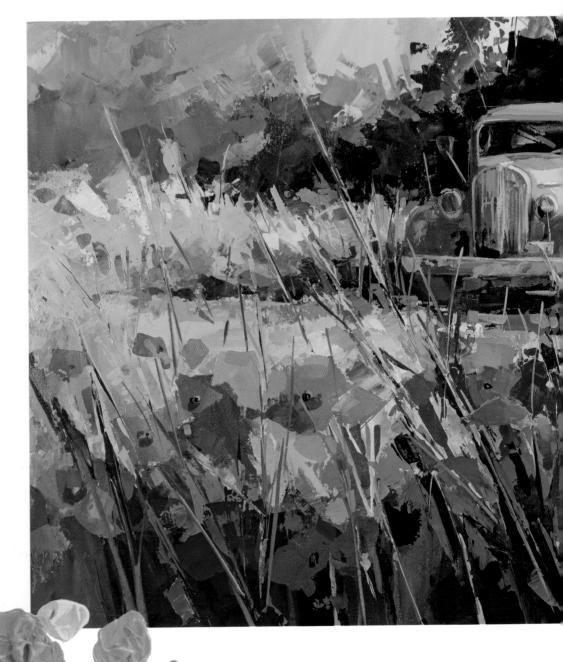

	Bonn

Introduction	6
About this book	7
Colour and vision	8
Paints and pigments	10
Basic mixing	14
Colour wheels	16
SECTION 1:	
Pigment properties	18
Fluid and heavy-body acrylics	20
Pigment permanence	22
Opaque and semi-transparent	
acrylics	24
Luminescent acrylics	26
Gel mediums and grounds	30
Flow release, varnishes and	
drying extenders	32
Wash properties	34
Using texture in paint	36
SESTION 2	
SECTION 2: Pigment aesthetics	38
Mixing colour on the palette	40
Mixing colour wet-into-wet	42
Mixing colour with layers	
and glazes	44
Comparison of colour schemes	46
Primary palette	50
Six-colour palette	52
Analogous colour palette	54

Split-complementary palette	58
Tetradic colour palette	60
Tertiary palette	62
High and low colour key	64
Luminosity in colour	66
Colour value	68
Colour temperature	70
Neutrals and earth tones	72
SECTION 3:	
Choosing pigments for painting	7.0
	76
Choosing and using a colour scheme	78
Light, shade and shadow	82
Backgrounds	84
Skies and clouds	86
Water scenes	90
Buildings	94
Plant life	98
Still life	102
Animals	106
Landscapes and trees	110
Portraits and figurative painting	118
Paints and brushes	122
Canvas and other substrates	124
Index	126
Key terminology	127
Acknowledgements	128

contents

Complementary palette

Hibiscus

Acrylic paints include brilliant, semi-transparent pigments that can be used to create luminous, glowing flowers that evoke early dawn light. Opaque pigments further extend the range of acrylic paint effects. The rich subtleties of this hibiscus painting come from the qualities of modern acrylic paints.

introduction

This beautifully understated work, Butterfly Chair by Joseph Krawczyk, is not what many expect to see in an acrylic painting. Early acrylic paints left a lingering impression in the public perception with harsh and garish colours. Although modern acrylic paints range from quiet neutrals to brilliant explosions of colour, the degree of subtlety possible in acrylics often surprises people.

Subtle treatment

Acrylic paints tease your senses; the high, singing notes of quinacridones accent the deep rumble of Raw Umber and other earth tones. The colours of the rainbow shimmer and dance on the palette, waiting for the touch of the artist to bring a vision to vibrant life on the canvas. Ah, but how do you move from the vision to the completed painting? How do you unleash the amazing colour potential of acrylics in your paintings?

Acrylics are the new kid on the block, having been in existence only since the early 1950s, unlike oils and watercolours, which have been around for hundreds of years and complacently bask in their established positions in the arts. So what are acrylics? Are they simply an annoyingly fast-drying substitute for oils or an awkward alternative for watercolours?

In skilled hands, acrylics can indeed be painted to mimic the effects of oils. Acrylics can also be painted with a wide range of watercolour effects. Either approach simply takes old processes and techniques and superimposes them on something new and different. However, to merely mimic oils or watercolours is to miss the true potential of acrylic itself.

Through the centuries, painters have been on a constant quest for the best pigments, the most permanent colours and the most readily usable paints

available. A set of acrylic paints we can easily buy today would have seemed like a sacred object to so many of those artists who came before us.

Approaching acrylics with the beginner's mind, and allowing old ways of working with paint to become secondary to discover how acrylics themselves work best opens the door to sheer delight. Once I accepted them for what they really were, they became my favorite paints instead of my most despised.

I love their fast-drying qualities, which allow me to keep painting instead of waiting impatiently for that perfect stage of drying. I love the vivid colours possible, as well as the subtle understated colours I can create with them. Contrasts make art come alive, and acrylics offer a huge range of contrasts.

The permanence of the dried paint is another great virtue of acrylics. I can paint over any colour with an opaque white and then paint a fine transparent colour over the white with no problems of bleed-through from the former colour. This allows me to apply colour freely and alter it at will. Such experimentation leads to new colour discoveries rather than disaster.

And, oh, the colours! The range of pigments available is enough to make me swoon. Major manufacturers have developed high-quality paints with pigments used for centuries as well as freshly invented synthetic pigments that bring delicious new possibilities to the palette.

Out of this array of beautiful colour, you are free to paint anything you can envision. Once the painting is completed, the likelihood is that it will outlast the same painting created with oils because of the unique polymer properties of acrylics. How wonderful is that?

Lexi Sundell

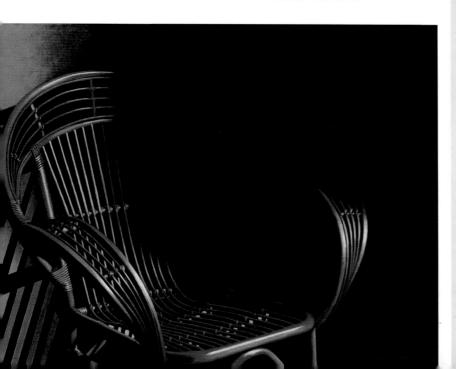

ABOUT THIS BOOK

SPECIAL FEATURE **Fold-out flap** PAGE 127
The Sundell Colour Wheel and the list of
substitute paints for each position on the wheel
are referenced throughout this book, and
reproduced here on a fold-out flap for ease
of access.

Refer to the colour wheel easily when using other parts of the book

SECTION 1 **Pigment properties** PAGE 18 Explains the different types of acrylic paints and mediums available and the physical effects they create.

Throughout the book, Titanium White is used for making tints of colours

demonstration of the product in action

SECTION 2 Pigment aesthetics PAGE 38

Explains colour theory, as well as the visual and aesthetic ways different pigments combine when mixed or painted.

SECTION 3 **Choosing pigments for painting** PAGE 76 Demonstrating the theory from sections 1 and 2, the author and other artists choose exceptional colour for specific subjects.

Colour and vision

We commonly look at colour as something external in the world that we see with our eyes. Scientific research has proven that this is incorrect. Colour arises in the mind from the way the brain processes and transforms signals from the eyes.

While it may be shocking to realise that colour only exists as a useful illusion created in our minds, it opens the door to greater effectiveness as artists. After learning some of the ways the brain interprets visual information, we can deliberately use the right cues in our colour handling to trigger recognition of the illusion we are trying to create in paint.

What is colour?

Visible light is composed of a fairly narrow section of the electromagnetic spectrum, and the human eye is only able to respond to those particular wavelengths. Visible light is not, however, what we call colour – only the

signals from the eyes are translated by the brain into what we call colour.

Colour can be understood as a combination of value, hue and chroma because the rods and cones in the eye react to light and send information in those categories to the brain. Rods register only variations of light and dark, the range of values we can illustrate with a grayscale, and they work in dim light. On a moonlit night, a red bike lying in the driveway will be a clearly visible shape defined by light and dark shadows, but it will not look bright red the way it did at noon. That perception of bright red comes from the cones, which work fine at noon but not so well in dim moonlight. The three kinds of cones respond to partially

overlapping ranges of wavelengths that translate into hue and chroma.

The brain's job is to take the mass of signals from the rods and cones and form a useful picture of our environment. One of the techniques it uses is to seek out edges in order to define objects. After identifying edges, the brain is likely to exaggerate them by increasing value contrasts because of the importance of recognising objects.

The brain also adjusts for changing light conditions so we retain a fairly constant perception of our surroundings – we are aware that the red bike is a red bike at noon, twilight and midnight under the moon despite changing light conditions.

MIND TRICKS WITH VALUE

The brain's effort to adjust for different light conditions can be surprisingly drastic in affecting how we perceive values. Observe what happens when we combine two different visual examples of value, a gradient and a grid of circles, illustrating the Bartleson-Brenneman effect.

A simple gradient

graduations of value

from black to white.

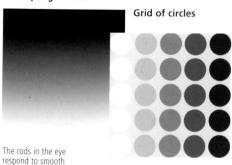

The circles in each vertical column are the exact same value. The circles in each horizontal row are one of each value used.

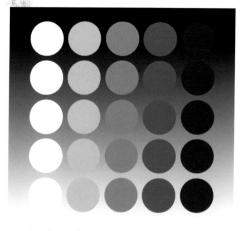

Overlay the circles on the gradient

The mind interprets the circle values as lighter against the dark background and darker against the light background.

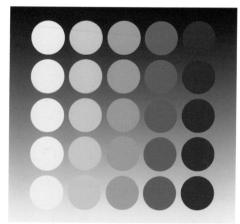

Value affects how we perceive colour

The same handling of values in cyan changes how our mind interprets colour in the circles. Observe how the horizontal rows of coloured circles look different from each other even though the rows are identical.

HUE AND CHROMA

High chroma means the hue is bright and saturated, as shown in this yellow hue.

Low chroma means the hue appears dull in colour like this greyed yellow hue.

Value contrasts provide a strong visual structure for colour, while hue and chroma add more dimensions to our experience of colour. While moonlight is lovely, who wants to see the world in that subdued manner all the time? Hue and chroma bring us the glories of a sunset, the glowing colour of a flower and the richly translucent depths of water.

Chroma often changes in unison with value, although rods respond

to value changes and cones respond to chroma changes. The reason is that cones lose the ability to identify chroma as available light diminishes, so less chroma is perceived when the light dims. The rods perceive the dimmed light as reduced value in the grayscale, so changes in chroma and value can be related but are fundamentally different. Chroma refers to the saturation of hue present and value refers only to light and dark, regardless of hue.

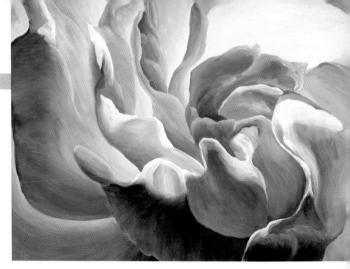

Ways of reducing chroma

A frequently used method of reducing chroma is by tinting with Titanium White. Applying a thin wash of paint can also reduce chroma. Chroma can be reduced without changing value by mixing the hue with a grey of the same value as the hue. The saturated blue hue on the left is mixed with a same value grey to make the lower-chroma blue on the right.

Another way of reducing chroma is by desaturating the hue by mixing it with its complementary opposite. Complements are described on pages 56–57. In this example, green and red hues blend into a low-chroma neutral in the middle.

Creation

The practical application of value, hue and chroma can be seen in this painting. Strong value contrasts provide a dramatic structure while assorted hues vary widely in chroma to create a radiant effect in this flower. Contrasts within all three of these components of colour can be used for strong impact in your painting.

Bridget Riley - mind tricks in action

Op artist Bridget Riley excels at creating paintings that explore the ways our brains interpret and alter values. In Arrest 2, she uses distinctly defined edges and a wide range of values to compose a compelling image. Notice how the individual wavy lines combine into larger patterns because of the way she used values. We see two main groupings of those lines due to the graduated application of values.

ADDITIVE AND SUBTRACTIVE COLOUR

We perceive colour according to the principles of additive colour, but our paints work according to the principles of subtractive colour. As artists we must create illusions of light with materials that combine colours altogether differently than the way light combines them.

Additive colour

Light works with additive colour. If you add blue light to red light, you get magenta light, but a magenta that is radiantly brighter than either the blue light or the red light alone.

The more colours of light you add, the greater the radiance. When you add enough colours it gets so bright all you can see is white. This is called additive colour mixing.

Subtractive colour

Pigments are not light. They reflect light, but not all of it. A black rock absorbs sunlight while reflecting very little. That is both why it gets hot and why it looks black. Black is the absence of colour, the result of a lack of reflected light.

A blue pigment looks blue because it reflects blue light into our eyes. The blue pigment absorbs the other colours in light, sucks them out of sight like a vacuum cleaner. Likewise, a red pigment absorbs everything but red light.

Red and blue pigments mix into a purple, but a duller purple than either the blue or red. When two pigments absorbing light are combined, they reflect even less light than they did separately.

After adding more pigment colours, the mixture turns black as most of the incoming light is absorbed and removed from our sight. Therefore this is called subtractive colour mixing.

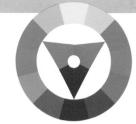

Additive colour wheels use red, green and blue (RGB) as their primaries. Mixing these primaries creates the yellows, magentas and cyans that we see as the brightest, most radiant colours.

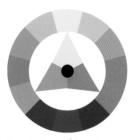

Pigment colour wheels use the brightest hues of cyan, magenta and yellow (CMYK, with "K" referring to black) as the primaries, since they mix to make the other, duller colours.

Paints and pigments

Different manufacturers offer a dazzling array of paints. Just looking at all of them is enough to make your head spin. How do you choose wisely from so many options? What is best: Carbazole Violet or Dioxazine Purple? Or are they the same thing with different names? How do you know without buying every single tube of paint on the market? Paint manufacturers sometimes seem to choose paint names the same way fashion designers often do romantically without much practical utility. Fortunately there are ways to cut through the confusion and discover what you need to know. On the following four pages paints and pigments are demystified, and colour groups are explored. In the equipment guide on page 122 you will find out how to decode the information on the label of a tube of paint.

PIGMENTS AND PAINTS

What is the difference between pigment and paint? Pigment provides the colour, and a binder is the vehicle to carry that colour. Paint is a mixture of the two.

In acrylic paint, the binder is an acrylic emulsion. In most acrylic paints this is a whitish substance that dries to a clear film if no pigment is added. The fact that the emulsion is white before drying means it slightly obscures the full colour of the pigment until it dries, which is why acrylics darken as they dry. Winsor & Newton is the only manufacturer offering an acrylic emulsion that is already clear before drying so the usual darkening does not occur.

Some paints – known as fugitive paints – are not lightfast and tend to fade or discolour over time. Paints with 'hue' at the end of their name, such as Alizarin Crimson Hue, usually refer to formulations resembling a paint that is either fugitive or toxic. meaning that the colour can be achieved without the negative side effects. Alizarin Crimson Hue is a lightfast paint that resembles the fugitive Alizarin Crimson.

Avoid cheap 'student grade' paints as they may lack good pigment strength, may be loaded with useless fillers and may not meet proper standards of lightfastness. Quality paint - by companies such as Winsor & Newton ('Artists' Acrylic' range), Golden Artist Colors and Daniel Smith - is worth the small additional cost.

ORGANIC AND INORGANIC PIGMENTS

Organic pigments not only refer to pigments obtained from living synthetic pigments are organic, such as the guinacridones, phthalos and azos. For vibrant, clear colour, these pigments are unsurpassed. Their tinting power is also excellent and many are semi-transparent.

inherent colour that often comes

from iron oxide in various forms

as well as hydroxides of copper,

chromium and aluminium. These

may be intermixed naturally with

clays, which can include talc and

Organic

pigments

Ouinacridone

Phthalo Green

Inorganic pigments

Cobalt Blue

Raw Umber

plants, but to all pigments that contain carbon. Most pigments in acrylic paints are manufactured in laboratories. Many wonderful

Inorganic pigments are primarily minerals and obviously do not contain carbon. Inorganics have

silica. While these pigments can be opaque, some are semi-transparent. Synthetic inorganic pigments are

more finely ground than natural inorganics, making the colour more evenly distributed in the paint. Synthetic inorganic pigments include materials such as manganese and zinc as well as the cobalts and cadmiums.

COLOUR GROUPS

Colour evokes powerful emotions, which sometimes vary culturally. For example, some cultures use black as the colour of mourning, while others use white. The important point is we all use colour to express emotion.

The major colour groups and important paints in each group are shown on the following pages. The paints have been selected for their mixing qualities and overall usefulness. Remember to doublecheck the index number for the pigment you want, since the common names can vary wildly (see page 122). In this book, only permanent pigments are discussed because a great selection of modern permanent pigments have replaced fugitive pigments painters had to use in the past (see above).

All paints shown in colour groups except Primary Magenta, Quinacridone Crimson, Cobalt Violet Hue and Permanent Violet Dark are single-pigment paints.

Clockwise from top left: Ouinacridone Crimson Primary Magenta, Quinacridone Magenta and Quinacridone Rose.

The magentas

Magenta is the beautiful red-violet (or cool red) between red and purple. Magenta adds rich subtlety and a sense of graciousness to a painting. Soft blends of magenta can be utterly delicious.

As a subtractive primary (see page 9), it is bright and lively when used for high-chroma colour. The recent development of quinacridone pigments resulted in gorgeous magentas for the acrylic palette.

Reds

Cadmium

Red

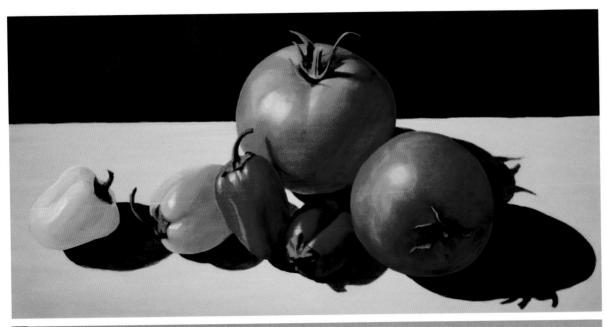

RED AND ORANGE COLOUR STUDY

Exploring different reds. oranges and vellows from the colour groups below (and the yellows on page 12) allows you to discover the most effective uses of the wide variety of paints available in this colour range.

Background and shadows on table painted in mixtures of Buff Titanium. Raw Umber and Yellow Ochre.

Buff Titanium and a small amount of Raw Umber are used in the table top.

Cadmium Red Deep makes excellent shadows.

Tints of Cadmium Orange Medium form the highlights and surrounding area in both tomatoes.

Full range of Cadmium

tints of Chromium Oxide

Green and Raw Umber.

Hansa Yellows with a small amount of Pyrrole Orange for the shadows in the two left peppers.

Naphthol Reds with shadows in Anthraguinone Red and highlights in tints of Naphthol Red Light in the two red peppers. Yellows

Hansa Yellow Light

Hansa Yellow Medium

Hansa Yellow Deep

Cadmium Red Dark

Cadmium Red Deep

Oranges

Cadmium

Orange

Medium

Pyrrole

Orange

Raw Umber

Naphthol Red Light

Naphthol Red Medium

Titanium

Titanium

White

Clockwise from top left: Anthraguinone Red, Cadmium Red Medium, Naphthol Red Medium and Ouinacridone Red.

Red is vibrant, hot and sexy, sometimes spilling over into outright violence. Red is the colour of blood and passion, yet some cultures regard it as a divine colour of spirituality.

Many fine reds are available in acrylic paints and as you become familiar with them, you will learn to choose the best ones for different purposes. Some are opaque and some are semi-transparent, and they vary from cool to warm.

Clockwise from top left: Cadmium Orange Deep, Cadmium Orange Medium, Pyrrole Orange and Quinacridone Gold.

The oranges

Orange is the colour of vitality and strength. Balanced between red and yellow, orange carries the passion of red made gentle by the sunny joy of yellow. Orange adds a sense of lively action.

The cadmium pigments make fantastic orange paints, but other choices are also available. Cadmiums are opaque, so pyrroles and quinacridones are needed for transparent effects. They can also be mixed from warm reds and yellows.

A good exercise to learn how to control greens for the desired effect is to paint the same subject repeatedly in different greens to see how they handle. Adjusting singlepigment green paints to appropriate chroma levels often defeats artists. Creating a harmonious, natural range of greens can also be difficult because of mixing problems, particularly with the brilliant phthalos. In this example the geranium leaf is painted, and then two sections of the leaf are painted in alternate colours for further exploration.

Chromium Oxide Green

> Ouinacridone Burnt Orange

Quinacridone Nickel Azo Gold

Yellow Ochre

> Cadmium Yellow Light

Raw

Umber

Quinacridone Cora

Chromium Oxide Green is a low-chroma green that adjusts well with small amounts of Yellow Ochre and Raw Umber to make natural-looking foliage. Tints of this mixture are used for the green areas of the leaf and stem

More Raw Umber is used in the Chromium Oxide Green tints for the darker shadows.

A thin glaze of Quinacridone Coral is applied over the dried tint of Yellow Ochre.

A thin layer of Quinacridone Burnt Orange is brushed over the lighter tint of Yellow Ochre. Mixtures of Quinacridone Burnt Orange and Quinacridone Nickel Azo Gold are used in the outer decaying leaf edge.

A tint of Yellow Ochre is used

for the lighter areas in the

decaying leaf edge.

Quinacridone Coral is lightly painted over the dried Quinacridone Burnt Orange outer leaf edge.

A little Ouinacridone Burnt Orange is scumbled over the darker green leaf areas.

Green

Anthraguinone Ouinacridone Red

Gold

Neutralising the Phthalo Green/ Quinacridone Gold tint with Anthraquinone Red gives a suitable green for the leaf.

Even when using Phthalo Green mixed with Quinacridone Gold instead of a yellow, this tint is far too bright and high-chroma for a subdued geranium leaf green.

Tints of Quinacridone Gold are used, keeping the colour integrated with the green.

> Anthraguinone Red is used for the decaying edge of the leaf.

Anthraquinone Red is scumbled over this darker area of the leaf.

A tint of Cadmium

Red Deep is applied

over the tint of Yellow Iron Oxide.

The decaying leaf

tints of Cadmium

Red Deep with a

little Quinacridone Crimson.

edge is rendered in

The deepest shadows in the decaying edges are rendered in Alizarin Crimson Hue

Cobalt Green is a low-chroma green so a tint of Cobalt Green and Cadmium Yellow Deep makes a satisfactory geranium-leaf green.

The darkest shadows in the decaying edge are painted with Cadmium Red Deep.

Cadmium Red Deep is scumbled over the darker area of the green leaf.

A tint of Yellow Iron Oxide

works for this lighter area.

Cadmium Yellow Deep

Cobalt Cadmium Green

Yellow Iron Oxide

Clockwise from top left: Cadmium Yellow Medium, Hansa Yellow Medium. Lemon Yellow and Yellow Ochre.

The yellows

Yellow is the essence of sunshine and is a joyful colour. Yellow is both light and bright, usually much more so than other hues, so it works well for luminous accents in a painting. The inspired light in religious paintings is often painted in yellow.

The arylides, cadmiums and bismuth make fine high-chroma yellows. Iron oxide produces lowerchroma vellows.

Clockwise from top left: Chromium Oxide Green, Pervlene Green. Phthalo Green (Blue Shade) and Phthalo Green (Yellow Shade).

The greens

Green is the metaphorical colour of envy but also the colour of burgeoning life in spring. Greens challenge the beginning artist perhaps more than any other colour (see above).

Starting with single-pigment greens is preferable to using convenience mixtures, because adding additional paints to the mixture may create an unexpectedly muddy appearance. Chromium Oxide Green and the phthalo and perylene greens each mix beautifully with Bismuth Yellow or Hansa Yellow to make a wide range of greens. Chromium Oxide Green can be further adjusted with Yellow Ochre and/or Raw Umber for natural-looking foliage greens. Greens can also be mixed from blues and vellows.

BLUE AND PURPLE COLOUR STUDY

A variety of blues and purples can work well together. In this example several blues are used with two different purples. You can try a similar exercise that includes Phthalo Blue and Cerulean Blue, which were not used here.

The background is painted in tints of Cobalt Blue and Cadmium Orange Hue, which combine to make a lovely soft neutral.

Highlights are rendered in pure Titanium White because of the shiny surface of the vase.

Tints of Ultramarine Violet are used for a softer, lowerchroma purple.

Ultramarine Blue makes a rich transition from Dioxazine Purple into the Cobalt Teal and Cobalt Blue body colour of the vase.

Dioxazine Purple is used to blend into the Indanthrone Blue shadows. Tinted Dioxazine purple blends into a vibrant purple.

A bright Cobalt Teal is used for the main body colour of this stoneware vase, which has a richly colourful barium glaze.

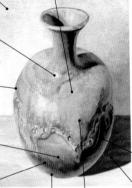

A lighter tint of Dioxazine Purple shows reflected light on the underside of the vase.

Tints of Cobalt Blue are painted over the Cobalt Teal for variation in the surface colour of the vase. Indanthrone Blue is used for the darkest shadows on the vase, which are almost black.

vase is painted in a neutralised tint of Indanthrone Blue and Cadmium Orange Medium Hue.

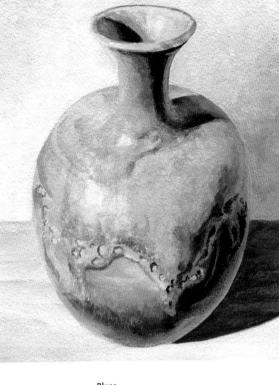

The shadow of the

Cobalt

Purples

Ultramarine

Violet

Cobalt

Blue

Dioxazine

Purple

Blue

Other

Ultramarine Indanthrone Blue

PIGMENT CONSIDERATIONS

- Always read the paint label to see what pigments are in the paint before you buy it. The common name on the front of the tube can be misleading as you may find that you are buying the same pigment with a different name from a different manufacturer.
- Choose single-pigment paints for your mixing palette. Single-pigment paints provide maximum chroma, which always reduces as more pigments are added to a mixture.
- · When possible, choose a singlepigment paint that has hue and chroma matching your subject as closely as vou can.
- Use multiple-pigment paints as convenience mixtures to save time mixing combinations you use frequently.
- Experiment with different paints to discover which ones work best for your purposes, sometimes by painting the same subject in several different combinations of paints.
- · As you become familiar with your paints, you will learn to create paintings with flair and personality!

Clockwise from top left: Cerulean Blue, Indanthrone Blue, Phthalo Blue (Green Shade) and Ultramarine Blue.

Blue can be the colour of the sky, and open water in the landscape. Blue can be intense and bold or soft and retiring. Blue expresses quiet introspection and sometimes sadness. However, the vibrant feathers of the bluebird are associated with happiness. Blue can convey quite a range of emotions!

Cerulean Blue is often used for skies, while Indanthrone Blue goes to a dark midnight colour. Phthalo Blue and Ultramarine Blue are vibrant and bright, mixing well with other paints to make greens and purples.

Clockwise from top left: Cobalt Violet Hue, Dioxazine Purple, Permanent Violet Dark and Ultramarine Violet.

The purples and violets

Purple is the traditional colour of royalty because it was legally reserved for royalty due to its expense. Still regal, purple is far more widely available now, delighting painters with its richness. Today purple is often favoured as a spiritual colour.

Although now affordable, only a few permanent purple pigments are available for artists. For that reason, two convenience mixtures are included here (see page 17). Cobalt Violet Hue is a mixture created to emulate the extremely toxic cobalt arsenate formerly used by artists. Permanent Violet Dark is the other mixture.

Basic mixing

When you pick up a paintbrush, the first thing you need to know is how to mix paint to create the amazing effects you imagine for your art. In acrylics there are several mixing methods.

You can mix paint directly on the canvas, board or paper using techniques common to both oil and watercolour painting. You can paint wet-into-wet or use glazes and scumbles. Mixing paints on your palette is also an effective way to create the colours you want.

MIXING FUNDAMENTALS

The wheel at right shows the relationship of the generic colours to each other and displays high-chroma single-pigment paints that mix well together. The Sundell Colour Wheel on page 17 provides a good starting point for mixing pigments. The chart of substitutes on the same page allows other paints to be correctly used in the framework of the colour wheel.

One paint used almost constantly is not shown on this colour wheel or the chart. White, specifically Titanium White, appears in most paintings. By mixing white with other colours, varying tints are created, which is immensely useful. Although 'tint' refers to a colour mixed with any white, in this book, for convenience, a tint will always refer to Titanium White mixed with the colour unless specified otherwise.

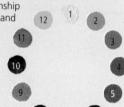

- Yellow Yellow-orange
- Red-orange
- Red
- Magenta Red-violet
- Blue-violet
- Blue Cyan
- 10 Green
- 11 Yellow-green
- 12 Green-yellow

FIVE PRINCIPLES OF MIXING

Single-pigment paints mix together with less chroma loss than multiple-pigment paints.

The closer together the paints are found on the colour wheel, the higher the chroma of their mixture will be.

Lower tinting strength paints must be used in larger amounts to balance more powerful tinting strength paints in a mixture.

Paints opposite each other on the colour wheel mix to a lowchroma neutral.

Adding an opposing colour can neutralise a high-chroma mixture if it is too bright.

TINTING STRENGTH

Tinting strength refers to the ability of a pigment to affect the colour of another pigment. Pigments vary widely in their tinting strength and that affects how they handle in a mixture. Information about the tinting strength of each pigment can be found on the label, in manufacturers' catalogues or online. Your own experience of mixing will quickly inform you as well.

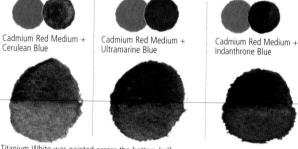

Titanium White was painted across the bottom half while wet to bring the colour out of the dark mixture.

Cadmium Red Medium mixed with Cerulean Blue does not show much Cerulean Blue as it has weaker tinting strength than Cadmium Red Medium.

The stronger tinting strength of Ultramarine Blue mixes to a nice purple with an equal amount of Cadmium Red Medium

The powerful tinting strength of Indanthrone Blue overwhelms the same amount of Cadmium Red Medium.

EXPERIMENTAL MIXING TO CHOOSE A SPECIFIC PAINT

The quick method of mixing directly on heavy watercolour paper makes it easy to select from several paints in the studio. In this case, three green paints are tested in mixtures with Hansa Yellow Medium to see which one might match a particular subject best. Try this freely with any paint combinations you would like to see for yourself. Hands-on experience will bring a whole new understanding of your paints.

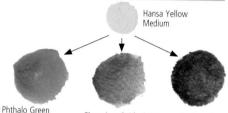

Chromium Oxide Green Pervlene Green (Yellow Shade)

MIXING MULTIPLE PIGMENTS

Our exploration of greens expands to multiple-pigment mixtures instead of just combining a single-pigment paint with another singlepigment paint. This requires careful handling to avoid making mud.

Cadmium Red Medium opposite to the greens on the colour wheel - was added to the mixture across the bottom half.

Green Gold + Green Gold + Phthalo Cobalt Green Green (Blue Shade)

Green Gold is already a threepigment mixture in the tube, so adding more pigments creates a dull, muddy look. These swatches each contain five pigments and are dull and muddy. Adding the red makes an even duller mix.

Cadmium Yellow Medium + Cobalt Green

Cadmium Yellow Medium + Phthalo Green (Blue Shade)

Cadmium Yellow Medium is a single-pigment paint and was used for this example. These mixtures of three single-pigment paints show that you can reduce chroma without making lifeless and uninteresting mixtures.

WAYS TO PRACTISE PAINT MIXING

Paints can be mixed on the palette with either a palette knife or a flat brush. These paints can be completely and evenly mixed or left in an uneven state, depending on what you want to paint and how you want to paint it.

When creating a painting, your paint can be mixed on the paper, canvas or board directly but this has to be done rather quickly because of the fast drying time of acrylics. If you let the paint dry on the substrate, glazing and scumbling techniques can be used for additional optical mixing.

Apply your curiosity to paint mixing. It is useful to discover for yourself what happens when you try different combinations. After you have become familiar with your paints through simple experimental mixing, you can explore more detailed methods of paint mixing on pages 40 to 45.

AVOID MIXING MUD

Medium

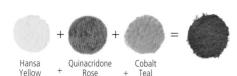

A dull muddy colour results from mixing the three primary colours, Hansa Yellow Medium, Quinacridone Rose and Cobalt Teal. Mixing too many pigments widely spaced apart on the wheel is a guick way to create a muddy mess.

MIXING IN STEPS AROUND THE COLOUR WHEEL

Mixing colour directly on heavy watercolour paper is a great way to quickly explore colours for later use. This example uses Hansa Yellow Medium from the first position on the colour wheel and mixes it with each of the next eleven colours in sequential steps to see what happens. Adjacent colours on the colour wheel always make the highest-chroma – meaning brightest – mixtures so the mixes with yellow-orange (Cadmium Orange Medium) and green-yellow (Bismuth Yellow) will be the brightest. To see these paints in context on the Sundell Colour Wheel, turn to page 17.

- **1** Mixed with the adjacent colour, Cadmium Orange Medium, a lively yelloworange is created.
- 2 Pyrrole Orange is two steps away from Hansa Yellow Medium, and this mixture creates a slightly duller colour; however it is still fairly bright.
- **3** The mixture of Hansa Yellow Medium and Cadmium Red Medium makes a colour that once again is slightly duller than the previous step. As these are single-pigment paints being combined, the loss of chroma is still fairly mild.
- 4 When mixed with Quinacridone Rose, an even more subdued red-orange mixture results. This is actually the mixed secondary for the number three red-orange position on the colour wheel because Hansa Yellow Medium and Quinacridone Rose are both primaries. This mixture is obviously duller than the single-pigment Pyrrole Orange on the colour wheel in the third position.
- **5** Quinacridone Violet with Hansa Yellow Medium makes a mixture that no longer looks orange. A warm brown appears instead.

- **6** The opposite colour of Ultramarine Violet neutralises Hansa Yellow Medium.
- 7 Ultramarine Blue produces a low-chroma green when mixed with Hansa Yellow Medium. This mixture is slightly duller than the Quinacridone Violet mixture, also five steps away from Hansa Yellow Medium on the Sundell Colour Wheel.
- 8 Cobalt Teal mixed with Hansa Yellow Medium offers a brighter chroma than we might expect, since both pigments are high chroma, despite their distance apart on the Sundell Colour Wheel.
- **9** The high chroma of Phthalo Green (Blue Shade) creates a rather lively green when mixed with Hansa Yellow Medium. A lower-chroma substitute for this placement on the wheel would not look as bright as this mixture.
- 10 Phthalo Green (Yellow Shade) mixed with Hansa Yellow Medium is livelier yet, only two steps away from the Hansa Yellow Medium placement on the colour wheel.
- 11 Bismuth Yellow has low tinting strength (see page 14) and its mixture with Hansa Yellow Medium is extremely bright and yellow.

1 Hansa Yellow Medium + Cadmium Orange Medium

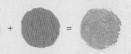

2 Hansa Yellow Medium + Pyrrole Orange

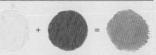

3 Hansa Yellow Medium + Cadmium Red Medium

4 Hansa Yellow Medium + Quinacridone Rose

5 Hansa Yellow Medium + Quinacridone Violet

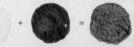

6 Hansa Yellow Medium + Ultramarine Violet

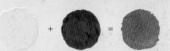

7 Hansa Yellow Medium + Ultramarine Blue

8 Hansa Yellow Medium + Cobalt Teal

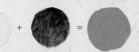

9 Hansa Yellow Med. + Phthalo Green (Blue Shade)

10 Hansa Yellow Med. + Phthalo Green (Yellow Shade)

11 Hansa Yellow Medium + Bismuth Yellow

Colour wheels

Colour wheels, those rainbow circles of possibility, entice us with their glowing hues. Just looking at a colour wheel is enough to inspire a run to the easel and brushes.

Who thought these up in the first place? Mother Nature certainly does not present us with ready-made colour wheels. The arc of a rainbow is the closest she comes, and those hues are not arranged at all the way we organise our colour wheels.

Of course, it took the genius of Isaac Newton to first imagine connecting the spectrum seen in a slice of rainbow into an unending circle. He was thinking of light when he did so, but artists adopted the idea for paints as well.

The collision between the way light works and the way pigments work still continues today, both in colour wheel choices and in the ways we try to understand our paints (see Colour and vision, page 8).

THE REALITIES OF PIGMENT OPTIONS

Bruce MacEvoy found the hue, chroma and value for most of the pigments in use for modern paints and mapped them using Munsell's methods. The three-dimensional model was too awkward for daily use, so he flattened the value scale, resulting in this colour wheel, right. Notice the uneven distribution of the available pigments. They do not march neatly around a colour wheel like the even distribution of light wavelengths. Instead, some hues are represented by many pigment choices and others by few. These pigments also vary widely in chroma, tinting strength and values. This brings us face to face with the reality of pigment choices. Our paints can't show everything we can see. For more information, go to www.handprint.com.

MAPPING COLOUR

Albert Henry Munsell took the next step in colour mapping, after Newton. Colour wheels showed a spectrum of hues, but lacked the other two components of colour: chroma and value. He created a 3D graph with a vertical value scale running up through the centre of the hue circle and a horizontal axis for chroma, to make a model that maps hue, chroma and value accurately for each colour. In this illustration, the hue circle is shown at Value 6 and Chroma 6. We also see two different values of chroma in the red hue increasing outwards from the centre to Chroma 8, but the chroma scale may actually go much further. A strong bright red, for example, could be located at Value 5 and Chroma 24.

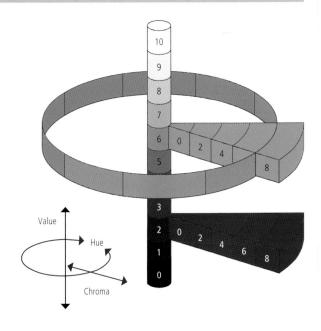

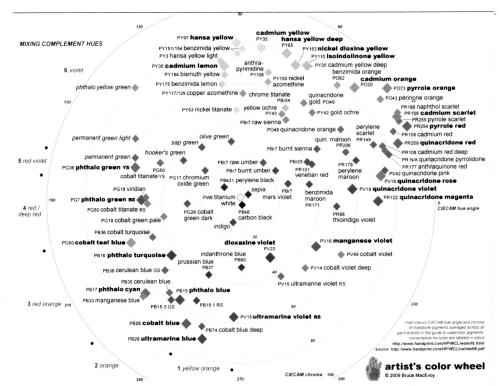

SUNDELL COLOUR WHEEL AND SUBSTITUTE PAINT LISTING

Trying to corral our irregular assortment of pigments into a functional colour wheel is a little like herding cats. The pigments will behave according to their own unique makeup, but we can still group them according to their shared hues and opposing complements to simplify palette choices.

The author's colour wheel is designed to provide a reliable tool for the artist seeking exceptional colour in acrylics. Building a palette with single-pigment paints is a good idea because it gives the widest array of colour-mixing options. The more pigments are combined, the lower the chroma drops, so starting with single-pigment paints allows higher-chroma choices when desired. Most of the chosen pigments have high tinting strength (see page 14). The mixtures may easily be reduced in chroma if needed for specific paintings.

A chart is included below showing suitable substitutes for each of the 12 colour positions on the wheel. This makes exploring alternate paints less daunting, since you know where they fit into an established framework.

The pigment numbers are also given with the paint name in the wheel and the chart. Remember to make a habit of reading the pigment numbers for any paint you buy so you select exactly what you want from any brand of acrylic paint (see page 122).

Paints that are convenience mixtures of multiple pigments are included in some colour categories. They are placed at the end of the list after the single-pigment choices. You can readily identify them by the multiple pigment numbers following a paint name.

Neutrals and earth tones may be found on pages 72-75. After you are comfortable with this colour wheel, a few neutrals and earth tones are excellent additions to a working palette.

If you are concerned about lightfastness, information can be found on the paint tube, in the manufacturer's catalogue or online. All paints included in the Sundell Colour Wheel and substitute paint listing are lightfast when produced by quality manufacturers.

The Sundell Colour Wheel and substitute paint listing can also be found on the fold-out flap on page 127.

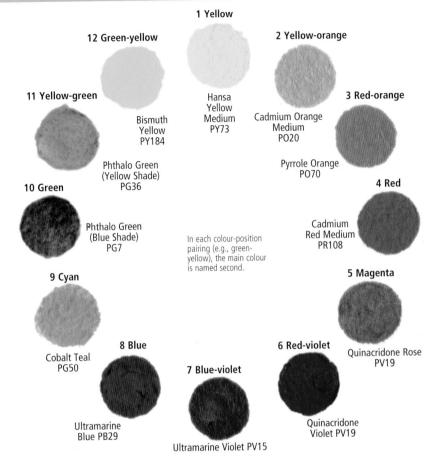

1. Yellow Cadmium Yellow Medium PY35 Hansa Yellow Deep PY65 Yellow Iron Oxide PY42 Nickel Azo Yellow PY150 Cadmium Yellow Medium Hue PY74 PY65 Primary Yellow PY3 PY73 PW6 Naples Yellow Hue PW6 PY42 **PY83**

2. Yellow-orange

Cadmium Yellow Deep PY35 New Gamboge PY153 Azo Yellow Deep PY65 Quinacridone Gold PO49 Cadmium Yellow Deep Hue PY184 PY74 PY65 Cadmium Orange Hue PO73 PY65 PY74

3. Red-orange

Cadmium Orange Deep PY35 Perinone Orange PO43 Quinacridone Coral PR209 Quinacridone Burnt Orange PR206 Quinacridone Burnt Scarlet PR206 Quinacridone Nickel Azo Gold PO48 PY150 Quinacridone Sienna PO49 PR209

4. Red

Cadmium Red Dark PR108 Cadmium Red Deep PR108 Naphthol Red Light PR112 Naphthol Red Medium PR5 Permanent Red PR170 Pyrrole Red PR254 Pyrrole Red Dark PR264 Quinacridone Red PV19 Perylene Maroon PR179

5. Magenta

Primary Magenta PV19 Permanent Rose PV19 Anthraquinone Red PR177 Quinacridone Crimson PR206 PR202 Quinacridone Magenta PR122

6. Red-violet

Cobalt Violet Hue PV19 PR122 PW4 PV23 Alizarin Crimson Hue PR122 PR206 PG7

7. Blue-violet

Dioxazine Purple PV23 Carbazole Violet PV23 Indanthrone Blue PB60 Permanent Violet Dark PB60 PR122 Prism Violet PV23 PW6 PR122

8. Blue

French Ultramarine Blue PB29 Phthalo Blue (Green Shade) PB15 Cobalt Blue PB28 Cobalt Blue Deep PB73 Anthraquinone Blue PB60 Cobalt Blue Hue PB29 PB15

9. Cyan

Cerulean Blue P36 Cerulean Blue Deep PB36 Cerulean Blue Chromium PB36 Cobalt Turquoise PB36 Primary Cyan PB15 PW6 Manganese Blue Hue PG15 PG7 PW6

10. Green

Cobalt Green PG26 Cobalt Green Deep PG26 Permanent Green Light PY3 PG7 Permanent Green PY3 PG7 Cascade Green PBr7 PB15

11. Yellow-green

Chromium Oxide Green PG17 Chromium Oxide Green Dark Green Gold PY150 PG36 PY3 Rich Green Gold PY129

12. Green-yellow

Lemon Yellow PY175 Cadmium Yellow Light PY35 Hansa Yellow Light PY3 Cadmium Lemon PY35 Cadmium Yellow Light Hue PY184 PY3

Fluid and heavybody acrylics

After going through the process of pigment selection, you are now confronted with yet another choice – which kind of paint to use? The two main groupings of acrylic paints are fluid and heavy-body paints. How do you choose the best kind of paint for your artwork?

The terms fluid acrylics Heavy-body acrylic and heavy-body acrylics are self-explanatory. Here we see a puddle of liquid acrylic and a blob of heavybody acrylic straight from the tube. Fluid acrylic

Fluid acrylics are the best choice for painting without showing brush strokes. They are also excellent for spattering effects. Fluid acrylics sold in bottles typically have the same pigment density as their thicker counterparts that come in heavy-body acrylic paint tubes. This can be useful for painting glazes but sometimes a thinner pigment density may be desirable for a more delicate glaze.

You can thin a fluid acrylic by mixing it with water or with a glazing medium. Mixing with water dilutes the fluid acrylic, but if it is too diluted and thinly spread on the painting, no acrylic film will develop in drying. The tiny scattered bits of dried paint will be in danger of separating from the painting and can be easily rubbed off the surface. Diluting with a glazing medium is preferable because it allows the density of pigment to be reduced as much as required but also allows the paint to dry to a durable acrylic film.

Heavy-body acrylics are usually the main paints chosen by artists because of their versatility. They can be used to create texture and impasto effects but can also be brushed to a smooth surface.

Heavy-body acrylics can be diluted into a fluid, but this will reduce the pigment density accordingly. As with fluid acrylics, mixing with glazing medium is preferable to mixing with water, especially given the amount of dilution needed to make a heavy-body acrylic into

Heavy-body acrylics also can be mixed with other mediums, which is discussed on pages 30 and 31.

USING FLUID AND HEAVY-BODY ACRYLICS IN A PAINTING

In this example, both heavy-body acrylics and fluid acrylics are used in the same painting for different purposes. Pyrrole Orange opposes Cobalt Teal, and a trio of blue-violet placements – Ultramarine Violet, Dioxazine Purple and Indanthrone Blue – oppose Cadmium Yellow Medium. Indanthrone Blue is listed for blue-violet because when applied heavily it is dark and almost looks like Dioxazine Purple. Yet, when tinted with Titanium White, the paint shows much less violet in its appearance.

Indanthrone Blue

Dioxazine Purple

Ultramarine Violet

Cobalt Teal

Cadmium Yellow Medium

Cadmium Orange Medium

Quinacridone Gold

Pyrrole Orange

Cadmium Red Medium

Titanium White

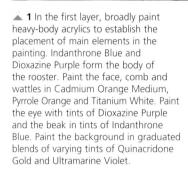

2 This closeup shows the dark edge of the eye being painted in Indanthrone Blue. Continuing with the same palette, apply glazes of fluid acrylic paints over the comb, face and wattles to add more definition.

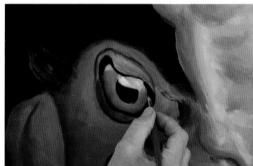

▶ 3 Develop the comb, face and wattles with the fluid acrylic glazes shown in the previous detail. Paint additional heavy-body acrylics into the rooster's feathers. Paint the background in another layer of the previous colours with heavy-body acrylics but add Dioxazine Purple in the darkest areas around the face and side of the bird. The painting is now ready for fluid acrylic spattering.

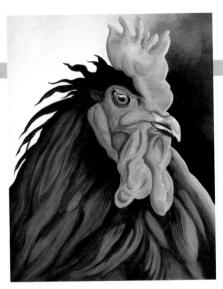

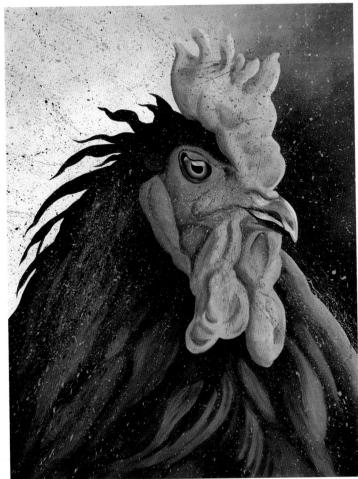

4 As the background is lighter on the left to emphasise the dark feather outlines and darker on the right to emphasise the highlighted comb, beak and feathers, the spatters work with this imbalance. Add more Cobalt Teal spatters to the dark background to accent the opposition with the redorange in the comb and wattles. Add orange spatters to the lighted background to contrast with the greater mass of blue feathers there. Apply spatters unevenly to the feathers and face to create more variation. Apply red spatters to the comb, face and wattles as a lively spark, since red is analogous to the yellows and oranges.

▲ 5 Paint a heavy-body mixture of Cadmium Yellow Medium and Cadmium Orange Medium along the leading edge of the comb to emphasise the highlights. Allow some spatters to remain and obscure others for an interesting effect. You will see the lively effect of the Cadmium Red Medium fluid spatters on the comb.

▲ 6 Repaint both the eye and the beak with heavy-body acrylics after spattering, again obscuring some spatters and allowing others to remain, otherwise the eye and beak will be excessively obscured by spatters. Notice how the spatter pattern on the face was accented with the fluid Cobalt Teal in particular, a vibrant complement to the Pyrrole Orange in the face.

Pigment permanence

How long will the art you create last? Paintings that crack, fall apart, fade, discolour and otherwise degenerate are a dreadful outcome for creative inspiration. So what are the important factors you need to know about pigment permanence?

PIGMENT PERMANENCE AND PAINT STABILITY

Not only is it important to use lightfast pigments to avoid fading and discolouring, but the binder used to make the paint is worth considering as well. High-quality paint with a dense pigment load is far more effective for painting than poorer-quality offerings.

The so-called 'student grade' paints are not good choices. Fugitive pigments may be used to save

Alizarin Crimson Hue replaces the fugitive Alizarin Crimson, a dye made from the cochineal insect. Quinacridone Burnt Scarlet is a lovely example of a new inorganic pigment that also can be used as an alternative to Alizarin Crimson.

money in manufacturing, and pigment density is reduced to lower the price, so these paints should be avoided.

The acrylic emulsion used in formulating acrylic paints is usually quite reliable. This acrylic emulsion dries into a flexible film, which is the main reason acrylics are not prone to the cracking problems that can plague oil paints.

The clear emulsion is also not subject to the yellowing over time that happens with oil-based paints. Lightfast colours consistently remain true to their original appearance.

The main concern with permanence in acrylics is the fact that the fully dried surface of the paint remains slightly porous and sticky. Dust and other contaminants can embed themselves into the surface. Varnishing helps prevent any difficulties with this issue.

HISTORICAL OVERVIEW

Humans have always created artwork with whatever materials were available at the time. Clays found in the soil were a good early source of earthy colours durable enough for ancient cave paintings to survive to the present. Plants and some insects were used for colourants, all too often with short-term results. Carmine was derived from scale insects. Alizarin Crimson came from madder root and proved to be a fugitive colour (see page 10). Indigo was originally made from a plant called woad but is now synthetically made. Still fugitive, indigo is now used in blue jeans.

In their quest for permanent colour, artists suffered through the use of extremely toxic materials that provided colours otherwise unavailable. Vermilion was the result of alchemical experiments mixing sulfur with cinnabar, an ore of mercury. Artists loved the colour, but mercury is the element formerly used in hat making that caused mercury poisoning, long before anyone understood its toxic qualities.

Lead was another dangerous material used in many paints. Red lead was substituted for the more expensive vermilion, providing an equally toxic alternative. It is possible that lead paints aggravated Van Gogh's mental and physical health problems.

Let us not forget arsenic, which appeared in many different paint formulations. Cobalt Violet contained arsenic, but greens including Scheele's Green and Paris Green were more commonly created with the material. Paris Green was used in wallpapers in homes where cases of arsenic poisoning were reported.

The array of permanent pigments that can be used with reasonable safety in the studio today are truly a treasure for the modern artist. We are far more fortunate with our paint options than our ancestors.

PIGMENT AVAILABILITY

Lamborghini Spyder Lou O'Keefe

Characterised by two pairs of complements, blue with orange and purple with yellow, this painting of a car was made possible by modern manufacturing. The pigments used in contemporary art materials are developed for other uses first, such as automotive paints. So this painting about a manufactured luxury car is also created with paints related to the manufacture of that car.

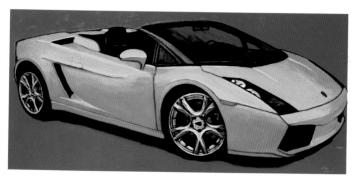

You may be surprised to learn that a flashy sports car is directly related to your acrylic paint choices. The main pigment consumers are the automotive and plastics industries, so if an inorganic pigment falls out of fashion for cars, after a few years you probably won't be able to find it as an artist's pigment. For example, Quinacridone Gold (PO49) is a lightfast, transparent, staining, mid-valued, moderately intense earth-yellow pigment. Manufacture of PO49 ceased in 2001 because there was insufficient demand for the pigment from automobile manufacturers, its principal consumers. Most artist's paints made with this pigment were discontinued in 2005. See the listings on www. handprint.com for more information

on discontinued pigments.

SUBSTRATES

Pigment permanence is related to the binder in the paint and also on the substrate used. You could use the most permanent possible pigment in your paint but if you create your painting on newsprint, the life of that painting will be short.

Newsprint is made from wood fiber and contains cellulose, which causes the paper to decay, become yellow and brittle, and eventually disintegrate. Besides the problems of a substrate made of poor materials, issues may also arise with unwanted chemical reactions between the paint and the substrate.

Acrylics can be painted on a multitude of surfaces but are most commonly painted on canvas, watercolour paper or board. Of the three, boards can present the most problems with pigment permanence.

Boards are made with a wide range of materials, not all of them archival or permanent. Cradled and sealed birch is the most archival choice as it is less acidic than other woods and the sealing prevents oxidation. Pressed boards are made with non-archival glues that can delaminate over time.

Canvas primed with gesso is an acceptable substrate for acrylics. In addition to the cottons and linens, some new synthetic polyflax or polyflax/cotton blends are available. Although too new for long-term testing results, they look promising.

Heavy watercolour paper is also an excellent substrate for acrylics. High-quality papers will not contain cellulose and should last extremely well with proper care.

ENVIRONMENTAL FACTORS

Place a completed painting in an inappropriate environment and the most permanent, most archival materials in the world do not stand a chance. Extreme moisture and temperature fluctuations are deadly for the stability and unblemished appearance of a painting. Air pollution may also cause unwanted chemical reactions in the paint.

Furthermore, you need to keep in mind the standards behind the lightfastness ratings of the paint manufacturers (see page 122). These standards are based on indoor placement of the painting without direct sunlight in a steady humidity that is not too high and a similarly steady temperature that does not go to extremes.

Electric Casey Jennifer Bowman

This striking painting features two pair of complements, blue with yellow-orange and cyan with red-orange. Notice the unusual background treatment with the geometric patterns. Using permanent pigments in high-quality paints on an archival substrate and taking proper care of the finished painting will ensure that beauty such as this can be enjoyed long into the future.

Opaque and semitransparent acrylics

Acrylic paints have some unique properties that can be used to excellent advantage once they are understood. They can be used thickly, like oil paint, and as thin washes, as in watercolour. Pigments vary from opaque to semi-transparent.

Do not confuse pigment qualities with the qualities of the acrylic emulsion holding them. Those emulsions may be heavy-body or fluid and that makes no difference to whether or not the pigment they carry is opaque or transparent.

Unlike oils, where a hidden layer may later bleed into a more recent layer, changing the visible colour even weeks after drying, a lightfast acrylic colour will remain exactly as you see it once it has dried. When using opaque acrylics, this means that any part of a previously painted layer can easily be completely covered so it has no further effect in the painting. This offers a great freedom to experiment in colour, especially with the quick-drying time of these paints.

Titanium White is opaque and an excellent choice to cover areas that need to be completely repainted. Many other colours are also opaque. If in doubt about the opacity of a specific acrylic colour, you can quickly test a colour to see how well it can hide an existing colour layer.

Other acrylic paints are semi-transparent and lend themselves to other possibilities. Applying thin glazes of these semi-transparent paints modifies the colours under them. Allowing a glaze to dry before adding another allows optical colour mixing where directly mixing the colours on the palette would create a different and unwanted look. Multiple layers of glazes can be used to create richly varied tapestries of colour in your paintings. Commonly used semi-transparent acrylics are the quinacridones, synthetic pigments that have only recently become available for painters. The quinacridones add a stunning warm brilliance to the palette. Other semi-transparent acrylic paints such as Indanthrone Blue and Carbazole Violet have much stronger tinting ability and must be handled with restraint if fully saturated colour is not wanted.

Opaque and semi-transparent acrylic paints are most commonly combined in paintings. They can be used to create bold areas of dramatic colour or delicately graduated blends as desired.

CHANGING ACRYLIC COLOURS

Opaque paints are extremely useful if you make a mistake or change your mind. If a disruptive texture has not been added to the painting, it is easy to completely repaint an annoying compositional element to change or eliminate it. If you want to change it to a combination of opaque paints, you can do so directly. If you want to change it to semi-transparent paints, the old colour will partially show through them. In that case, paint the area to be replaced with the extremely opaque Titanium White and let it dry. This allows semi-transparent paints to be used without distortion by the former colours.

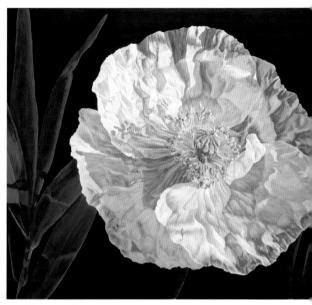

The illusion of transparency

Just because a paint is opaque itself does not mean it cannot be used to create the appearance of transparency. White Gossamer was painted entirely with opaque acrylic paints and shows transparent glowing flower petals. The petals were painted in tints of Ultramarine Blue and Raw Umber with Titanium White in varying mixtures. Since these paints themselves are not transparent, the effect was achieved by careful control of tonal values in the mixes.

Main palette Titanium White Carbon Black Chromium Oxide Green Raw Umber Ultramarine Blue Cadmium Orange Medium Cadmium Yellow Medium

COMPARING OPAQUE AND SEMI-TRANSPARENT

Painting opaque and semi-transparent acrylics over each other is a good way to see how the paints will affect each other. In these examples, the first circle was allowed to dry before painting the second overlapping circle.

Semi-transparent over opaque

The overlap area shows the optical colour mix that resulted from the semi-transparent Quinacridone Red painted over the dried layer of opaque Cadmium Yellow.

Quinacridone
Red is close to a
complementary
colour to the
Opaque Chromium
Oxide Green, so the
overlap area is quite neutralised
(see page 74).

Opaque over semi-transparent

Opaque Cadmium Yellow covers the semi-transparent Quinacridone Red so almost none of the red shows in the overlap.

Opaque Chromium Oxide Green even more thoroughly covers the semitransparent Quinacridone Red in the overlap.

EXPLORING TRANSPARENCY

Semi-transparent acrylic paints can readily be used to create the effect of glowing, transparent petals, as shown here in *Cup of Fire*. The petals were painted with the quinacridones on a lightly gessoed canvas. The slightly absorbent surface made it easy to paint soft blends in varying colours. Additional glazes of the quinacridones were used to create the deeper colour areas of the petals.

In order to maximise the richly saturated brilliance of these paints, no opaque paints were used in the outer petal colours, but Titanium White was used as a blending colour for the gradations painted into the centre.

Main palette

Quinacridone Red Quinacridone Pink Quinacridone Gold Quinacridone Magenta

Flower centre

Chromium Oxide Green Raw Umber Phthalo Green (Yellow Shade) Cadmium Yellow Cadmium Orange Titanium White

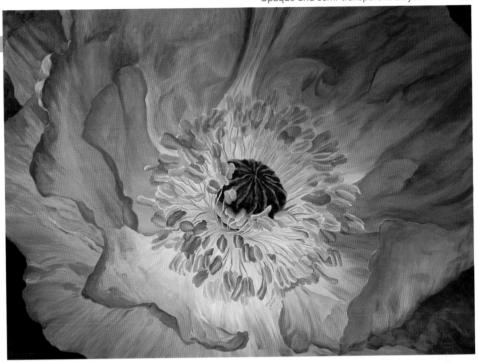

OPAQUE AND SEMI-TRANSPARENT ACRYLICS TOGETHER

In this detail of Bahama Treasures by Bern Sundell opaque and semi-transparent acrylic paints work well together. In different areas of the painting, Titanium White was mixed with all of the paints except Burnt Sienna. Titanium White combines with Burnt Sienna to make an unpleasant chalky colour, a problem not found in the rest of the palette.

The semi-transparent quinacridones were painted in glazes over the dried opaque mixes. They were also mixed with Titanium White and other colours to create softer, subtler blends in some of the conch shells. A small amount of Carbon Black accented the deepest shadows.

Main palette

Titanium White
Raw Umber
Burnt Sienna
Yellow Ochre
Cadmium Orange Medium
Cadmium Yellow Medium
Ultramarine Blue
Cerulean Blue
Quinacridone Red
Quinacridone Coral
Carbon Black

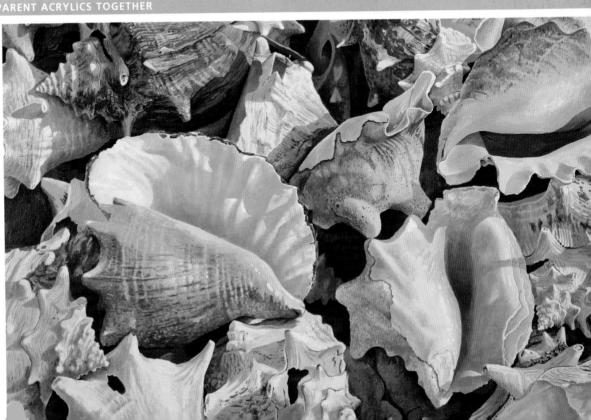

Luminescent acrylics

Luminescent acrylics are a category all of their own in acrylic paints. They sparkle, glitter and refract light in completely different ways than heavy-body or fluid acrylic paints. But what is the difference between duochrome, interference, pearlescent and iridescent paints, and how do you use them? This group of paints – luminescent acrylics – causes inherent difficulties when the artist tries to integrate them into their normal palette. These paints play by different rules in their surprising and unexpected colour shifts. They constantly change colour with the movement of the viewer. And how do you categorise a paint that is a sparkling light aquamarine on white paper but turns gold when painted across black? The behaviour of these paints defies the colour wheel.

Luminescent paints form colour with mica platelets, titanium dioxide and metallic oxides. They are quite stable since the metals are already oxidised so they will not change colour with further oxidation, and the other materials can be trusted for durability.

Titanium dioxide is familiar to us as the pigment for Titanium White, which is a dense, opaque paint. How can the same pigment be used for these wild rainbow

effects? The answer lies in the particle size used. The particles in Titanium White are large compared to the particle size used in luminescent paints.

Coating mica platelets with the paints creates some amazing colour shifts. Controlling the process precisely allows the manufacturer to make paints that reflect and refract light in certain hues but not others. Painting them in thin layers and separating those layers with a glossy (not matt) gel or medium may further enhance them.

Luminescent acrylics can be mixed with other acrylics. For example, Iridescent Electric Blue mixed with heavy-body acrylic paints can produce some startling colours. Duochrome acrylics, however, lose their characteristic dual colour shifts when mixed with other acrylics. Some of the other luminescent paints can be used to colourful advantage in such mixtures.

PEARLESCENT ACRYLIC PAINTS

Pearlescent acrylics are transparent – except for Black – and look fairly similar to each other on white watercolour paper. The differences between them are much more pronounced when painted across a stripe of black paint.

Pearlescents mix well with other paints, including other iridescent and regular acrylic paints. Do not expect them to look white over an area of your painting that has a layer of bright colour. If you need a whiter look there, you will need to paint some Titanium White, let it dry and then paint the pearlescent paint over it.

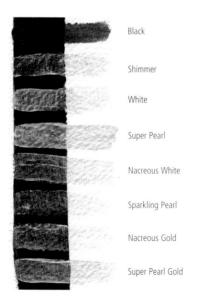

INTERFERENCE ACRYLIC PAINTS

Interference colours have subtle effects and have been compared to oil sheen on water. As you might guess, this does not photograph particularly well, but the swatches offer an idea of the main colour changes you can expect from the different colours.

The alternate green shown is simply by another manufacturer. These paints have distinct variations from manufacturer to manufacturer so you may want to explore all your options.

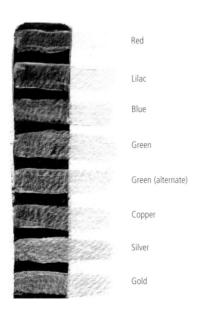

SILVER AND GOLD IRIDESCENT PAINTS

The paint swatches in this example show a variety of silver and gold metallic iridescent acrylic paints. The variations between manufacturers can be extreme in this category, as you can see from some of the alternates in the swatches.

Iridescent paints mix well with each other, so obtaining the desired brilliance can be achieved that way if the colour straight from the tube is not what you want for a given effect.

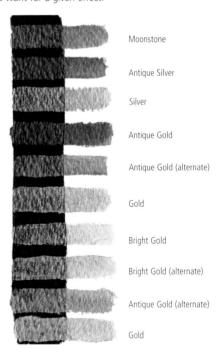

DUOCHROME ACRYLIC PAINTS

Painting duochromes across a stripe of black paint and onto white watercolour paper shows their oddities immediately. Radical colour shifts that one would not predict from looking at the often nondescript dab of paint on the palette immediately appear.

What is lost in this still photo of the paint swatches is the way they change with the movement of the viewer. All of the luminescent acrylics are similar to opal in the way we perceive their shifted, refracted colours in movement.

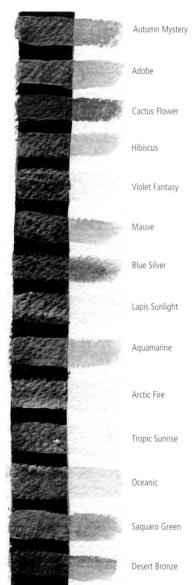

IRIDESCENT ACRYLIC PAINTS

As you can see from the painted swatches, iridescent acrylic paints are both more consistent painted over black and white and more opaque as well. For predictable results they are easier to use than duochrome or interference acrylics.

Some of the paints pictured are metallics. A still photograph cannot properly convey how bright they can be in real life.

Iridescent acrylics mix well with regular acrylic paints to offer a wide and sparkling range of colours. Iridescent paints are an excellent choice for experimenting with luminescent acrylics.

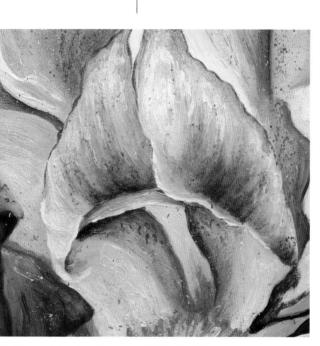

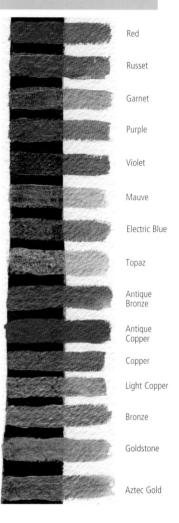

This detail from a painting of an iris is an example of the use of Iridescent Red and Shimmer Pearlescent. Mixing a pearlescent paint with a normal acrylic paint such as Cadmium Yellow Medium can add a striking liveliness, effective for an inner glow of light in this flower.

DISCOVERING DISADVANTAGES OF LUMINESCENT ACRYLICS

One of the biggest disadvantages of luminescent acrylics cannot be seen in these photographs of paint swatches, but becomes immediately obvious in a completed painting. The surface of luminescent acrylics is drastically different than that of regular acrylic paints.

At certain angles depending on the light, luminescent acrylics are obvious patches against the other paints, and that pattern can overwhelm your actual colours and composition in the painting.

Mixing the luminescent paints with all other paints in the painting can eliminate the problem, but it may not be the solution you want. Using small areas of luminescent acrylics is another way to minimise the problem.

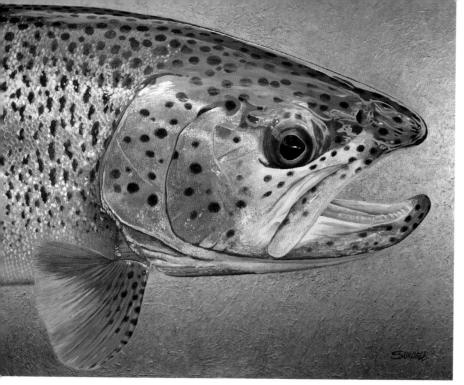

River King Bern Sundell

Pearlescent and iridescent acrylics were used along with heavy-body acrylics in this work. The background was painted with metallic gold iridescent paint that was also used in part of the head of the fish to integrate the fish with the background.

USING LUMINESCENT ACRYLICS: SUBJECT 1

Fish scales are a naturally iridescent subject for painting. The following example of a rainbow trout shows them off to good advantage.

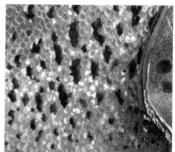

The detail of fish scales from *River King* starts to give some idea of the contrast between the surfaces of luminescent acrylics and regular acrylics. This is more apparent in real life and the artist has since discontinued using luminescent acrylics in his popular series of trout paintings.

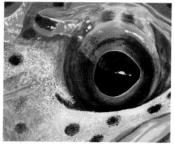

The richness of the iridescent paints intermingled with heavy-body acrylics is shown in this detail from *River King*. The effect is colourful and lively against the contrasting darker colours of the eye and upper part of the head.

USING LUMINESCENT ACRYLICS: SUBJECT 2

Careful selection of subject matter is important in making luminescent paints aesthetically pleasing in your painting. Naturally iridescent subjects make sense for these materials.

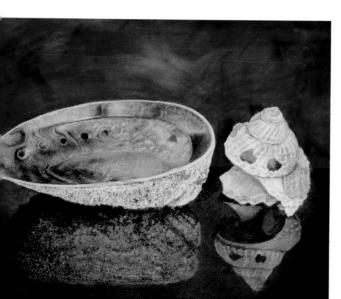

New Zealand Paua Shaugn Briggs

Luminescent acrylics were used in this painting of a paua shell. The artist concentrated them in the areas of the shell that would actually be iridescent and avoided them in the outer coating of the shell that typically is dull and opaque.

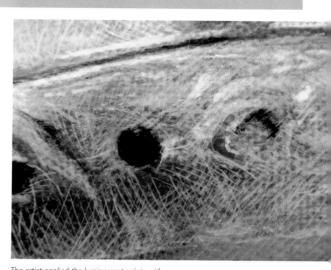

The artist applied the luminescent paints with skill and delicacy over a paint layer that is not luminescent. The varied colours catch the light in a convincing way.

PAINTING WITH LUMINESCENT ACRYLICS

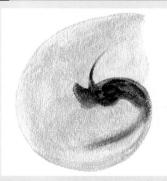

Palette Pearlescent White, Pearlescent Shimmer, Pearlescent Black, Nacreous Gold and Super Pearl Gold.

1 Pearlescent paints provide the base coat of paint for the shell. Pearlescent paints have a subtle shimmer that can be quite lovely. The colours used in this layer are slightly more varied than the still photograph implies, because of the colour shifts seen in movement.

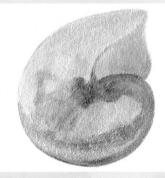

Palette Arctic Fire, Aquamarine, Blue Silver, Lapis Sunlight, Mauve, Violet Fantasy, Hibiscus, Cactus Flower, Autumn Mystery and Adobe.

2 Duochrome acrylics have been applied over the pearlescent colours. The shell shows more lively colour at this stage. The lighter areas have an attractive pink glow that appears with movement but is less apparent in this still photograph.

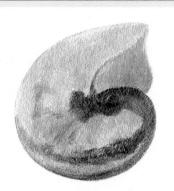

Palette Paints used include Blue, Green, Lilac, Red, Silver and Gold.

3 Interference acrylics have been painted over the preceding two layers. The photograph shows the more subtle appearance of the shell but does not illustrate the delicate sheen in movement. The dark shadow began shifting to a blue-grey in the shell.

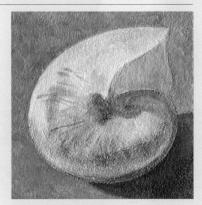

Palette Luminescent paints used were Electric Blue, Aztec Gold, Bronze, Antique Copper, Topaz, Violet, Purple and Russet. Heavy-body acrylics used were Quinacridone Gold and Yellow Ochre.

4 Iridescent paints were introduced at this stage of the painting. The background shadow was first painted in Electric Blue and the brightly lit background area in a tint of Pearlescent Shimmer and Electric Blue. After drying, a mixture of Quinacridone Gold and Yellow Ochre was thinly applied to allow the layer underneath to still show luminescence.

A nautilus shell provides the subject for a painting that shows the application of different kinds of luminescent acrylics. Small amounts of heavy-body acrylics were also incorporated into the painting.

Normally the author would not paint the different kinds of luminescent acrylics in entirely separate layers as shown in this example, but for demonstration purposes it was useful to better indicate their nature

A selection of some of the luminescent acrylics used in this painting.

Aquamarine

Arctic Fire

Cactus Flower

Hibiscus

Lapis Sunlight

Mauve

Autumn Mystery

Blue Silver

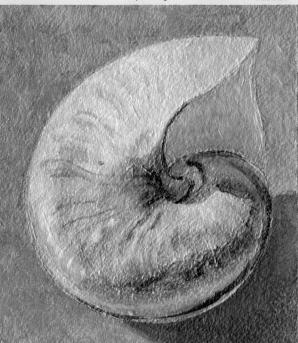

Multiple layers of iridescent and pearlescent paints along with Titanium White and Indanthrone Blue completed the shell. The Titanium White highlights and Indanthrone Blue shadows were allowed to dry and then painted with Pearlescent Shimmer to avoid any variation in surface sheen. Pearlescent Shimmer or other white pearlescent paints work well to tint other luminescent paints to dilute the intensity of their colours when needed.

Gel mediums and grounds

Grounds are used to prepare the substrate - typically canvas or board - to take paint. Gesso, the most commonly used ground, is used to partially soak into the substrate and form a surface that will receive paint without flaking or separating from the substrate. Gel mediums are used to modify acrylic paint in order to create different textures while painting. Gel mediums are not used as grounds, and vice versa. Knowing the characteristics of the grounds and gel mediums available allows you to choose the best options for bringing vour own creative vision to life.

Gesso is the standard and most reliable ground for both canvas and board. Many prepared canvases and boards come already primed with gesso. Even if you stretch your own canvas, primed rolls of canvas can be bought.

Yet it can be handy to keep some gesso in the studio even if you use already primed materials. Sometimes the canvas texture may need to be smoother and additional coats of gesso can do the trick.

Gel mediums come in a wild assortment of characteristics to change the way your paint handles. Some are stiff and others soft, and yet others may be stringy or even coarsened with silica. The array of products can be startling, but properly chosen gels can make it easier to accomplish your objectives in painting.

Gesso ground After applying three coats of gesso to the canvas, the sealing of the fibres in the canvas was complete, so nothing more could be absorbed. Dioxazine Purple, Quinacridone Coral and Cobalt Blue were painted with a flat Taklon brush, using the same amount of paint as the example painted on absorbent ground. Notice the brushstrokes are more pronounced and the colours brighter on the gesso ground than on the absorbent ground (right).

Gesso is the most common type of ground and is usually applied in a minimum of two coats for proper priming of a canvas or board. It is better to buy high-quality gesso. The bargain gesso is not really cheaper since it will require more coats to do the same job. An alternative to gesso is absorbent ground. This will allow some of the paint to soak into it and allow softer effects (see above). The absorbent ground is more delicate and should have a protective coating of soft gel and varnish when completed.

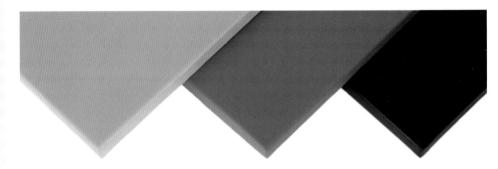

Coloured gesso can be purchased for a coloured ground. Black is the most commonly available alternative to plain white gesso. If you want to make your own coloured gesso you can add heavy-body acrylic paint to white gesso. Initial white coats of gesso on the canvases above were followed by gesso mixed with Raw Sienna, Raw Umber and Mars Black, from left to right. Because of the white opacity of gesso, the Raw Sienna looks more like Yellow Ochre and the Raw Umber is similarly muted. The black canvas had more paint added. A finished painting on the Raw Umber gesso can be seen on page 37 in Using texture in paint.

A coloured ground gives the advantage of a readymade undertone, as this detail shows, which can be quite lovely as additional layers of paint are added. Sometimes the undertone is subtle, as in these window reflections with their subdued radiance, or more obvious in the boards where the Raw Sienna/gesso mixture shows more clearly through the paint. The finished painting can be seen on page 95.

Absorbent ground Despite

brightness of the colours.

using the same amount of paint

and the same brush as the gesso

ground example (left), the paint on the

not as bright. Some of the paint was

absorbent ground has softer blends and is

absorbed by the ground, which reduced the

DIFFERENT TYPES OF GEL

Heavy Gel is best for strongly textured work, Regular Gel is a good general-purpose gel and Soft Gel is more subtle in its texture. Soft Gel can be used as a protective barrier before varnishing. Self-levelling Gel is usable in glazing and is not as runny as the liquid mediums. Gels can be chosen that dry in a glossy, satin or matt surface. Mixing gloss and matt gels produces a satin gel. Gloss gels dry transparently clear, but matt or satin does not. The addition of titanium particles makes a gel satin or matt but reduces its opacity at the same time. This reduces the chroma of the paint mixed with it or lying under it in the painting, so choose according to what you need.

The shadows make it obvious how well each gel medium holds its shape.

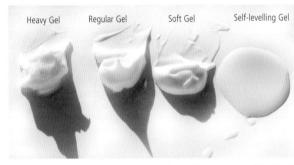

Heavy Gel with Cadmium Yellow

Regular Gel with Chromium Oxide Green

Soft Gel with Ultramarine Blue and Titanium White

Self-levelling Gel with Dioxazine Purple

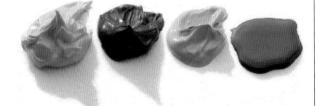

IMPASTO EFFECTS WITH GELS

In the three examples below, three different gels were mixed with heavy-body acrylics to demonstrate how they can be used to paint impasto effects. The same flat, hog-bristle brush was used in all three examples because of its stiff and coarse bristles that leave a pronounced brushstroke.

Heavy Gel Medium was mixed with Pyrrole Orange. Powerfully textured and dimensional effects can be created with this gel.

Regular Gel Medium and Cobalt Green do not show the same depth and ability to hold extreme shapes as the Heavy Gel Medium. However, it makes an attractive textured brushstroke nonetheless

Soft Gel Medium and Manganese Blue Hue were mixed for this example. This gel does not hold as much texture as the others but still provides a good appearance. This gel can also be used to protect fragile layers, such as the Crackle Paste ground.

The detail from a painting at right using Soft Gel Medium with several different paint combinations shows the rich effects possible with multiple layers of gel. Varying tints of Dioxazine Purple, Ultramarine Blue and Cobalt Turquoise were mixed with Soft Gel Medium and applied with either a flat Taklon brush or palette knife. Each layer dried completely before the next was added.

CRACKLE PASTE A SPECIALITY GROUNT

Crackle Paste is an unusual ground that has to be applied heavily and then allowed to cure for three days. As it is fragile, it must be used on a rigid substrate, in this case Masonite. The Crackle Paste was applied with a palette knife, and in the course of drying, these radiating cracks appeared. A finished painting using this ground can be seen on pages 36–37 in Using texture in paint.

Heavily applied Crackle Paste results in a dried pattern of dramatic spiderweb cracks, creating a unique painting surface.

Flow release, varnishes and drying extenders

Fortunately for the artist, speciality products have been developed to make some of the standard characteristics of acrylic paints more versatile. Flow release permits delicate flowing lines to be painted easily in acrylics and also changes the way paint can be absorbed. Varnishes help minimise the harmful effects of ultraviolet rays and the tendency of acrylics to remain slightly absorbent after drying. Drying extenders lengthen the working time of the paint to allow easier blending of colour on the painting.

FLOW RELEASE EXPLAINED

Flow release is a liquid product that is a surfactant, which means it reduces surface tension. Surface tension is what makes water hold the rounded shape of a dewdrop. Reducing surface tension makes it impossible to hold the normal rounded shape and water immediately flattens and flows.

Mixed with water and acrylic paint, flow release reduces the surface tension of the entire mixture, allowing our paint to flow smoothly and readily penetrate absorbent surfaces like watercolour paper and raw canvas. This creates stronger staining effects than paint alone can do (see right).

The lack of surface tension also allows thin and delicate lines to be painted, a task that can be quite challenging with heavy-body acrylics. Wonderfully fine detailing can be achieved using flow release.

FLOW RELEASE FOR STAINING

In this example, transparent Quinacridone Rose was used to demonstrate staining on heavy watercolour paper.

Without flow release Quinacridone Rose was painted directly on heavy watercolour paper. A fairly smooth blend appears and a ragged edge at the bottom shows the behaviour of the paint.

With flow release A similar swatch was painted with a water and flow release mixture added, according to the manufacturer's instructions. Notice the smooth blend and the greater depth of colour achieved with the same amount of paint and the same brush on the same piece of paper.

USING VARNISHES

Varnishes protect the completed painting by preventing dust and dirt from becoming embedded in the acrylic paint, which remains very slightly absorbent and sticky, even after drying. Some varnishes may also provide protection from ultraviolet rays.

Applying a layer of Soft Gel Medium mixed with a little water provides an additional protective layer between the paint and the varnish. After the gel has dried, a polymer acrylic varnish or an MSA varnish can be used. Polymer varnishes are the easiest to use but may be more difficult to remove later. For the most archival purposes, MSA varnish with UVLS (ultraviolet light stabilisers) is recommended.

MSA stands for Mineral Spirits Acrylic and has to be thinned in a ventilated area with either mineral spirits or turpentine. Do not even attempt to use it without the necessary ventilation. This varnish dries to a hard protective surface but can be removed with mineral spirits or turpentine if that is required later.

Varnishes can be matt, satin or glossy, just like gel mediums. They also have the same opacifying effects because titanium dioxide is used to dull the gloss. If your painting has strong darks, a matt or satin varnish will lighten the look of those dark colours.

FLOW RELEASE FOR FINE LINES

Delicate detailing of fine lines, such as in small tree branches against the sky, or in the signature on a painting, can make artists mutter irritably at acrylic paint. Flow release offers a delightful solution to such difficulties.

Without flow release No flow release was used in painting the author's name on heavy watercolour paper. Notice the breaks and skips in the lines.

With flow release With a correctly mixed flow release solution, the signature becomes almost effortless to paint.

USING DRYING EXTENDERS

The quick-drying characteristics of acrylic paint can be either a delight or a frustration, depending on what you are trying to do. Use drying extenders if you want to work an area of paint into soft blends before it dries. They also keep the paint in better working condition on an ordinary palette if you have the misfortune to not be using a Sta-Wet palette (see page 123).

Drying extenders are available as an additive to be mixed with acrylic paint. Some paints are specifically formulated to be slower-drying straight from the tube, such as Golden's Open line of paints or the Winsor & Newton paints.

PAINTING WITH DRYING EXTENDERS

Drying extenders can be an excellent choice for painting skin tones. For this example, drying extender was mixed as an additive into regular heavy-body acrylic paints, but some Golden Open acrylics and Winsor & Newton acrylics were also used. Without drying extenders the soft, smooth glow of this young face would have been far more difficult to achieve.

A modified split-complementary palette was used. Quinacridone Rose opposes Chromium Oxide Green, Phthalo Green (Yellow Shade) and Naples Yellow Hue. Raw Umber was used for shadows and to partially neutralise some of the other colours. Titanium White completed this limited palette.

Ouinacridone

Chromium Oxide Green

Phthalo Green (Yellow Shade)

Naples Yellow Hue

Raw

Titanium White

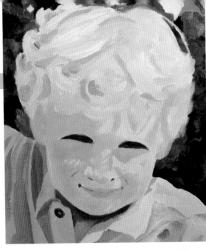

1 Use tints of Quinacridone Rose for the shirt, and tints of Quinacridone Rose and Naples Yellow Hue for the skin tones. Use Chromium Oxide Green with Raw Umber and a little Titanium White for the background hollyhocks. Use Ouinacridone Rose and Titanium White for the flowers and Raw Umber for the darker shadows in the painting.

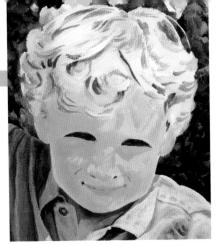

2 Develop the background foliage and flowers further with the same paints used in step 1, as well as a little Phthalo Green (Yellow Shade). Glaze the shirt with varying mixtures of Chromium Oxide Green, Raw Umber and Titanium White. Allow a slight glow of the underlying Quinacridone Rose to remain visible. Paint tints of Raw Umber mixed with Ouinacridone Rose into the hair for the darkest shadow areas.

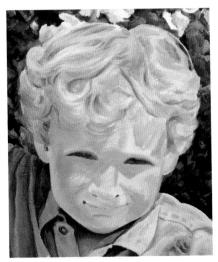

3 Paint tints of Naples Yellow Hue into the hair, softening the harsh shadows established earlier. Taking advantage of the slower drying times of the paints, tint blends of Quinacridone Rose, Naples Yellow Hue and a little Chromium Oxide Green with Titanium White and work them into the face. After drying, use a stiff, flat brush to texture the hair with Regular Gel Medium.

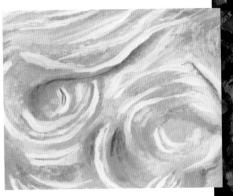

4 Mix Naples Yellow Hue with either Ouinacridone Rose or Chromium Oxide Green and add it to small amounts of Raw Umber to define the darker areas of the hair. Add highlights to the hair with Titanium White. The gel texture will help catch the paint, creating highlights that are almost white. Add more Quinacridone Rose to the lips and cheeks. Adjust the values in the face once more to complete the look of light falling across the child's face and paint your signature with flow release.

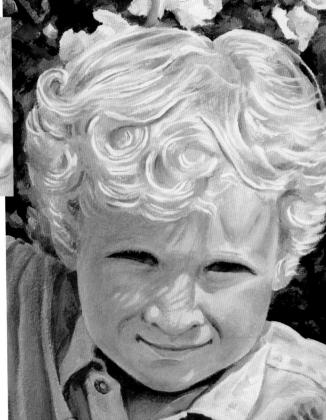

Wash properties

Acrylics are so versatile that they can be worked in a manner similar to both watercolours and oils. The softly blended washes characteristic of watercolour can be achieved with acrylics. Some differences do exist, so let's explore them.

While the differences between watercolour washes and acrylic paint washes are significant, careful control of the amount of water used is vital for success in both. Lots of water equals lots of flow in the paint and less water means more precise control in the movement of paint. Practice brings an understanding of water control, both in the brush and on the paper.

As would be expected, wash effects can certainly be used on watercolour paper but may also be applied to canvas with a thin ground that leaves the canvas slightly absorbent, or a special ground manufactured to be absorbent. Each of these produces results with different qualities. Paper is more absorbent than canvas and takes the paint with a greater depth. Textures also affect how the paint settles into the paper or canvas.

The most significant difference between watercolour and acrylics is the fact that acrylics dry permanently. They cannot be rewetted for additional changes like watercolour. This has advantages and disadvantages.

Additional wetting of the paper will not disturb a beautifully smooth dried wash in acrylics. If the paper is still somewhat absorbent, another wash can be applied over part or all of the first one. However, the more acrylic paint goes into the paper and dries, the less the paper is able to absorb water. When the paper becomes sealed with acrylic paint, no more wash effects can be absorbed.

Either opaque or semi-transparent acrylic paints can be applied in washes. The semi-transparent paints will most strongly resemble watercolour. Opaque acrylics can make excellent washes for backgrounds designed for additional detailed painting once they have dried.

Washes can be loosely painted on wet paper. Water in the brush as well as in the paper has to be controlled, even for casual effects. Experimentation gives you the proper feel for it.

- 1 This example shows a simple wash of Phthalo Green (Yellow Shade) blending from darker at the top to lighter at the bottom of the heavy watercolour paper. The paper was wet enough to look shiny when the paint was applied at the top with a brush and then blended softly into the lower part.
- **2** An even wetter paper was used in this example of 'shooting' in washes. Extremely wet paper allows paint to shoot out in all directions in the wet surface when a loaded brush touches the paper. This paper was lying flat and not tilted to get the Quinacridone Red paint to flow.
- **3** Three vertical bands of paint, Quinacridone Red, Hansa Yellow Light and Phthalo Green (Yellow Shade), were allowed to blend together on a wet watercolour paper. The texture shown is a result of the paper texture allowing the paint to settle into the recesses. Smooth paper would give an evenly graduated blend if that were desired.

CONTROLLED WASH AREAS

Applying water to a carefully defined area on the paper allows wash effects to be used in specific areas without spilling into other areas of the painting. Painting the following example in different colours from your palette is a good way to practice. Notice the difference between using a really wet brush and a drier brush loaded with paint on the wet paper. Touching a brush to a paper towel quickly removes excess water for precise control.

1 Dark pencil lines were used to draw the circles so they would show up clearly. The painted area of the left circle was wet with water before painting Quinacridone Red around the outer edge of the circle. Paint was blended to the centre and then lifted in the middle with a paper towel touched to the surface to absorb excess paint and water. A dry brush can also be used for lifting paint in this way.

- 2 After drying, Phthalo Green (Yellow Shade) was applied in the right circle in the same way as the Quinacridone Red in the left circle. The wash of paint was applied with a smaller brush that left a coarser blend than the smoother wash on the left. Choosing the correct size brush for the effect you want also comes with practice.
- **3** Once again, the paper was left to completely dry before painting the next step. By now you know that wherever the water lies on the paper, the paint will follow. After precisely painting the football-shaped overlap with water, Quinacridone Red was laid along the right edge and Phthalo Green (Yellow Shade) on the left edge. They naturally blended together towards the middle.

LISE THE RIGHT PAPEL

For best results, always use 638 gsm (300 lb) high-quality watercolour paper that takes paint beautifully and resists buckling. This cannot be emphasised too much. Painting on thin, poor-quality watercolour paper often convinces the unfortunate artist they cannot handle water media on paper. All that has really happened is that they couldn't handle water media on paper that would be practically impossible for anyone to use.

Green Frenzy Loren Kovich

Wash effects in this painting were applied freely and loosely, allowing accidental blends of several colours. Washes on canvas appear different from washes on watercolour paper. In this painting, additional detail of stylised river rocks, fish, and ripples were painted over the acrylic wash background.

Floor Play Linda McCord

Just look at this painting to see what can be done with controlled areas of washes. Each goblet has multiple small washes painted in the coloured tops and for the shadows falling across the floor. Some detail was painted with a dry brush, but the entire painting is really a rainbow array of carefully applied wash effects. These washes achieve the appearance of transparent glass and the movement of light through that glass.

EXPLORING EXAMPLES OF WASH TECHNIQUES

Artists use wash effects in wonderfully varied ways to create compelling artworks with exceptional colour. When you look at acrylic paintings, you may find it helpful to notice any wash effects and how they were used. Later, you can apply the effects you need to your own paintings.

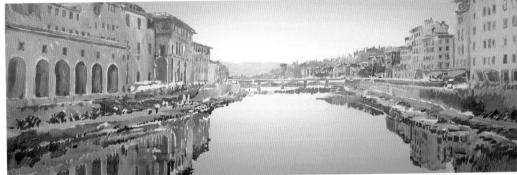

Morning on the Arno Carol Carter

Golden-orange washes dominate this serene painting on paper, a great contrast with Green Frenzy. Smoothly blended washes for the sky and water bring a sense of stillness to the scene. Controlled areas of wash effects were used in the buildings and final detail was added with a dry-brush technique over the washes.

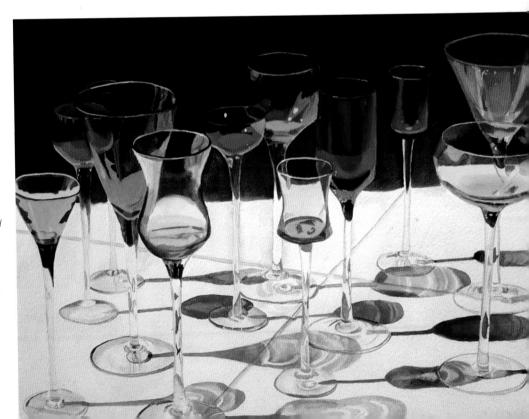

Using texture in paint

While acrylics can be used for wonderful wash effects, sometimes texture is what will give a painting the most impact. Using texture makes possible a different kind of depth and highlights. So, what are the ways we can create texture in acrylics and how can we use them to best advantage?

Heavy-body acrylics can be applied with coarse brushes or palette knives to create textural looks. Gels can be mixed into the paints to alter their texture further, as shown on pages 30–31. You can even mix sand into the paint to add texture.

These are all direct and straightforward ways to create texture in acrylics and they can be used to create enormously varied appearances. Your use of these textures is enhanced by the proper use of colour and subject matter. If you are painting a smooth, serene sky, coarse texture may detract from the effect you want to create. But if you are working with more dramatically varied surfaces, texture can be an invaluable tool

Texture can be created by methods other than mixing gels and sand into the paint. The ground used to prime the canvas or

board itself can have additives to start with a textured surface for your painting. Speciality grounds are available that exist only to create unusual textures for paintings.

Never underestimate the usefulness of battered old brushes. 'Bad hair day' brushes help create interesting texture in your brushstrokes. They can be particularly effective with the heavier gels that hold the texture of coarse brushstrokes.

CRACKLE PASTE AND PALETTE KNIFE

In this example, Crackle Paste and Heavy Gel Medium are applied with a palette knife to paint a leaf lying on a rough rock. The Crackle Paste was applied to the Masonite panel in the background rock area and allowed to cure. A section of it is shown on page 31.

Main palette

Raw Umber Quinacridone Nickel Azo Gold Hansa Yellow Light Titanium White

1 After three days of curing (see page 31), brush Raw Umber over the surface carefully and wipe the excess off the lighter areas with a paper towel. This allows Raw Umber to fill the cracks in the ground. Crackle Paste is an extremely fragile ground usable only on rigid substrates and as soon as the paint is dry, apply Soft Gel Medium and allow to dry in three successive coats to stabilise the surface.

GEL LAYERS FOR TEXTUR

An alternative texture is shown in a similar subject in this example. Cerulean Blue adds a complement to the Cadmium Orange, making stronger contrast possible in this painting.

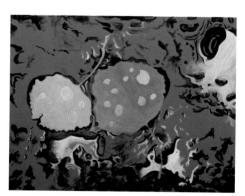

1 Apply a first layer of paint to a canvas with a coloured ground using Raw Umber in gesso as shown on page 30. Raw Umber, tints of varying mixtures of Quinacridone Gold and Cadmium Orange Medium, and tints of Cerulean Blue form this paint layer. Notice how flat the painting looks at this stage.

Main palette

Raw Umber Quinacridone Gold Quinacridone Burnt Orange Cadmium Orange Medium Cerulean Blue Titanium White

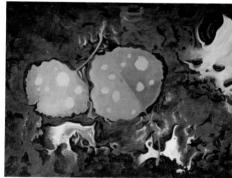

2 Using a 'bad hair day' brush (see left), apply a layer of Regular Gel Medium to the dirt and rock background, using brushstrokes to create texture in the desired patterns. After this plain gel layer is dry, apply another layer of paint with flat and round brushes. Add Quinacridone Burnt Orange to parts of the dirt and rock background.

2 Loosely apply Heavy Gel Medium with a palette knife in the leaf area. By using a palette knife application for both the Crackle Paste on the rock background and the gel for the leaf, related textures are created.

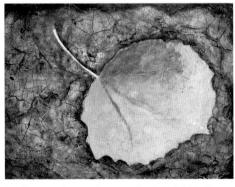

3 Paint more Raw Umber over the Soft Gel Medium on the background rock. Underpaint the leaf with softly blended tints of Raw Umber, Quinacridone Nickel Azo Gold and Hansa Yellow Light. Notice how the gel texture of the leaf adds interest to the blended colours, yet the leaf surface has a distinctly smoother look than the background rock because of those very same soft blends.

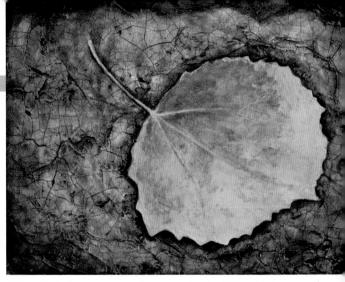

4 Make final adjustments to the background rock with Raw Umber. Add additional glazing to the leaf and stem with tints of Raw Umber, Quinacridone Nickel Azo Gold and Hansa Yellow Medium. All of the texture in this painting was created prior to adding paint layers.

3 After the paint is dry, apply a second layer of Regular Gel Medium with the 'bad hair day' brush, taking care to create new patterns of texture over the previous layers. After drying, drag coloured highlights over the peaks of the texture with a flat brush. Using multiple layers of gel texture that change with each layer alternated with partial paint layers allows a rich appearance to develop. Leave the leaves and water smooth, and complete the water drops to contrast with the busy background texture.

BE VERSATILE WITH TEXTURE

Experiment with different textures combined with the colour effects suitable for the subjects of your paintings. Trying various approaches to texture will develop them into natural tools in your arsenal of painting techniques. You will find that selecting a texturing method becomes easy and spontaneous as you continue to practice.

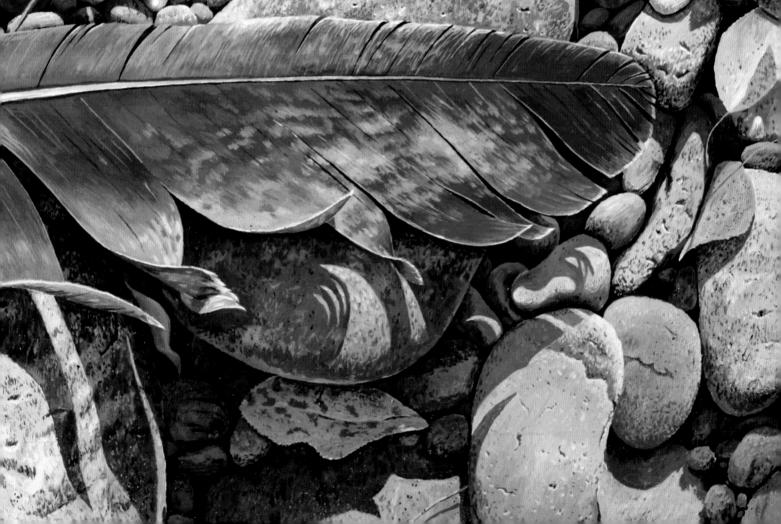

Mixing colour on the palette

Mixing colour is the key to painting well, but managing an acrylic palette poses some challenges. How to arrange a palette, how to control the pigment mixtures and how to take proper care of a palette all are important considerations for the artist. So what are some of the best ways to handle a palette?

If necessary you can use a simple paper plate for a palette. Some artists prefer a piece of glass or a butcher's metal tray. But for acrylics, one choice stands out as the most user-friendly solution, the Sta-Wet palette.

The Sta-Wet palette is a lidded plastic tray that holds a thin flat sponge with a sheet of palette paper laid on top of it. Water wicks from the sponge through the paper into the paints placed on the paper. If the piles of paint are fairly shallow and not heaped like

Mount Everest they stay beautifully moist and actually last a couple of weeks or so.

Acrylic paints dry so fast they usually gum up rapidly on other palettes, and 'skin' - that horrible dried crust on top of the wet paint. A Sta-Wet palette does not dry out, and if the paints are sitting with the lid removed for an extended time, a gentle mist of water sprayed over the paints keeps them in great shape.

the palette and mixed until twelve colours are available. around the outside edge of the palette to allow extra Please note that the colours are placed in a circle on the palette only for your convenience in this book to relate them to the Sundell Colour Wheel (see page 17). If this palette was intended for actual use instead of

In this example, the three primary colours are placed on demonstrating mixing, the paints would be arranged mixing room in the middle. A pile of Titanium White would also be placed in the middle of the palette because it is mixed with nearly everything during the course of a painting.

Primary colours:

Yellow, magenta and cyan are the standard primary colours from the pigmentmixing colour wheel. The ones above are featured in the Sundell Colour Wheel for those placements.

Primary

Six-colour palette: The piles of paint have been mixed with a stiff, flat brush to make the three secondary colours: red-orange, blue-violet and a vellowgreen. Use a brush instead of a palette knife to reduce the chance of tearing the paper palette. If a hard palette is used, a palette knife works well for mixing.

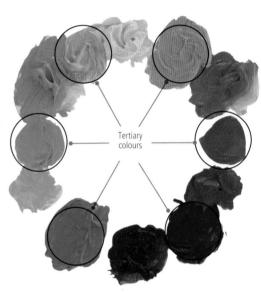

Twelve-colour palette: The tertiary colours – the six colours that fall between the primaries and secondaries – have now been mixed. For each tertiary colour, the primary on one side has been mixed with the secondary on the other side. Notice how this approximates the Sundell Colour Wheel. A twelvecolour palette has now been mixed from the three primary colours.

PHYSICAL MIXING: SIX-COLOUR PALETTE

For the six-colour palette, the single-pigment paints in the primary and secondary placements on the Sundell Colour Wheel have been used (see below). These are all the main colours pictured in the Sundell Colour Wheel.

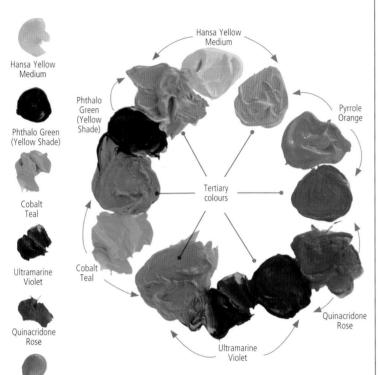

Once again, the tertiary colours have been mixed from the adjacent primaries and secondaries. Notice how much brighter this palette appears than the twelve colours mixed from only the three primary colours (see opposite). Combining pigments reduces chroma,

Pyrrole Orange

so these single-pigment secondaries are brighter than the mixed secondaries in the primary palette. This makes a good visual example of how the twelve single-pigment paints chosen for the Sundell Colour Wheel provide the maximum possible chroma range.

ARRANGING YOUR PALETTE

The best way to arrange the paints on your palette is the way that is most convenient for you for the subject you have chosen. The paints can be arranged on the outside edge of the palette like a rainbow progression of colour. However, it may be easier to place colours that you intend to mix a lot next to each other. Colours that will be used extensively should be allowed more room than colours that will only be used occasionally in the painting. White often works best in the middle where it is accessible in all directions.

MIXING NEUTRALS ON THE PALETTE

Sometimes a painting will require a neutral created from a pair of complementary colours in a varied range of mixtures. Mixing colour on the palette can make this more easily controllable. This same process can be used for mixing adjacent colours instead of complementary colours.

- ▶ Ultramarine Violet on the left is mixed in varying degrees with Hansa Yellow Medium on the right. You can pick up any desired variation with your brush and take it to the canvas quickly and easily when the paint is laid on the palette in a range of mixtures like this one.
- ▶ Since tints of Titanium White are frequently used in painting, adding Titanium White to the range of mixtures can be helpful. Sometimes unevenly mixed colours are desirable for interest in a painting, as shown here in some of the mixed white combinations. If an even mixture is desired, it can, of course, be created on the palette with additional mixing action.

Proper care and cleaning of the palette makes it far easier to focus on the painting instead of complications with the palette itself. Struggling with a palette is an unnecessary waste of time and energy.

▶ After a while, even the best-quality palette deteriorates into a used mess. The one at right was used for three paintings. The waffle pattern comes from the sponge underneath. If that disturbs you, place the sponge smooth side up. Either way works. When the palette is ready for cleaning and renewal like this one, discard the paper palette sheet, clean the sponge if it is still good and add a new paper palette sheet.

Sponges eventually decay. The one below is stained from lots of use. When left too long, a wet palette grows mould, which turns the sponge into an unpleasant slime. Rinse the sponge in water with borax and a few drops of bleach, then add a few drops of bleach to the water held in the sponge to prevent mould. It only takes a tiny amount of bleach to kill microbes, and permanent pigments remain impervious to bleach. Larger amounts of bleach will, however, make the sponge and paper disintegrate. Borax is a household laundry soap sold as a powder and is available in grocery stores.

Mouldy sponge material washes away under running water, leaving holes. A badly deteriorated palette needs to have the sponge cleaned or replaced and a new palette paper inserted.

Mixing colour wet-into-wet

Mixing colour wet-into-wet is a direct and immediate way to manipulate paint that can be greatly satisfying. Most artists use this method in some or all of their work. While creating watercolour effects is covered in Wash properties (see page 34), in this section we will explore ways to mix more textural effects wet-into-wet.

Applying colour to the canvas or paper and then adding another colour and starting to mix them directly is a great way to create lively brushwork and textures in your paintings. Some of the most exciting painterly effects are achieved by painting wet-into-wet. Getting comfortable with the process allows you to paint with immediacy and strengthens your skill as an artist.

After picking up one colour of paint from your palette with a brush and applying it to an area of the canvas, you might want to either wipe the paint off the bristles with a paper towel or use another brush to pick up the next colour to avoid leaving unwanted colour mixed into the second colour on the palette.

Colour can be mixed thoroughly on the canvas to make a smooth blend or it can be left partially mixed and show brushstrokes for a painterly effect. Other colours can be added, but combining too many different pigments will make grey or black. Two colours mix well and sometimes a third can be added for emphasis or neutralising. Mixing more than three colours gets unwieldy. Titanium White is not usually counted as one of those colours as it can be used to make lighter tints with any mixtures.

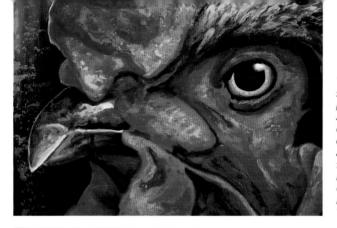

This detail from Royal Rooster shows the rich colour effects possible from mixing wet-into-wet. Almost all the painting in this detail was done in that manner, except for the blue-violet accents added after drying. The comb, face and wattles used Permanent Red, Cadmium Orange Medium, Quinacridone Rose, Anthraquinone Red, Indanthrone Blue and Titanium White.

MIXING TWO PIGMENTS

The following examples show two colours being mixed wet-into-wet on heavy watercolour paper. Each step was photographed during the mixing process to show the lively way in which the look changes with this direct approach.

As a simple example, Cobalt Teal is mixed with Titanium White in a soft blend.

While still wet, more Cobalt Teal is brushed into the previous blend, adding stronger value contrasts and painterly brushstrokes for emphasis.

Quinacridone Magenta was heavily applied and a little Hansa Yellow Medium mixed directly into it, leaving distinct brushstrokes of the yellow paint throughout.

Additional Hansa Yellow Medium is added. Larger quantities of the lower times strength yellow are needed to make a brighter mix with the Quinacridone Magenta.

For a more textural look, Hansa Yellow Medium is thickly applied and partially mixed into Phthalo Green (Blue Shade), providing a graduation of colour across the swatch. The flat Taklon brush effectively moves the thick paint and mixes it further.

Working the paint with the flat brush blends it more evenly and makes the texture much less pronounced.

MIXING THREE PIGMENTS

Mixing three pigments, particularly if two of them are complements, can produce neutralised greys. Titanium White can further modify the resulting mixtures.

The swatch is first painted with Quinacridone Gold tinted with Titanium White. Phthalo Green (Yellow Shade) is painted in the lower right corner and blended upwards and across with Titanium White.

Quinacridone Rose, the complement to Phthalo Green (Yellow Shade) is painted into the wet mixture. Some neutralising towards grey is visible in the brushstrokes.

MIXING TWO COLOURS WITH A TINT

Another common need in mixing colour wet-into-wet is to create lighter tints of the mixture. In the following examples, Titanium White is used. Zinc White is not as strong in tinting strength and is not as opaque. Buff Titanium would create a lower-chroma tint.

Indanthrone Blue, an intense pigment with great tinting strength, has Hansa Yellow Medium mixed into the left and across the middle, without a lot of effect on the powerful dark value of the Indanthrone Blue.

Yellow Ochre meets Raw Umber in this swatch painted in earth tones.

Cobalt Blue and Titanium White are painted in an irregular mixture showing brushstrokes and strong value contrasts.

Quinacridone Violet is mixed in a loosely graduated blend with Titanium White. Brushstrokes are left clearly visible.

By adding Titanium White to the area where the Hansa Yellow Medium was added, the mixture is greatly lightened and we see a blue-green cast to the colour.

Titanium White added to the Yellow Ochre lightens it. The white is also used to alter the values in the Raw Umber. A patch of nearly white paint divides the Raw Umber from the lightened Yellow Ochre.

The mixing wet-into-wet continues with Cobalt Blue and Titanium White. Heavier texture appears in the swatch.

For a different look, more Titanium White is added, reducing values in the swatch but still keeping the loose brushstrokes visible. Then Quinacridone Rose is applied across the bottom half in a slightly more smoothly blended area of colour.

More Indanthrone Blue is added to the lighter mixture to add contrasting values in the brushstrokes.

Additional Yellow Ochre is applied to add a painterly effect in the brushwork.

Ultramarine Violet is painted into the wet swatch, giving a new look to the mixture.

The brush is used to blend the Quinacridone Rose into a neutralised grey. More Phthalo Green (Yellow Shade) is added during the process.

To increase the contrast of the complements, Quinacridone Rose is painted across most of the wet Quinacridone Gold tint. The neutralised grey area somewhat subdues the complementary contrast of Quinacridone Rose and Phthalo Green (Yellow Shade).

Pyrrole Orange is liberally applied to the wet swatch of Indanthrone Blue with a tint of Hansa Yellow Medium shown in the previous section on mixing two colours with a tint. Pyrrole Orange is the complement of Indanthrone Blue.

Additional mixing with the flat brush produces some neutralised greys in the swatch.

Mixing colour with layers and glazes

One of the most outstanding effects of acrylic paints is the glowing luminosity that can be created with glaze mediums and thin layers of paint. The action of light moving through multiple semi-transparent layers can be magical. By patiently adding layer upon layer of these glazes, an amazing richness emerges on the canvas.

Since acrylic paint needs to be applied heavily enough to dry into a durable film, thinning paint with water to apply a thin layer of colour can have disastrous results. The paint tends to be too thin to form a film during drying and can be rubbed away by accident in handling.

To avoid this, artists use an acrylic glazing medium or gel medium to thin the paint (see page 30). Most of the mediums on the market are slightly white before they dry to a clear film, so correctly estimating the strength of the colour during mixing

requires a little practice. Fortunately, the process of building a depth of colour through multiple layers of glazes works well with pale mixtures that gradually appear richer and darker as multiple layers are added. This gives the ability to easily control the stopping point when the colour has reached the desired intensity.

Matt or satin glazes and mediums contain titanium and they are slightly opaque, even when dry. Using glossy glazes or mediums eliminates this effect. If a matt or satin final surface is wanted, varnish can be used to accomplish it without as much interference to the clear depth of the accumulated layers.

PAINTING WITH LAYERS AND GLAZES

A glance at the placement of the palette selections for this painting and where they fall on the Sundell Colour Wheel (see page 17) reveals a tetradic palette (see page 60). The only exception is with

Raw Umber, a paint used in small amounts to neutralise green mixtures in the painting. This particular colour combination works extremely well with the natural colours of the flower and leaves in the painting.

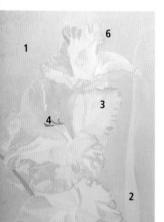

Stage 1 The first layer of the painting renders the image in pale colour. Use a gloss glaze medium to thin the paints to achieve these pastel shades.

- 1 Use Ultramarine Violet for the background.
- 2 Phthalo Green (Yellow Shade) establishes the leaves and stem.
- 3 Quinacridone Rose and Ultramarine Violet form the petals with a few splashes of Hansa Yellow Medium.
- 4 Paint the stamens in Ultramarine Violet that has not been thinned in glaze medium.
- 5 In this initial layer. some of the green areas of the stem and leaves are darker, since they will be in shadow in the final painting.
- 6 A few edges of the petals have a stronger coloured edge as well because that is characteristic of this flower

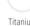

Ultramarine Dioxazine Violet Purple

Quinacridone Phthalo Green Hansa Yellow (Yellow Shade)

Medium

Raw Umber

Titanium White

Stage 2 Continue painting with the previous glaze mixtures and develop the forms of the flower and leaves further. Use as many layers as you need without rushing the increase of colour. This stage of the painting is fairly ugly, which is sometimes necessary. Building layers may require steps that are individually unattractive, but as other colour is applied, the value of those foundation layers becomes evident.

- 1 Include a tiny amount of Raw Umber in the shadows of the leaves and stem.
- 2 In the background, introduce glazed layers of Hansa Yellow Medium, alternating with the Ultramarine Violet layers to partially neutralise the Ultramarine Violet.

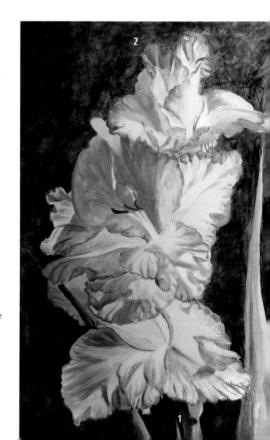

Stage 3 Continue adding layers of glaze using the previous mixtures. The values in the flowers need to be defined with multiple layers of glaze. The leaves take on a smoother glowing look.

1 Create a dramatic shift in the background by switching to Dioxazine Purple. This pigment is powerful and dark, so keep it thinned in the glaze medium and apply it in vertical strokes over the uneven Ultramarine Violet and Hansa Yellow Medium layers. Allow a little of those prior layers to show so that the background has some life to it. 2 Add more blended layers of Dioxazine Purple to create rich, dark shadow across the bottom of the background. This helps bring the painting closer to the intended final appearance.

Stage 4 Continue developing the glazes as described at right to complete the painting. Some artists work with 20, 30 or even more layers of these glazes, so do experiment. The radiance that results is not matched by any other technique.

- 1 Continue developing the depth in the background with more Dioxazine Purple. Then apply a glaze of Hansa Yellow Medium over the background.
- 2 Complete the leaves with delicately applied glazes of Phthalo Green (Yellow Shade) mixed with a little Raw Umber.
- **3** For the final highlights in the leaves, a slight tint of the Phthalo Green (Yellow Shade)

and Raw Umber mixture can be painted in soft streaks that follow the form of the leaves and stem.

4 Bring the blends of the flowers into dramatic contrast by deepening the Ultramarine Violet shadows and the strong Quinacridone Rose edges on the petals. The Hansa Yellow Medium splashes of yellow blend into the petal edges and the shadows.

For a few areas of the flowers, particularly the upper flower, mix Hansa Yellow Medium with Quinacridone Rose into glazes for the petal areas that have an orange colour cast.

Add a sharp emphasis to the petal edges with either Quinacridone Rose or Quinacridone Rose mixed with a little Hansa Yellow Medium.

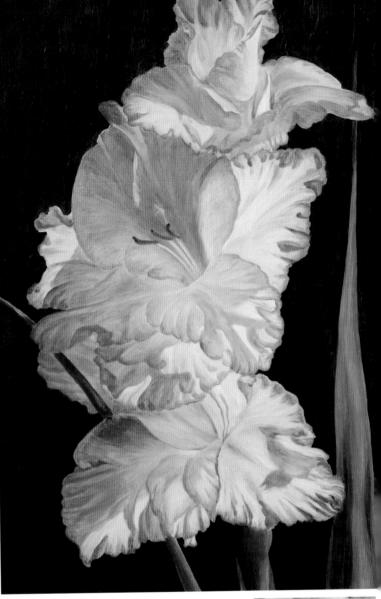

Comparison of colour schemes

Artists who first begin to learn about colour schemes are often surprised to learn that the paintings they most admire follow specific colour schemes. Using paints selected by their placement and relationships on the colour wheel evokes distinctive harmonies and emotions. So how do you employ these colour schemes in your own work?

To create a specific mood or atmosphere through the controlled use of colour.

By selecting a suitable colour scheme, the colours that most easily create a certain mood or atmosphere can be emphasised to their best advantage in the painting.

Monochromatic colour scheme

Titanium

A monochromatic colour scheme uses a single paint from the Sundell Colour Wheel (see page 17) plus Titanium White for tinting

The monochromatic colour scheme is invaluable for exploring value in a painting. The ability to perceive light and its reflective behaviours comes into sharp focus when painting with an emphasis on values.

When using a dark pigment with powerful tinting strength, such as the Ultramarine Blue used here, you can create a great range of values. A pigment such as Hansa Yellow Light provides a much narrower range of values, since that pigment cannot go darker in value than the mid-range on the value scale.

Complementary colour scheme

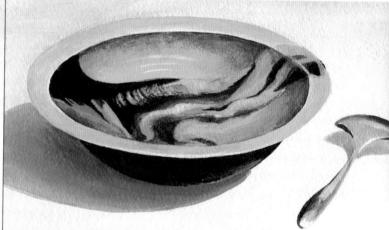

Orange

Ultramarine

Titanium

A complementary colour scheme offers the strongest contrast possible, since it uses colours opposite each other on the Sundell Colour Wheel. Opposing colours also neutralise each other when mixed, which allows useful variations in chroma.

By using only two opposing colours in the painting, one of them can be emphasised to create mood in a highly specific way. In this example, Cadmium

Orange Medium dominates and is supported by Ultramarine Blue. Modify the Ultramarine Blue by mixing with small amounts of Cadmium Orange Medium to neutralise it, or tint with Titanium White.

For further explorations, paint with Ultramarine Blue as the dominant colour. Try other pairs of complements from the Sundell Colour Wheel. Remember the list of substitute colours on page 17 adds even more possible combinations to test.

To create a colour harmony throughout the painting by the use of a limited palette.

By using a clearly related and limited palette, the resulting mixtures in the painting maintain a natural colour harmony. No discordant hues appear in the work.

To use colour schemes to deeply explore hue and chroma relationships.

Discover how certain hues in a colour scheme can be emphasised and how other hues in that same colour scheme can support that emphasis. Mixtures that alter chroma play into this dynamic in the painting as well.

To use colour schemes to deeply explore value relationships.

By using extremely limited colour schemes, such as a monochromatic colour scheme, working with the paint becomes a process of establishing and refining values. Some artists use this as a basis for developing the first layer of a painting, applying a wider colour range later in the work.

To develop a more powerful use of the full palette by understanding the nuances of relationships used in colour schemes.

An informed understanding of the full palette comes after thorough exploration of colour schemes. Certain aspects of colour relationships from colour schemes begin to naturally arise when using the full palette, making the painting more effective.

Analogous colour scheme

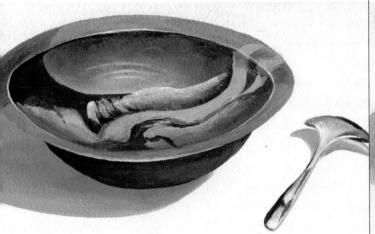

Ultramarine

Ultramarine

Cobalt Teal

Titanium

An analogous colour scheme employs three to four adjacent placements on the Sundell Colour Wheel. This example shows Ultramarine Violet, Ultramarine Blue and Cobalt Teal. Using adjacent colours makes a smooth colour harmony without any complementary contrasts. Value contrasts, however, are vital to the success of an analogous painting.

Cool or warm colours may be chosen to establish mood. In this case, cool colours are dominant. Consider how this painting would look if painted with a warm trio of Hansa Yellow Medium, Cadmium Orange Medium and Pyrrole Orange. For further study, try a series of paintings using different sets of analogous colours.

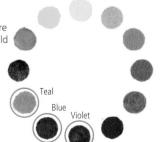

Six-colour scheme

Medium

Pyrrole Orange

limited-palette colour schemes.

range of possibilities.

Ouinacridone ROSP

Ultramarine Violet

Cobalt Teal

Phthalo Green (Yellow Shade)

A six-colour scheme uses a palette of the three primary colours plus the secondary placements midway between them. This means three pairs of complementary colours are included, making a variety of neutrals possible. This colour scheme has less natural harmony inherent in the colour selections than the more

Primary colour scheme

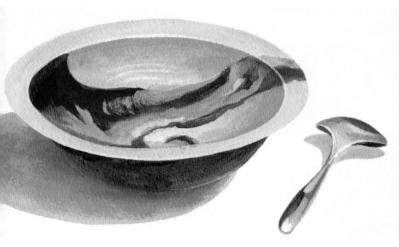

Medium

Titanium White

A primary colour scheme consists of the three pigment primaries. These high-chroma paints provide an extensive range of mixing options. Keeping the palette limited to three colours maintains a harmony throughout all the potential mixtures.

This example combines Hansa Yellow Medium, Quinacridone Rose and Cobalt Teal with Titanium White for tinting. Try a series of paintings that each emphasise a different primary with varied mixtures of the supporting primaries. This can be a rewarding exercise in colour play.

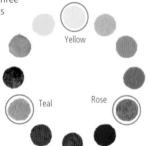

Split-complementary colour scheme

Quinacridone Rose

Phthalo Green (Blue Shade)

Phthalo Green (Yellow Shade)

n Bismuth e) Yellow

Titanium White

A split-complementary colour scheme

is a combination of the complementary and analogous palettes. Three adjacent colours and the complement of the middle colour are selected from the Sundell Colour Wheel. Neutrals can be achieved with this palette by mixing the complementary pair. This lovely colour scheme brings a harmony with the analogous colours accented by the vibrant contrast of the complement.

With twelve adjacent trios and their middle complements available, you can explore a host of possibilities in a series of paintings. The number of options increases dramatically when you also use substitute colours from the list on page 17.

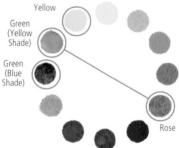

Tetradic colour scheme

Orange

Medium

Ouinacridone Cadmium

Rose

Ultramarine Blue

Phthalo Green (Yellow Shade)

Titanium

White

A tetradic colour scheme is particularly

distinctive because it employs two pairs of complements that are separated by at least one placement on the Sundell Colour Wheel. This unusual set of colour relationships may be difficult to use unless one colour is chosen as the dominant colour.

While tricky to master, the results can be visually arresting in ways other colour schemes do not accomplish. Try using one tetradic colour scheme in four separate paintings, each emphasising a different colour within it. Then try another selection of tetradic colours and do another series of four paintings. Remember, the list of substitutes on page 17 also expands your options.

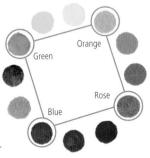

Tertiary colour scheme

Cadmium Orange Medium

Naphthol Red Medium

Quinacridone Violet

Ultramarine

Phthalo Green (Blue Shade)

Bismuth Yellow

White

A tertiary colour scheme is made up of the colours between the primary and secondary placements on the Sundell Colour Wheel. This makes another

distinctive palette. Like the six-colour palette, it includes three pairs of complements, offering a good range of neutrals as well as the lively contrasts of the complements themselves.

Due to the diverse colours in this palette, emphasizing one colour or one pair of colours helps make the palette work well. In this example, Naphthol Red Medium is the most pronounced colour used but mixtures of the other colours, particularly the neutrals, make a melodious supporting palette. Explore as many different options with this palette as you can imagine, extending your understanding of these colour relationships.

Primary palette

A primary palette – three basic colours that can mix all the other colours – sounds simple enough. In practice, this proves to be far more complex.

Additive colour describes how light mixes to create brighter and brighter colours until becoming white, and subtractive colour describes how pigments mix, absorbing more and more light

> until enough combined pigments become black. This is described in more detail on page 9.

Because additive colour becomes increasingly brighter, the primaries are darker hues, as mixing them creates the brighter hues. Mixing the brighter hues cannot create darker hues in additive

colour. The opposite holds true for subtractive colour, resulting in two different sets of primary colours.

Once we start working with actual pigments, the subject becomes even more complicated. The idea behind primary colours is that they cannot be broken down further because they are the most basic colours. With that in mind, all single-pigment paints could legitimately be considered primary colours, since no single-pigment paint can be broken down any further.

The important principle to keep in mind is that mixing single-pigment paints adjacent to each other on the colour wheel is going to result in brighter colours than mixing multiplepigment paints, due to the subtractive nature of pigment colour.

To properly understand colour handling, it is helpful to start with minimal palettes and discover with practical experience how they work. Mixing the three primaries of yellow. magenta and cyan teaches us a great deal. Refer back to page 40 in Mixing colour on palette to see the three paints from the primary positions on the Sundell Colour Wheel sequentially mixed to create a palette of twelve colours. Try this for yourself and then create a painting with that palette.

PRIMARY PALETTE AND SUBTRACTIVE COLOUR

In order to work effectively with our primary palette of yellow, magenta and cyan, we have to clearly understand how subtractive colour works in the pigment colour wheel. Since our paint does not radiate light but reflects it, the pigment colour wheel works guite differently from the light colour wheel. Paint absorbs all the light except the wavelengths of light that our eyes and brain translate into colour.

Magenta paint absorbs all of the wavelengths except the ones we see as magenta. This is true for all other hues.

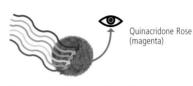

When we mix magenta and cyan paints, not only does the mixture turn blue-violet, but this blue-violet is not as bright as the magenta and cvan paints separately. This is because when magenta paint is mixed into cyan, it still absorbs everything but the magenta hue, including some of the cyan hue the cyan paint would reflect if it wasn't mixed in with the magenta, and vice versa.

Ouinacridone Rose + Cobalt Teal = Blue-Violet When mixed, each of the hues absorb a little of the other, making the result less bright.

The more pigments you add to the mixture, the more light will be absorbed in the mixture. If you add enough different pigments, the mixture turns black because all of the light will be absorbed, or subtracted. In this example, yellow has been added to magenta and cyan. which makes a dull, neutralised colour that is not yet black.

Hansa Yellow + Cobalt + Quinacridone Medium

USING A PRIMARY PALETTE TO MIX NEUTRAL GREYS

Bern Sundell used the capability of a threeprimary palette in mixing neutral greys to good advantage in Leather and Steel. Yet he used enough colourful accents as well as variations in the neutrals to keep the painting rich and interesting instead of dull and lifeless. Notice that the grey background is not left flat and expressionless either but shifts according to the light.

Main palette Hansa Yellow Medium Quinacridone Magenta, Cerulean Blue. and Titanium White

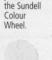

magenta and

cvan are the

primaries in

Yellow,

Cobalt Teal

WHY USE ONLY THREE PRIMARIES?

With the wonderful array of paints available, why would you want to limit yourself to only three paints? Actually, there are some excellent reasons to do so.

- Achieve a deep understanding of how those three paints mix without being distracted by other colours and their effects, which may be surprising.
- · Create a colour harmony in your painting that comes from using closely related mixtures.
- Focus on learning to handle values without being distracted by myriad paint-mixing complications.
- Learn to create simple and direct effects.
- · Sequentially explore different primary combinations by substituting primaries from the list on page 17 and gain a deep understanding of those alternative mixtures.

Or, best of all, you may want to just paint something wonderful with minimal complexity. Sometimes the greatest mastery is found in the greatest simplicity.

COLOUR WHEEL MIXED WITH JUST THREE PRIMARIES

Ouinacridone Rose + Cerulean Blue = blue-violet (secondary colour)

Ouinacridone Rose + blue-violet (i.e. the above mix) = red-violet (tertiary colour)

Blue-Violet (i.e. the top mix) + Cerulean Blue = blue (tertiary colour)

Yellow, magenta and cyan are the primaries in the Sundell Colour Wheel. The specific paints chosen for those placements are shown at right, which are all single-pigment paints. See page 17 for more on the Sundell Colour Wheel.

To experiment with variations of this particular primary palette, you can consult the list of substitutes on page 17 and try different combinations of primaries. For example, if Cerulean Blue (also a single-pigment paint) is used instead of Cobalt Teal, the blue becomes much stronger, as shown in the example left.

It is not recommended to use multiple-pigment paints for primaries in a three-primary palette, as the resulting mixtures will lose more brilliance than if single-pigment paints were used.

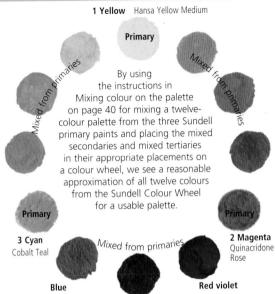

Blue-violet

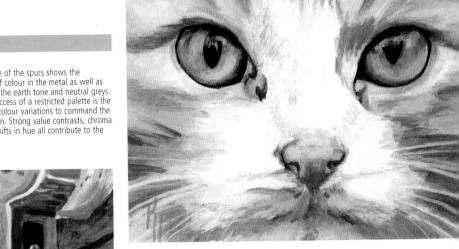

This detail of the painting

reveals some of the colour effects used in the metal to give the reflective quality of the material a colourful accent. Variations in the earthy brown neutrals of the leather straps continue these effects in a quieter way.

This detail of one of the spurs shows the interesting use of colour in the metal as well as the variations in the earth tone and neutral greys. Crucial to the success of a restricted palette is the ability to evoke colour variations to command the viewer's attention. Strong value contrasts, chroma variations and shifts in hue all contribute to the final result.

Fluff Kiana Fecteau

Since the primary palette includes the three brightest hues in the colour wheel, a light and lively painting can be created with them. Mixed neutrals are hardly noticeable in this work as our eyes are drawn to the distinctive mixed-green eyes and contrasting magenta nose of this cat. The yellows and soft mixed oranges of the fur around the eyes enhance the overall effect. Cyan was used only in mixtures in this painting.

Six-colour palette

We saw on the previous pages how a primary palette can be used to approximate almost any colour needed in a painting. However, a palette of six single-pigment paints will provide an even greater range of brilliance and mixing power because the secondary colours in it are not mixed from the primaries. With the proper selection of pigments, six colours plus Titanium White can provide all some artists ever want to use.

After working with three primary colours, expanding to a six-colour palette opens the door to even more varied colour-mixing possibilities. The six-colour palette is most commonly composed of three primary colours and three secondary colours, preferably all single-pigment paints for maximum mixing power. These six paints can be mixed to add the six tertiary colours to the palette as well. For an example of the primaries and secondaries in the Sundell Colour Wheel being mixed to make the six tertiary colours for a twelve-colour palette, please review page 41.

As with the primary palette, alternative pigment substitutes can be chosen from the list on page 17. It is wise to experiment with variations in this palette before settling upon your favourites. You may find the palette you want to use most often this way.

BUILDING THE SIX-COLOUR PALETTE

The primaries of yellow, magenta and cyan are circled (with the dark ring) along with the secondaries of red-orange, blue-violet and vellow-green (in the pale ring), the basis for the six-colour palette. The positions of the mixed tertiaries are in numbered circles. One possible mixing option for each tertiary position is shown below and the mixes are bright and vibrant, as single-pigment paints have been used.

- Green

(Yellow Shade) + Hansa Yellow Medium =

Hansa Yellow Medium + Pyrrole Orange = Yellow-orange

Pyrrole Orange +

Ouinacridone Rose - Red

Ouinacridone Rose + Ultramarine Violet = Red-violet

Violet + Cobalt Teal = Blue

Phthalo Green (Yellow Shade)

Green-yellow

Backyard Trout Bern Sundell

Even with a six-colour palette, it is vital to consider the subject and mood of your painting before you finalise your paint selection. The palette shown below lends itself well to a natural-looking landscape, where low-chroma blues, greens and neutrals are required.

Main palette

Cerulean Blue Chromium Oxide Green Yellow Ochre Pyrrole Orange Quinacridone Rose Ultramarine Violet Titanium White

The split-primary palette is an archaic and forced palette model that is based on the now discredited theory that red, yellow and blue should be considered primary colours (see www.handprint.com). Each of these supposed primaries is divided into a cool and a warm version, so the three primaries end up being represented by six paints instead of three paints.

The confused thinking behind the split-primary palette has its basis in the belief that paints are impure. The same 'impurity' ascribed to paint is also inherent in how our eyes perceive colour, because not only do some pigments reflect light across all wavelengths, but the individual cones in our eyes register multiple wavelengths as well. In other words, 'pure' colour is strictly a figment of the imagination without any basis in reality.

Relating the typical split-primary palette to the Sundell Colour Wheel, it could largely be duplicated by renaming placements green-yellow and yellow as a primary, placements red and magenta as a primary, and placements blue and cyan as a primary. There is nothing at all wrong with working with those paint combinations if you so choose, but it is an arbitrary choice, not one founded on current scientific understanding of colour

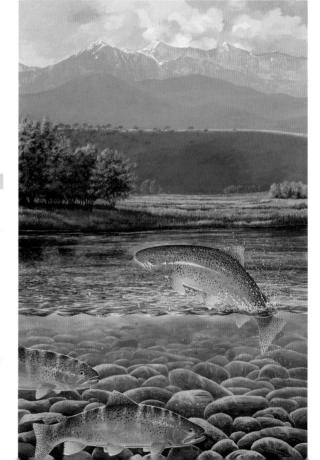

SPECIALISED USAGE OF THE SIX-COLOUR PALETTE

While the six-colour palette taken from the Sundell Colour Wheel (see page 17) is capable of an extensive range of colours for a variety of subjects, sometimes it is helpful to choose a really specialised six-colour palette for a specific painting project.

To paint the portrait of an outdoorsman who loves to fish in the Bahamas, the author selected one of these specialised palettes. The goal was to render high-key colours commonly seen in the Bahamas, as well as the tanned face of the angler.

Substitutes for the six-colour palette in this painting were chosen as follows: Naples Yellow Hue, Quinacridone Burnt Orange, Quinacridone Magenta and Indanthrone Blue. Unchanged were Cobalt Teal and Phthalo Green (Yellow Shade) and the usual Titanium White. Naples Yellow Hue is not a typical selection for a six-colour palette as it is a multiple-pigment mixture, but it works well with the other colours to make the necessary skin tones.

Stage 1 The initial layer of paint establishes the main areas of the painting.

- 1 Use Indanthrone Blue in the background and also tinted for part of the sunglasses.
- 2 Add tints of Cobalt Teal to the sunglasses.
- 3 Paint the hair and sunglasses frames with a mixture of Indanthrone Blue, Quinacridone Burnt Orange and a little Naples Yellow Hue.
- 4 Begin the skin with varying mixtures and tints of Naples Yellow Hue, Quinacridone Burnt Orange and a little Indanthrone Blue.
- 5 Paint the shirt in tints of Phthalo Green (Yellow Shade) and the hat in tints of Naples Yellow Hue.
- 6 Paint the hatband in tints of Ouinacridone Magenta.

Naples Yellow Hue

Phthalo Green (Yellow Shade)

Cobalt Teal

Ouinacridone Burnt Orange

Quinacridone Magenta

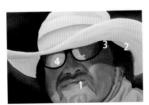

2 Brush a little 1 Add small Quinacridone Burnt amounts of Ouinacridone Orange into the Magenta to the skin shadowed areas tones, particularly in under the hat brim and then paint with the lips. Paint most of the skin wet-intoglazes of Naples Yellow Hue. wet with drying extender added to

the mix to facilitate

the smooth blends.

- 3 Add Phthalo Green (Yellow Shade) to the sunglasses frame mixture to make a distinct black.
- 4 After painting the lenses again, add highlights as a final touch.

Analogous colour palette

Working with the analogous colour palette offers many different options, but each painting created with such a palette will be founded on closely related colours. Painting with this palette is like creating art with a slice of the rainbow. The colours merge into one another in a harmonious way and naturally delight the eye. This offers a powerful way to establish specific moods with controlled use of colour.

Any three adjacent colours from the Sundell Colour Wheel (see page 17) can be used for the simplest analogous palette. Obviously the mood of a painting done with yellow-orange, redorange and red is going to have a hot intensity that does not appear in a painting done with blue-violet, blue and cyan. Initial palette selections play a major role in establishing the mood of an analogous colour scheme.

Moods can be further adjusted by the choice of high- or low-key pigments and by the choice of highor low-chroma pigments. The yelloworange, red-orange and red analogous colour palette previously mentioned will blaze in high-key or high-chroma pigments. This will alter into a deeply smouldering mood if low-key or low-chroma colours are chosen.

LOOSE ANALOGOUS PALETTE

A looser analogous colour palette can be constructed with three colours with a missing step between them. This palette cannot be extended to a fourth colour, since that would be the complement of the first colour in the selection. This palette offers more diversity than using three adjacent colours.

USING AN ANALOGOUS PALETTE

This loose-leaf cabbage head provides the opportunity to paint a range of greens, extending from a greved blue-green to brighter vellow-greens. The Perylene Green – used in the darkest shadows of the leaves – is so dark that a high contrast in values can be easily achieved.

Mixing batches of different combinations on the palette makes it easier to select the most suitable mixture for any given area in the painting. For example, mix a lot of Cerulean Blue, a little Chromium Oxide Green and a little Raw Umber for a basic greyed green. Add varying amounts of Titanium White to create a range of those greyed greens.

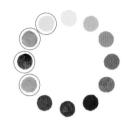

Oxide Green

Green

Green

Umber

Titanium White

Stage 1 At this stage, establish the basic shapes and values of the leaves

- 1 Begin the painting by applying Perylene Green in the upper background.
- 2 The outer leaves receive varying mixtures and tints of Cerulean Blue, Chromium Oxide Green and a tiny amount of Raw Umber.

3 The inner leaves receive varying mixtures and tints of Phthalo Green (Yellow Shade), Chromium Oxide Green and even less Raw Umber

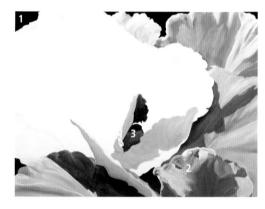

Stage 2 More complex variations in colour patterns in the leaves appear in the middle and upperback feaves.

- 1 Dark shadows. grey-greens and brighter vellowgreens interminale. The variations are due to the fact that the leaves are backlit and the light shining through parts of the leaves makes a dramatic colour shift as well as dark shadow areas.
- 2 For the brighter yellow-greens, mix Phthalo Green (Yellow Shade) with a little Chromium
- Oxide Green and a tiny amount of Raw Umber for the basic yellow-green. Add Titanium White as required for the desired tints.
- 3 Establish shadow areas with different mixtures than those used in the brightly lit areas. The deepest shadows typically have more Raw Umber and/or Chromium Oxide Green and use very little or no Titanium White.

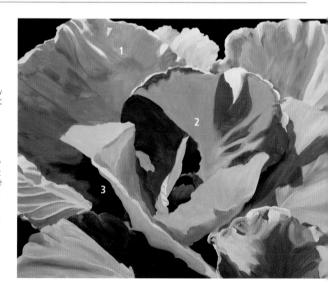

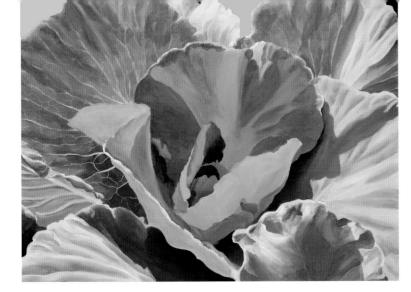

Stage 3 Introduce Bismuth Yellow into the mixtures in this stage of the painting. Bismuth Yellow with small amounts of the grey-green mixture can be used for the brighter veins in the backlit leaves. Add at least one more layer of paint to all of the leaves to soften the blends and create suitable value contrasts.

Stage 4 Complete the painting by further adjusting the blends of the mixtures and value contrasts in the leaves. The veins in the leaves have a surprising diversity of colour. Some are almost a bluish-grey that verges on white, others are pale yellow, and the rest are variations in between those.

The blue-grey veins appear where the light slants across the leaf.

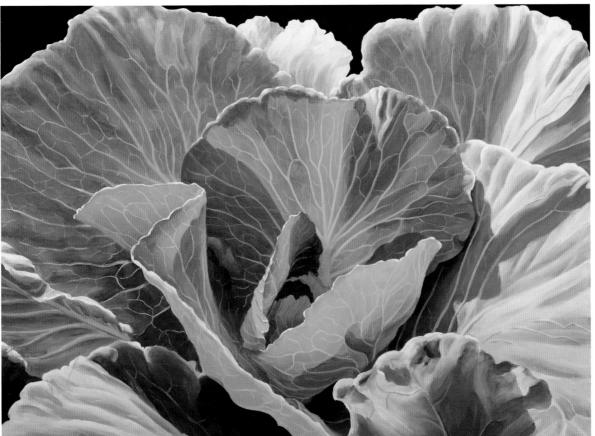

1 Paint a little Perylene Green into the darkest shadows of the leaves. Other than that, Perylene Green is not used extensively in these leaves.

2 The final step is to add the white highlights. Small linear accents of Titanium White — thicker in places, thinner in others, and sometimes skipping altogether — bring the edges of the leaves into sharp relief. The resulting strong value contrasts make this painting highly three-dimensional.

Complementary palette

For maximum brilliance and contrast, artists choose to combine complementary colours. If you pay attention, you are likely to find one or more pairs of complements in many of the paintings you see simply because they add such vibrant qualities. Choosing the right complements and then handling them in the way best suited to your subject is well worth studying.

THE CHARACTERISTICS OF COMPLEMENTARIES

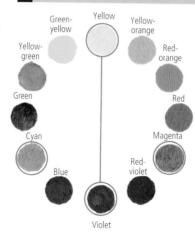

A complement for any colour is found by the easy process of looking on the Sundell Colour Wheel and locating the colour opposite it. Theoretically these two colours will mix to a neutral grey, although variations in the chemistry of mixing pigments makes that slightly variable. If we choose yellow, the complement is blue-violet. We also know that blue-violet can be mixed from the cyan and magenta primaries. Since yellow is also a primary, a mixture made with a complementary pair can be considered a mixture of all three primaries.

The main reason complements are chosen for paintings so often is that the two colours look exciting when placed next to each other. If a painting is done with a great deal of one colour and a few hits of its complement are added, it is like putting little exclamation marks in the painting.

In order to maximise the contrast, choose a strongly warm colour that opposes a cool complementary colour. Contrasts are the lifeblood of paintings so knowing how to increase them is very useful.

TWO APPROACHES TO RED AND GREEN COMPLEMENTS

These two paintings are examples of differing ways of using complementary pairs of red and green. Each is effective in creating a strong contrast and interest in the painting.

Royal Wulff Bern Sundell

The overwhelmingly dominant colour in this painting is green. A few earth tones and Titanium White were used, but the eye is drawn to the red accent used in the body of the fly to make the fly leap off the background. A shadow painted under the fly adds to this effect, as do the brilliant highlights. However, the main power of this painting is carried by the lively punch of that bright Cadmium Red Medium body against the deep green background.

The Two Red Chairs John Sprakes

This painting uses the complementary pair along with various greyed neutrals. Those neutrals help make the complements appear even brighter. Another factor in this painting is that both the red and the greens have been used in a range of mixtures with each other.

Notice the shadows in the red wood that can be created by mixing red with a green. Notice the green panel behind the chairs that has been neutralised with some red in places. Shadows on the upholstery of the chairs also show this neutralising effect.

APPROACHING YELLOW AND BLUE-VIOLET COMPLEMENTS

Exploring a variety of ways to use complementary pairs adds more options to the artist's arsenal of techniques.

The Saxophonist Sera M. Knight

The artist has taken another approach yet to the use of complementary colours in this painting. The paint was applied in broken colour with plenty of blue-violet. The saxophone was loosely painted with yellow in broken colour along with a few other areas that serve as accents. One can almost translate the yellow in the painting into the notes of the saxophone itself.

A CAUTIONARY NOTE

Using more than one pair of complements in a painting can add more contrast and brilliance. Two pairs is often very effective. Depending on the colours selected, three pairs can also work well. But using too many pairs of complements in equal amounts can make it hard for the eye to register the colours without confusion. This flower of life painting is a clear example of what happens when this is done - all six pairs of complements in the Sundell Colour Wheel (see page 17) appear in this painting. If using multiple pairs of complements, use your judgment to make sure the amounts and placements of those colours emphasise some of them and de-emphasise others for most effective use.

USING DIFFERENT KINDS OF COMPLEMENTS

Most of the time artists use a colour wheel based on mixing pigment colours. A pigment (subtractive) colour wheel has different positions for the hues than the light (additive) colour wheel. Yellow, for example, opposes blue-violet on the Sundell Colour Wheel, but opposes blue in a light colour wheel (see page 9). A defining feature of pigment colour wheels is that opposing complements fully absorb each other's colour as a natural result of subtractive colour, resulting in the lowest-chroma neutral grey mixtures. This does not happen in the light colour wheel where mixing colours always increases brightness. Both pigment and light colour wheels work well, but not at all in the same ways.

- 1 Paint French Ultramarine Blue and Titanium White onto heavy watercolour paper. This painting sets yellow against two kinds of complements – blue from a light-mixing colour wheel and blue-violet from the pigment-mixing Sundell Colour Wheel.
- 2 After the initial paint layer has dried, paint tints of Hansa Yellow Medium into the centre of the morning glory flower. By not allowing the yellow and blue paints to mix while wet, the inevitable green mixtures will be avoided. Complete the flower with a little Ultramarine Violet in the water drops and Dioxazine Purple in deep shadows of the petals.

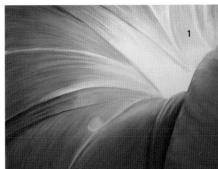

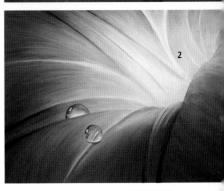

FIVE REASONS TO USE COMPLEMENTARY COLOURS

- Complementary colours are easy to use for strong colour contrasts in painting.
- Complementary colours increase the effectiveness of warm/cool contrasts.
- The carefully applied placement of a complementary colour is a good technique for making powerful accents.

Complementary colours can be mixed to provide neutral greys that can be adjusted to favour one colour or the other, adding liveliness to a composition that also uses one or both of the complementary colours at full strength.

Complementary colours can be used to direct the viewer's eye through the painting by creating intensity where needed

Split-complementary palette

The split complementary palette offers the harmony of the analogous palette combined with the vigour of the complementary palette. The complement can provide a sharp accent or provide a neutral mixture, depending on the objectives of the artist.

Using three analogous colours along with the complement of the middle colour creates a split-complementary palette. The middle colour of the three analogous colours is known as the key colour. The complementary

colour can be used to spice the palette either with contrasting accents or to create neutralised colours not available in the analogous palette alone.

A variation on the typical split complementary palette involves omitting the key colour, the middle colour of the analogous trio. This extremely limited palette loses both the direct complementary vibrancy and the neutralised colour possible from mixing the two complements.

A warm or cool trio of analogous colours for the split-complementary palette can be chosen to establish a variety of moods. The colour temperature of your paints is an important tool for creating emotional impact.

Changing the key of the colours used in the split-complementary palette allows even more flexibility for creating a variety of moods. A low-key palette will create a quieter mood than the corresponding high-key palette.

The split-complementary palette can achieve hot, lively, vibrant effects or sombre, deeply introspective feelings and everything in between them with simple changes of key and temperature. Take one subject and paint it in several variations of a split-complementary palette and observe the results.

SPLIT-COMPLEMENTARY AND MOOD

Using a subject that allows easy colour variations but that carries no great emotional content of its own quickly reveals how colour choices affect the emotional feel of a painting. A cup of toothbrushes lets us explore the split-complementary palette and create different moods with it.

Warm low key Fiery reds and oranges dominate this painting with only hints of the cool Manganese Blue Hue complement to be seen. The background is deep and intense despite the use of neutralised colour made from mixing the complements. Due to the low colour key (see page 64), the mood of these reds and oranges is darkly smouldering rather than a blazing inferno. If Manganese Blue Hue were more prominent in this painting, the reds and oranges would appear even more forceful. Adjustments in the amount shown of the single opposing complement will greatly modify the final mood

of a painting, so choose carefully as you paint.

Main palette Naphthol Red Medium, Pyrrole Orange, Cadmium Orange Medium, Manganese Blue Hue and Titanium White

Warm high key The diagram on the colour wheel is the same for this painting as Warm low key (see above), but different paint selections have been made for those placements. Quinacridone Red and Cobalt Teal Blue were chosen instead of Naphthol Red Medium and Manganese Blue Hue. This results in a palette that can easily be painted in a higher key. The reds and oranges still dominate, but very few neutrals appear in the work. The single opposing complement, Cobalt Teal Blue, has been used extensively in the background. Notice how bright and lively this combination looks. The painting has an expansive and joyful quality as the pure, clear colour was allowed to sing.

Main palette

Quinacridone Red, Pyrrole Orange, Cadmium Orange Medium, Cobalt Teal Blue and Titanium White

Cool low key

The mood abruptly shifts in this version of the toothbrushes. Cool blues and purples dominate with very little of the Cadmium Orange Medium complement to be seen. The background is dark and neutral, painted with a mixture of Cadmium Orange Medium, its complement Ultramarine Blue, and the adjacent Ultramarine Violet. Some people automatically equate a dark subdued colour scheme with sadness and depression, but it is worth taking a second look here. This colour scheme can be used to evoke the magic of moonlight, that tranquil peace the stillness of the moon brings. A meditative quiet pervades this painting.

Main palette Manganese Blue Hue, Ultramarine Blue, Ultramarine Violet, Cadmium Orange Medium and Titanium White

Cool full key Cool blues set

the tone for this painting, but it has a completely different mood from the Cool low key version. The combination of both high-key and low-key colour gives a lively lilt to the mood. Using both Cobalt Teal Blue and Manganese Blue Hue from the cyan placement on the Sundell Colour Wheel increases the sense of variety in the play

version as well.

of colour. The neutrals are lighter

and bluer than in the Cool low key

Main palette Cobalt Teal Blue, Manganese Blue Hue, Ultramarine Blue, Cadmium Orange Medium and Titanium White

Low-key limited palette This

starkly limited palette omits the key colour, the complement of Cadmium Orange Medium, from the

palette. As a result, this painting does not have the neutrals we saw in the previous example. Instead, the mixture of Cadmium Orange Medium and Dioxazine Purple makes a far warmer background. This would never be mistaken for a moonlit colour scheme. The look is still deep and fairly dark with a subdued use of the Cadmium Orange Medium complement, but a warmer vigor emerges.

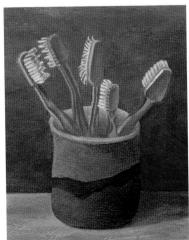

Main palette Manganese Blue, Dioxazine Purple, Cadmium Orange Medium and Titanium White

CHOOSING COMPLEMENTS FOR PAINTING NEUTRALS

Neutrals in a painting can be used to emphasise brilliant colours or to further enhance a low-key emphasis. Light-coloured neutrals can add an airy look while dark-coloured neutrals may bring a more reflective and thoughtful mood to a painting.

Ideally any pair of opposing complements from the colour wheel mixes to a neutral grey. However, we are working with actual pigments in our paints and those chemistries do not always produce the ideal grey in every combination on the wheel. Testing any specific pair of paints quickly shows the way they will work together.

In addition to those unavoidable variations, we can also deliberately mix neutrals that lean more heavily to one side or the other of the complementary opposition. This can be helpful for emphasising a mood in a painting.

In the process of selecting your palette for a split-complementary painting that will use neutrals, test your opposing complements to see if their mixture will create the look you want. Work with the possible variations until you find the combination that suits the appearance you want to create.

Going to the colour wheel to find complements does not help the painter confronted with a subject that is already neutral in colour in direct light. *October Gifts* (detail) by Bern Sundell presents this difficulty and the solution as well. In this example, shadows of the feather fall across the irregular, curving shapes of the rocks, following those shapes. By shifting to a lower colour key, convincing shadows were created without losing their subtleties of colour (see pages 64–65). The sunlit area of the large rock was painted with Ultramarine Blue, Raw Umber and Titanium White. The shadows have more Ultramarine Blue and considerably less Titanium White in the mixture.

Tetradic colour palette

The tetradic colour scheme can be a challenge to use effectively. Yet, if you look closely at paintings that catch your eye with an unusual – perhaps even jarring – colour balance, you will often find a tetradic colour scheme lurking in the paint. Handled with skill, this palette can make a painting with an arresting appearance and unique appeal.

The tetradic colour palette is composed of four colours that make two complementary pairs separated by at least one step on the Sundell Colour Wheel. If only one step separates the two complementary pairs, a rectangular pattern on the colour wheel results. If two steps separate the two complementary pairs, a square pattern is seen.

We more commonly relate to the colour wheel in a triadic sense, with the three primaries and their mixing derivatives, the secondary and tertiary colours. However, dividing the wheel into four instead of three is perfectly reasonable. Using a tetradic colour scheme composed of single-pigment paints is roughly equivalent to using a four-colour primary set.

One of the keys to effective use of the tetradic colour palette is establishing an emphasis in the palette. Choosing either a warm or cool emphasis helps steady the viewer's eye rather than leaving it lost in an equal balance between all four colours.

Rather than emphasising warm or cool, sometimes one colour of the four is allowed to dominate the painting. Deliberate variations in chroma can also help to accomplish the desired emphasis. Whatever solution is found, creating a visual imbalance in the four colours of the palette is vital.

USING THE SOUARE TETRADIC PALETTE

In a square tetradic colour palette, all of the colour mixtures created to fill the spaces on the colour wheel between the four colours chosen for the palette will be dulled by the same amount, as each side of the square has two colour placements to be mixed. For example, in the diagram of the square tetradic colour palette, blue and magenta mix to make blue-violet and red-violet on one of the sides of the square, yellow-orange and magenta mix to make red-orange and red on another, and so on around the wheel. As we know, colours closer together on the colour wheel generally make brighter mixtures than colours farther apart on the colour wheel.

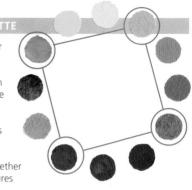

Warnish, Skye Jim Woodman

This painting uses the square tetradic colour palette shown above. The complementary pairs are yellow-orange/blue and magental/yellow-green. Warm colours clearly dominate. While a red-orange can be mixed from single-pigment yellow-orange and magenta paints, the brilliance of the foreground red-orange implies it is not such a mixture. However, the overall

colour scheme does fit the idea of a tetradic colour palette. The small patch of magenta on the far hill provides a sharp contrast with the yellow-green roof of the building, creating the main interest in the painting.

Main palette

Cadmium Orange Medium, Pyrrole Orange, Quinacridone Magenta, Ultramarine Blue, Green Gold and Titanium White.

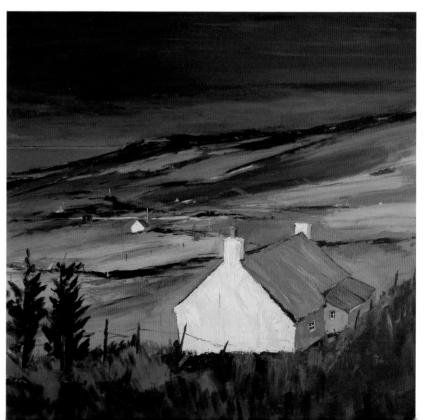

Autumn Heron Jennifer Bowman

A drastically contrasting style of painting is used in this work. Warm colours dominate despite the expanses of cyans and blue-violets in the background. Even the yellow chosen for the palette is a warm, rich yellow instead of a light, bright yellow. The rusty redorange of the heron also makes the warm emphasis unmistakable. Neutral mixtures are largely absent, emphasising strong colour throughout the painting.

Main palette Yellow Ochre Quinacridone Burnt Orange Ultramarine Violet

Cerulean Blue Titanium White

A View Worthy of the Climb Carol Carter

Yet another way to use this rectangular tetradic colour palette is shown here. Rather than emphasising either cool or warm colours, warm colours are stronger in the foreground and cooler colours lead us into the distance, where they dominate. Neutral mixtures are used in the rockwork and buildings effectively. Chroma variations are important in this work, with a deep, dark red-orange across the bottom of the painting opposing high-key cyans.

COMPARING RECTANGULAR TETRADIC PALETTES

Looking at three different ways of handling similar palettes allows you to see the varied potentials of tetradic colour palettes. The same rectangular tetradic palette dominates each one of the paintings on this page. The artists chose differing substitute paints for the placements on the Sundell Colour Wheel but used the same basic tetradic colour relationships. The complementary pairs common to all three of these paintings are yellow/blue-violet and red-orange/cyan.

Notice the way a rectangular tetradic colour scheme changes the mixing possibilities compared to a square tetradic colour scheme. With a square tetradic colour scheme, the missing steps on each side can be mixed so that all the mixed colours have similar loss of chroma from mixing. With the rectangle, the blue-violet and cyan placements mix to a high-chroma adjacent step for blue between them, as do the yellow and red-orange placements in mixing the adjacent

yellow-orange. But on the long sides of the rectangle, three steps appear, ensuring lower-chroma mixtures for those placements because of the extra distance between cyan and yellow as well as red-orange and blue-violet.

Cadmium Yellow Medium Quinacridone Burnt Orange Ultramarine Violet Cobalt Turquoise Titanium White

Cool colours are the emphasis in this painting, although warm colours are used to good dramatic effect. Cool and warm colours used in close proximity create a vibrant appearance, an effect that lends itself to the use of the rectangular tetradic palette. The artist employed substantial use of neutrals in this painting with high-chroma colour holding the main stage.

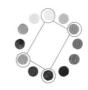

Main palette

Cadmium Yellow Medium Pyrrole Orange Ultramarine Violet Cobalt Teal Titanium White

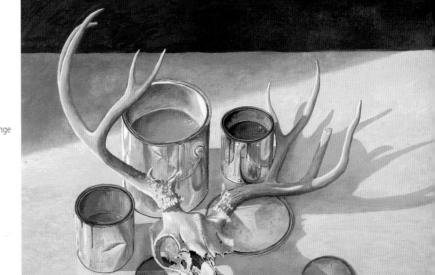

Tertiary palette

The tertiary colour palette is often overlooked, but using it can produce some surprisingly vibrant paintings. The eve is naturally drawn to distinctive and unusual colour combinations, so this is an excellent palette to explore to broaden the appeal of your paintings.

THE TERTIARY PALETTE

The traditional tertiary colour palette runs more to browns and grevs as the colours were mixed from all three primaries, neutralising them. But the contemporary tertiary colour palette is altogether different because it is created by mixing a primary with a nearby secondary.

Mixed tertiaries or single-pigment paints? Each tertiary colour is mixed from the primary colour and the secondary colour adjacent to its placement on the Sundell Colour Wheel. Using mixed tertiaries is one way to set up your palette for painting. However, it will usually be preferable to use single-pigment paints to give the greatest chromatic range of possibilities for mixing while painting. You can select tertiary paints for your palette from the Sundell Colour Wheel and also from the list of substitutes on page 17.

USING A TERTIARY PALETTE

The tertiary palette for Bowl of Apples by Bern Sundell is composed of the single-pigment paints below. You will note that two different red paints are used for the red placement on the colour wheel. Cadmium Red is an opaque red but Naphthol Red Medium is more transparent. This gives a useful flexibility in the ways you can apply red in the painting.

Cadmium Red

Medium

Naphthol Red

Medium

Quinacridone Violet

Stage 1 Sketch the outlines of the shapes on the canvas. Mix Ultramarine Blue with **Ouinacridone Violet** and Phthalo Green (Blue Shade) to paint the dark background.

2 Use varying tints of Ultramarine Blue for the shadow of the bowl and the interior stripe and shadows inside the bowl.

1 Paint pale tints of Bismuth Yellow and Cadmium Orange Medium on the table top. Add in a tiny amount of Phthalo Green (Blue Shade) to the mixture in the lower left corner.

2 Continue refining the apple in the bowl, painting a mixture of Bismuth Yellow, Phthalo Green (Blue Shade) and Titanium White in part of the vellow area of the apple.

3 Repaint the rest of the apple using the previous palette. Add small white highlights to the apple.

4 Paint the apple on the right with the same paint mixtures used for the apple in the bowl.

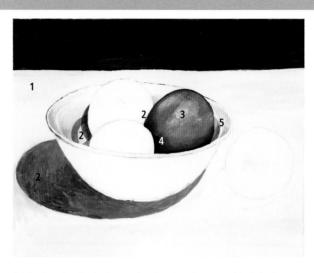

3 Paint Bismuth Yellow in the apple, then add Naphthol Red Medium over the edges of the vellow areas, taking advantage of its transparent qualities. Blend this into the opaque Cadmium Red as the red deepens away from the brighter vellow areas.

4 Apply Quinacridone Violet in the deepest shadows of the apple.

5 Add a little Ultramarine Blue to some of the red mixture and paint it on the interior of the bowl on the right to show the reflection of the apple on the shiny surface of the bowl.

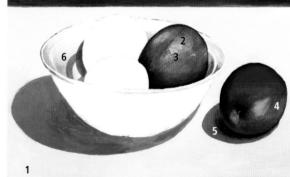

5 Apply varying tints of Ultramarine Blue for the shadow of the apple on the table. After drying, refine the shadows on the table with a tint of Ultramarine Blue mixed with a little Naphthol Red Medium.

6 Continue developing the interior of the bowl with tints of Ultramarine Blue.

Ultramarine Blue

(Blue Shade)

Bismuth Yellow

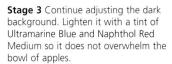

- **1** Paint the remaining two apples in the bowl using the same mixtures as used in the first two apples.
- 2 Notice the lighter area on the upper-left apple next to the inside of the bowl. Light is reflecting between the apple and the shiny interior surface of the bowl.
- 3 Paint varying tints of Naphthol Red Medium inside the bowl to show the reflections of the apples. Mix Cadmium Red with Cadmium Orange Medium and paint an accent line along the curved side of the bowl and along the lip on the left.

4 Add a tint of Phthalo Green (Blue Shade) to the interior of the bowl and the shadow of the apple on the table.

5 Paint small touches of Ultramarine Blue with a little Naphthol Red Medium and Titanium White into selected areas of the apples to show reflections from the blue of the bowl. In this detail, notice the painterly play with the colour in the bowl and on the apples. The freedom of these brushstrokes takes lovely advantage of the tertiary colour palette, resulting a vibrant and lively still life.

- 1 Paint the Ultramarine Blue stripes on the outside of the bowl, then add varying tints of Ultramarine Blue with Phthalo Green (Blue Shade) or Bismuth Yellow to fill the outer shape of the bowl.
- 2 Paint the Ultramarine Blue shadow on the right side of the bowl and add Cadmium Red to show the reflection of the nearby apple.
- **3** Paint a slight Cadmium Red and Cadmium Orange Medium mixture along the edges of the bowl as a lively accent.
- 4 Repaint the shadows on the table top with more Ultramarine Blue and Naphthol Red Medium in varying tints. Remember to put the darkest shadow where the bowl or apple touches the table. Paint a tint of Phthalo Green (Blue Shade) across the shadows near the front edge.

- **5** Add a little Bismuth Yellow to the lip of the bowl.
- 6 Add small touches of Phthalo Green (Blue Shade) or the Ultramarine Blue and Naphthol Red Medium tint to the apples. Paint the final Titanium White highlights on the apples.

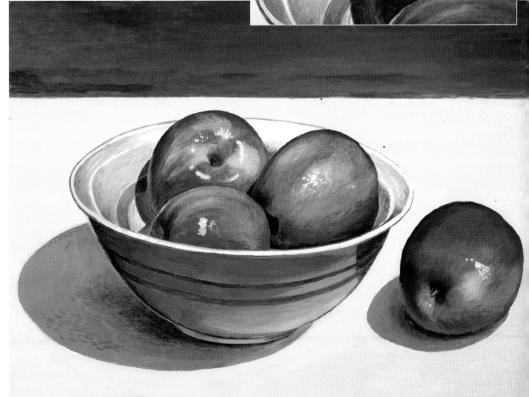

High and low colour key

High-key colours do what you would expect from the name – they hit the high, bright notes, while low-key colours provide the deep, dark rumble. You can make your paintings really sing with the high-key colours, while the low-key colours bring depth and power to your work.

High-key colours are high-chroma paints and may be tinted with Titanium White to accentuate their lightness. Typically a high-key colour does not drop below the mid-range on the value scale. High-key colours are usually cheerful, energetic, and express a zest for life.

Low-key colours fall in the lower range of the value scale and are often low in chroma as well as dark in value. Low-key colours are excellent for conveying dim lighting and quietly introspective or even melancholy moods.

Selecting paints that have bright, high-chroma pigments from the Sundell Colour Wheel with the list of substitutions on page 17 provides a specialised high-key palette for painting high-key colour. Alternatively, selecting low-chroma pigments that may also be dark in value results in the specialised low-key palette.

While paintings can be created exclusively in either high or low key, more frequently, both are employed to allow a full colour key in the painting. This makes it possible to have a wide value range, which is important in establishing the underlying structure and typically makes a more successful painting.

When you make decisions about your palette for a painting, carefully consider the mood you wish to create and the choices in high or low colour key that will support that mood most effectively. With practice, you will easily identify what emphasis in colour key will work best for your purpose.

- 1. Hansa Yellow Medium PY73
- 2. New Gamboge PY153
- 3. Quinacridone Coral PR209 4. Naphthol Red Light PR112
- 5. Quinacridone Rose PV19
- 6. Cobalt Violet Hue PV19, PR122, PW4, PV23
- 7. Ultramarine Violet PV15
- Cobalt Blue PB28
 Cobalt Teal PG50
- 10. Permanent Green Light PY3 PG7
- 11. Phthalo Green (Yellow Shade) PG36
- 12. Cadmium Yellow Light PY35

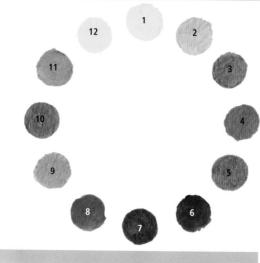

LOW-KEY PALETTE

- 1. Yellow Ochre PY43
- 2. Raw Sienna PY43
- 3. Quinacridone Burnt Orange PO48
- 4. Anthraquinone Red PR177
- Perylene Maroon PR179
- 6. Alizarin Crimson Hue PR122, PR206, PG7
- 7. Indanthrone Blue PB60
- 8. Anthraquinone Blue PB60
- 9. Cerulean Blue Deep PB36
- 10. Pervlene Green PBk31
- 11. Chromium Oxide Green PG17
- 12. Rich Green Gold PY129

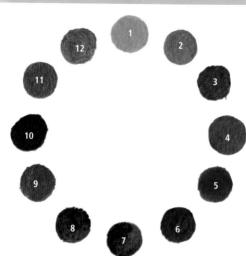

COMPARING HIGH-KEY, LOW-KEY AND FULL-KEY COLOUR

Be alert in your daily life and practise identifying high- and low-key colours wherever you go. Becoming more aware of light and its effect on the colour of your surroundings will bring new strength and variety to your paintings. A helpful practice is to paint a subject solely in high-key colour and then paint the same subject solely in low-key colour. By the time you paint this subject in full-key colour, i.e. a combination of the two, a new ease will have entered your work.

Desert Song Frederick G. Denys

Full-key colour provides a wide range of values and chroma in the landscape, allowing dramatic colour to unfold in the painting. A passing cloud leaves a shadow across the middle of the painting, the area dominated by low-key colour. Dark silhouettes of saguaros stand in sharp contrast against the brilliant high-key mountains that blaze in direct sunlight. The foreground coloration is handled with more subtlety, but still plays high-key colour against low-key colour. Technical mastery of the palette makes such richness in colour possible.

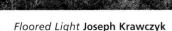

Low-key colours dominate this painting most emphatically. Even the highlights on the basket are muted, painted with neutralised yellows. The background is swallowed in darkness, a deep brown almost going black. The tiles are painted in low-chroma reds and a little neutralised yellow-orange. These dramatic value contrasts convey a strong sense of the light falling through the open weave of the basket. In the highly dimensional and tactile space of this painting, the viewer can almost feel the hard fibres of the basket and the smoothness of the tiles. Consider how the power of this painting would largely evaporate if the basket and tiles were painted in high-key colours.

Steelhead Flies Bern Sundell

This painting is clearly dominated by high-key colours. Light, bright and lively, the high-key effect is increased by the broken colour lines with white accents in parts of the flies. The colours mostly remain saturated, even in the lighter values. A few lowkey dark colours appear in the hooks, bodies and dressings of the flies. However, they do not overpower the high-key colour and instead provide a supporting framework. Imagine the difference it would make if the high-key shadows on the table top were painted in low-key colours. The mood of this painting would change drastically.

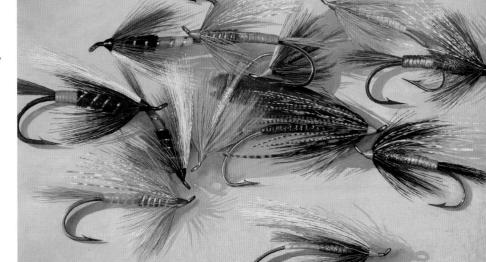

Luminosity in colour

Luminous, glowing colour in a painting holds the viewer's attention in the most gratifying way. The magic of light illuminating the canvas can be absolutely unforgettable. So how does the artist achieve such effects with colour, bringing the hidden luminosity of piles of paint on the palette into this stunning imagery on the canvas? The nine methods for painting in luminous colour are highlighted on the grayscale thumbnail of each finished painting to give you a few pointers.

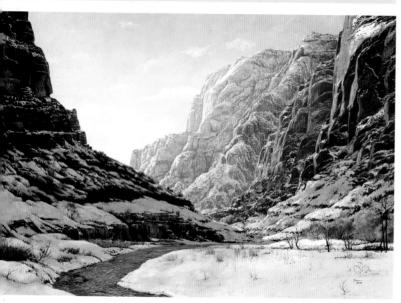

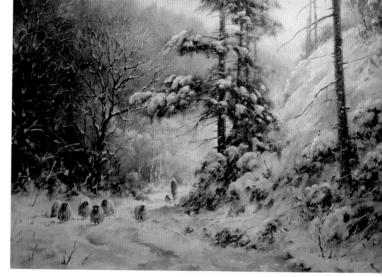

▲ The Last Strays Joe Hush

The luminosity in this painting is quietly romantic with the diffused evening light. The soft blends of colour (4) effectively establish this mood. We still have a strong sense of the source of light (1) with the glowing sky and the shepherd backlit as he comes around the corner behind the sheep (2). This painting relies heavily on the use of warm and cool colours with cool lavender shadows in the snow dominating the scene, accented by smaller areas of warm yellows and oranges (5).

This snowy landscape conveys a strikingly different mood than the above painting. Blends are soft, but this painting has a crystalline clarity of light that creates powerful value contrasts (3). This artist also utilises the contrasts of warm and cool colours with soft, subdued cool blues in the snow, stream and sky against the powerful warm red rock formations (5). The angled light adds to the luminosity of this painting (1).

NINE METHODS FOR PAINTING LUMINOUS COLOUR

If you practise looking for each of these nine methods in each painting you see, after a while you will naturally know which ones you need to use when planning paintings of your own.

Establish the

Confusion about the source of light does a painting no good at all. Flat, undifferentiated light is also detrimental. Consistent angled lighting that brings shadows into the composition also brings interest into the colour and offers the potential for creating a luminous glow.

Use distinctive backlighting

When the angle of light comes from behind the subject, a halo of light naturally appears around it. This enhances almost anything you choose to paint. Flowing hair takes on a romantic appearance, flowers glow with a new radiance and living creatures look vibrant.

Establish strong value contrasts

Luminosity suggests brilliant light, and a painting of brilliant light will look flat and featureless without strong shadow areas to differentiate the bright areas and emphasise their importance.

Apply smooth blends of colour

Coarse handling of colour transitions does not convey the liquid beauty of glowing light. The use of smooth blends of colour helps convey the radiance of light flowing around the subject.

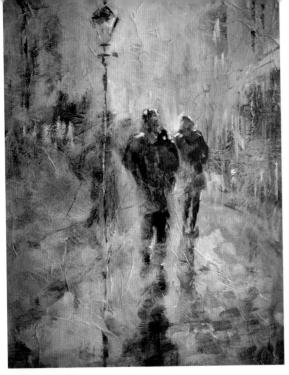

Misty Day Sera M. Knight

Wet, reflecting surfaces throw light in all directions in this painting, a somewhat diffuse scattering of warm and cool colours (5). The backlit couple walk into a pool of light from the lamp (1). The partially neutralised background colours let the hits of high-key and high-chroma accents really vibrate. The luminosity in this painting comes from a loose play with colour in the diffuse reflected light (6).

Winter Warmth Lou O'Keefe

A brilliant sunset illuminates this row of houses in the snow. Notice the soft blends in the sky in particular (4). The snow reflects the warm yellow of the sunset but the shadows of the snow are cool cyans and blue-violets (5). Strong value contrasts are also evident in this painting (3). Brilliant white highlights add to the sense of luminosity created by the powerful warm and cool colours in this scene (9).

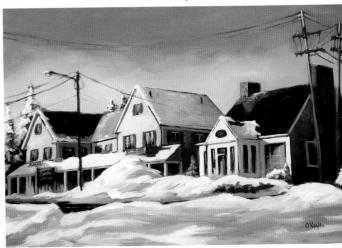

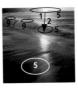

Meor Light Paul Geraghty

Dramatic, angled backlighting is the main factor creating luminosity in this painting (2). A hot yellow sun sets on the horizon, sending rays of light across the water and wet sand (1). Cool blues and purples in the water contrast with the warm, reddish-orange in the reflected light on the wet sand, in the crashing wave, and on the horizon (5). The backlit wave shows its transparency with that reddish-orange glow where the sunlight passes through it. The top edges of the wave have brilliant highlights to complete the strong value contrasts in the painting (9).

5 Juxtapose warm colours with cool colours

The contrast between warm and cool colours inherently adds luminosity to a painting. This can be done with dramatic contrasts but may be even more effective with subtle handling. A delicate shimmer can appear where pale tints of warm and cool colours are placed next to each other.

Include areas of reflected light

Luminosity is about glowing, flowing light, so areas of reflected light communicate this quite well visually. Along with light radiating through a partially transparent object such as a coloured glass vase or a flower petal, this delicate expression of the movement and transformation of light adds luminosity to the painting.

Apply the paint in multiple layers of glazes

The physical structure of thin, partially transparent layers of paint suspended in glaze medium or gel medium creates a form of luminosity due to the refraction of light within those layers. Review the section on Mixing colour with layers and glazes on pages 44–45 for more information.

Use neutrals to accent bright colour

Soft neutrals make highchroma colour really sing and vibrate, which can be an excellent tool for creating luminosity. A pale grey is ideal for this effect, but any neutralised or partially neutralised colour can be used.

Accent with brilliant highlights

Small Titanium White highlights add a lovely sparkle to a painting. These highlights maximise the value contrasts in the painting and emphasise the quality of light, greatly enhancing the luminosity of the image.

Colour value

Colour is a three-legged stool, with hue, value and chroma as the three legs. Yet, unlike a wooden stool, colour can stand on only one of those legs, the one pertaining to value. The eye still perceives values when hue and chroma have largely vanished from vision in low light. Value creates the main structure of colour in our minds, although we pay more attention to hue and chroma.

ESTABLISHING PIGMENT VALUE

Swatches from the Sundell Colour Wheel (see page 17) are placed to match the value scale. You can see the colours at the top of

the colour wheel are lighter in value than the colours at the bottom of the colour wheel. The brain registers yellow-reflecting colours as lighter than bluereflecting colours.

Yet this is trickier than it looks, because the Cobalt Teal is significantly lighter than you might expect and the Phthalo Green (Blue Shade) is much darker than you would predict from their positions on the colour wheel. These are actual pigments, not light,

so variations such as this should be expected. Try testing your own paints to see where they fall against a value scale by converting paint swatches like the ones below to a black-and-white photocopy or grayscale image on your computer.

By converting swatches of paints from the Sundell Colour Wheel to black and white, it is possible to establish their values.

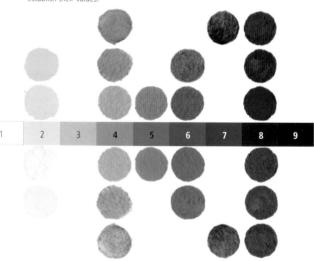

THE VALUE SCALE

A nine-step value scale (above) with step one as white and step nine as black is commonly used to illustrate value. With practice you can identify the value of the colours you are applying to your canvas.

Artists use different techniques to see values in their paintings. Some use a piece of red Plexiglas or film to view their painting. Others squint to reduce the available light coming into the eye so they can more readily perceive values alone. Photographing the painting and converting to black and white or making a black-and-white photocopy is another method. Quite often a problem with values will suddenly appear in the fundamental structure of your painting. This can be a lack of contrast or an imbalance in either light or dark values. You might then correct your difficulty by changing the colour values in the problem area.

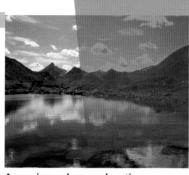

Assessing values on location

If working on location, it is not possible to make black-and-white photocopies, and an image on a camera would be too small. Take a piece of red Plexiglas or film and hold up to the view to eliminate colours and show the tones. Note: If your subject includes a lot of red you will need to use another colour film, since the film will hide objects of a similar colour.

HOW DARKENING OF ACRYLIC PAINTS IN DRYING AFFECTS VALUE

Acrylic paints darken as they dry, and this must be understood before using values in painting acrylic colour, since what you see when painting does not reflect the final result. Most acrylic paints use a whitish emulsion that dries clear. This makes the colour appear darker when dry because the whitish appearance of the wet emulsion no longer obscures the true colour. Lighter-value paints will show less colour shift in drying than darker-value paints because not as much dark colour is obscured while wet.

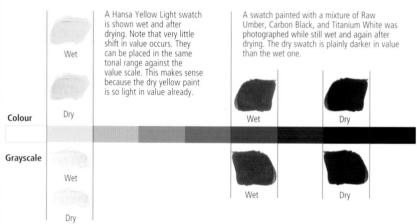

Matching the wet and dry swatches to the nine-step value scale is revealing. The visual above shows the placement of the two pairs of swatches converted to grayscale. While the Hansa Yellow Light shifted less than one step in drying, the Raw Umber mixture darkened a full two steps on the value scale. With this

knowledge you will find it easier to mix a lighter-looking paint to match a dried area of your painting when you need to retouch it. Experiment with other paints in your palette.

VALUES IN PAINTINGS

Artists use different techniques to see values in their paintings. However, the best way to become instinctively comfortable with handling values is to paint an entire series of monochromatic paintings. After completing enough of them, you will internalise the process of identifying values so you naturally use them properly in your paintings when you add other colours to the palette. Study the examples shown on this page and then create your own series of monochromatic paintings to master values.

Barn Owl Paul James

This painting is not strictly monochromatic, but it verges on it. Strongly defined values create a distinctive composition in this work. The notch in the upright timber and the owl hold the lightest values, effectively making the owl the focal point of the painting. To handle values this well requires a solid understanding of light, shade and shadow as well as acrylic paints themselves. In this painting the values reduce contrast by becoming darker as the painting recedes into the distant corners of the barn.

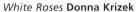

A deceptively simple but effective monochromatic sketch painting to establish the values within white rose petals and the complex nature of transparency and shine in glass. This study also shows the values in the cast shadows behind the vase.

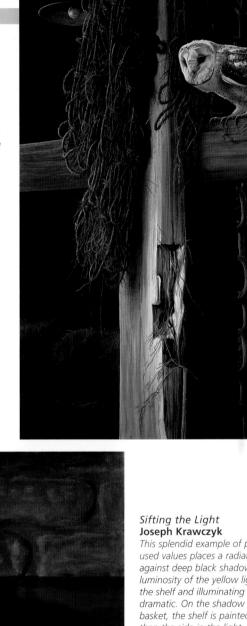

This splendid example of powerfully used values places a radiant yellow against deep black shadows. The luminosity of the yellow light falling on the shelf and illuminating the basket is dramatic. On the shadow side of the basket, the shelf is painted darker than the side in the light, even where some light filters through the woven openings of the basket. Although the bricks in the background are a quiet neutral, notice how the yellowish cast to them carries the diagonal glow of light across the painting without being obtrusive.

Colour temperature

Colour temperature can be a baffling concept at first. Is it the temperature of the air shown in the painting, the difference between a hot day in the desert and a cool day in the snowy mountains? Is it the colour temperature of the light and how it changes the colour of objects in that light? Could it be the colour temperature of the paints themselves?

For starters, the primary concern of the artist lies with the colour temperature of the paints themselves. The colour temperature of the paints chosen can be used to evoke the hot day in the desert or the cool day in the snowy mountains, but the paints themselves are what we must understand in order to accomplish this.

It is true that the light in which you paint will affect how the finished painting looks. If you have a painting created under incandescent light, take it outdoors to see the changes. Or point your automatic camera at a scene and photograph it with the cloud setting and then with indoor light bulb setting and observe the difference. This is why artists often choose natural north light for a studio, as it varies the least. The handicap of not being able to paint after dark leads other artists to choose various forms of daylight-equivalent electric lighting solutions for the studio.

But none of this speaks to the important issue of the colour temperature of the paints we use. Since the 1700s, yellow and red have been regarded as warm colours, with blue and green regarded as cool colours. Popular myth has it that warm colours advance visually and cool colours recede visually. Yet modern scientific understanding of how the eye and brain perceive colour does not altogether support these assumptions.

Oddly enough, research suggests that sunlight is not yellow at all but rather a pale green. We have not suspected this to be the case because of the amazingly agile way our brains process incoming visual information to create colour in our minds. But if sunlight is truly a pale green, this can hardly be considered a cool colour.

UNDERSTANDING COLOUR TEMPERATURE

The main reason warm colours are differentiated as warm is that they are typically high in chroma and light in value. Cool colours may be high chroma but mostly are lower in value. The difference between warm and cool has nothing to do with the myth of advancing or receding colours.

Our eyes know perfectly well that the blazing red-oranges of a sunset are not nearest us in the landscape. Those 'receding' blues are generally the result of using pale tints of blue, so that is a result of chroma and value rather than just the hue itself.

Contrasts between warm and cool colours are an enormously useful fundamental principle of painting, so we need to understand how to use them effectively. While the complexities of vision and colour perception are staggering, the best scientific consensus we have is that red-orange holds the position as hottest of the warm colours and its complement of cyan the position of the coolest of the

Arigato Lorena Kloosterboer

At a glance, you can see that cool blues and cyans dominate this painting. Hints of magenta, low-chroma red and earth colours offer a warm contrast to the higher-chroma and more saturated blues

Variations on a Theme Elizabeth Crabtree

A series of small, quick paintings like this one can be a great way to explore alternate warm and cool colour relationships. Towards the left, cool monochromatic blues establish a definite mood, while towards the right, intense red-orange and red colours illustrate the warm extreme. Other paintings in the series produce other possible combinations of warm and cool colours.

WARM AND COOL COLOURS

Dividing the Sundell Colour Wheel according to the warm and cool colour concept, it becomes obvious that colours on or near the dividing line may not be warm or cool at all, but show qualities of both.

Warm colours

Cool colours

For the painter, it is often the relative relationships of warm and cool colours that matter the most. We can evaluate any colour in relation to another colour in terms of which is the warmest and which is the coolest.

For example, comparing blueviolet with magenta, it is evident that magenta is closer to red-orange, the hottest placement on the colour wheel, and therefore warmer than blue-violet. But if we compare magenta with red, it is cooler than red because red is closest of those two colours on the colour wheel to red-orange. So whether we regard magenta as warm or cool is determined by its relationship to our choice of a comparison colour on the colour wheel.

Looking at more subtle variations, French Ultramarine Blue has slightly more red in its appearance than standard Ultramarine Blue, so it is considered to be warmer than Ultramarine Blue. Consulting the Artist's Colour Wheel by Bruce MacEvoy on page 16 will help show you positions of the pigments in many acrylic paints so you can quickly establish their warmth or coolness in relation to each other.

By paying attention to these relative comparisons, warm and cool contrasts in your painting can be emphasised where you want to attract the viewer's eye and minimised where you do not want a powerful focal point. These warm and cool contrasts add a wonderful vibrant look to a painting, making them an invaluable tool for the artist.

Three Crofts Jim Woodman

The colour balance in this painting swings dramatically to the warm with the powerful mass of hot red-orange across two-thirds of the painting. The sky with its soft cool blue intensifies the warm emphasis. Notice that a deliberate imbalance between warm and cool colours has been used in this painting. Equal amounts of warm and cool are not nearly as powerful as a deliberately invoked imbalance.

Romantic Woodland Joe Hush

A glowing warmth suffuses this landscape with softly blended yellows and oranges mixing into the green foliage and shadows. A partially neutralised blue-violet in the tree trunks and shadows provides a cooler note against all the warm colours.

Neutrals and earth tones

Neutral greys and earth tones effectively enhance the more brilliant colours in a painting. They can also be used for either subdued or dramatic moods. The power of their subtlety in creating mood is often underused in acrylic painting. Many artists overlook them because acrylics were initially regarded as brightly coloured paints that mixed harshly. Let's examine other possibilities.

Single-pigment paints that are already neutral, such as the earthy colours that include Yellow Ochre and Raw Umber, can be employed. Multi-pigment paints such as Alizarin Crimson Hue and Naples Yellow Hue are available. Mixing with their complements can neutralise high-chroma paints. Mixing three colours equidistant on the Sundell Colour Wheel produces neutralised greys.

Learning to choose the most appropriate method of mixing neutrals for the specific purpose is an important skill for an artist. The manufactured multiple-pigment paints have no little flickers of unevenly mixed paint colour enlivening them, and they do not shift into other colorations across an area by gradually emphasising one colour in the mix a little more. The rich diversity accessible through mixing is far more interesting than homogenous purchased neutral mixtures.

NEUTRAL PIGMENTS ON THE COLOUR WHEEL

Most of the neutralised colours, including earth colours in this colour wheel, are single-pigment paints substituted into the Sundell Colour Wheel. Exceptions are Lapis Lazuli, a powdered natural stone, and Alizarin Crimson, a multi-pigment mixture. The illustrated paints are as follows:

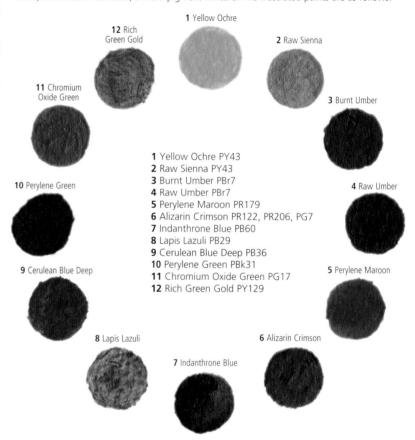

USING THE NEUTRALS COLOUR WHEEL

Consider the Neutrals Colour Wheel above as a starting point, not a destination. Often other ways of creating neutrals will be superior for your paintings rather than simply choosing your paint from this colour wheel. However, there will be times when the paints on this colour wheel can work beautifully for you.

Earth colours

Single-pigment earth tones are the most useful group of paints on the Neutrals Colour Wheel. These paints were originally natural clays made into paint but in modern times are manufactured pigments. The iron oxides easily dominate this category. Yellow Ochre, Raw Sienna, Burnt Umber and Raw Umber fall into this group.

Blue colours

Indanthrone Blue is such a powerful pigment that it is excellent for dark-valued neutrals, but when tinted with Titanium White it may not be neutralised enough, depending on the purpose. Lapis Lazuli is chosen simply because of a lack of other choices. Far more earthy colours are available than blue neutrals. Cerulean Blue Deep is a reasonable choice for its category. Greater selections of neutralised blues are readily achieved by mixing the wide range of higher-chroma blues with their complements.

Greens

Greens and yellow-greens pose another set of issues. More choices are available, but not necessarily excellent choices. Cobalt Green, unlike the various cobalt blue paints, is decidedly dull and lifeless, even though it is a single-pigment paint. Chromium Oxide Green is another single-pigment neutralised green, which is more 'alive' than Cobalt Green. Mixing with other colours readily alters Chromium Oxide Green to a range of desirable neutrals.

MIXING EARTH TONES TO NEUTRALISE OTHER COLOURS

Raw Umber is the star performer in this group. Raw Umber can be mixed with practically any other colour to neutralise it. Yellow Ochre is another valuable earth tone, but it will turn greenish when mixed with blue pigments. Otherwise, it is as useful as Raw Umber. For greater variation, the two can be used together in many neutralizing mixtures.

The swatches shown here were mixed directly as they were painted on heavy watercolour paper. All tints are made with Titanium White.

Yellow Ochre works extremely well with Chromium Oxide Green.

Yellow + Chromium + Titanium Ochre Oxide Green White

You can see the versatility of the previous mixture as a tint.

Yellow Raw Chromium Ochre Umber Oxide Green

Using both Yellow Ochre and Raw Umber in a mixture with Chromium Oxide Green extends the possibilities further.

Yellow Raw Chromium Titanium Ochre Umber Oxide White Green

The tint of the previous mixture shows subtle and useful variations that can be used readily in foliage, landscapes and other subjects.

Hansa Yellow Umber Medium

You can immediately see how subdued Hansa Yellow Medium appears when mixed with Raw Umber.

Umber Red Medium

Cadmium

This mixture smoulders with a deep glow.

Raw Ultramarine Umber

Raw Umber greatly reduces the chroma of Ultramarine Blue in this example.

Ultramarine_ Titanium Raw Umber + Blue White

Tinting the previous mixture produces softly greyed blues.

Raw Cobalt Umber Blue

Different blue pigments interact with Raw Umber to produce unique variations.

+ Titanium Raw Cobalt Umber Blue White

Those variations carry over into the tints of the mixtures.

Perylene Green

Pervlene Green painted heavily on the left and thinner on the right. It is pictured unmixed, as it is not a commonly used green, although it has great potential for painting neutrals.

Perylene Yellow Ochre Green

A lovely neutralised colour results from this mixture.

Perylene + Yellow + Titanium Green Ochre White

The tint of the previous mixture shows an even more subtle neutralised mixture.

Pervlene + Raw + Titanium Umber White Green

The tint of Perylene Green mixed with Raw Umber is another combination that offers wonderful potential in painting.

Chromium Raw Umher Oxide Green

Raw Umber mixes beautifully with Chromium Oxide Green to produce an even lowerchroma green.

Raw + Chromium + Titanium Umber Oxide Green White

The tint of the previous mixture shows additional potential for foliage variations.

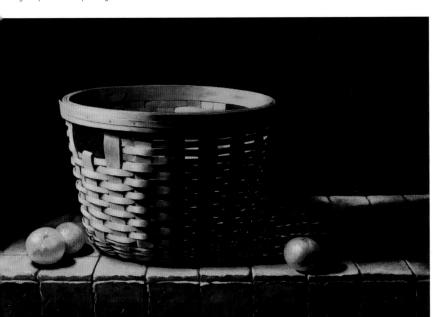

PLEASE LEAVE BURNT SIENNA AT THE STORE

Actually, the earth tone Burnt Sienna can be used successfully as long as no Titanium White is added. Since most artists use Titanium White constantly in their work, the unpleasant chalky pinkish coloration from tinted Burnt Sienna is a predictable outcome. This does not improve the painting when it happens. But if you have a passionate desire to paint with a truly ugly colour, go ahead and use

If you want a similar look that lacks the chalky pink problem, use Quinacridone Burnt Orange, Quinacridone Burnt Scarlet or even Quinacridone Sienna in the mixture instead. Your painting will sing happily.

Hearthside Joseph Krawczyk

Earth tones dominate this painting with its strong value contrasts. No bright, high-chroma colours appear in the painting and it also lacks cool neutrals. This work shows how subtle neutrals can create a powerful painting.

NEUTRALS FROM COMPLEMENTS

The mixing of neutral colours from complements can be reviewed on pages 56–59. Many options exist in the Sundell Colour Wheel with the list of substitutions on page 17. These examples should inspire you to test your own collection of paints on heavy watercolour paper to explore what they have to offer.

The following examples are mixed directly on heavy watercolour paper and the tints are made with Titanium White.

Phthalo Green + Quinacridone (Yellow Shade) Rose

The two complements create a subtle neutral grey where they are most evenly mixed in the centre.

Phthalo + Quinacridone +Titanium Green Rose White (Yellow Shade)

This tint of the previous mixture exhibits the soft grey more clearly.

Quinacridone + Bismuth Violet Yellow

This mixture shows how far pigments that are complements can vary from a neutral grey.

Dioxazine + Hansa Yellow Purple Medium

This pair of complements also mixes to a warmer neutral that is still useful.

Pyrrole + Cobalt Orange Teal

Once again the two complements warmly neutralise each other.

Cobalt + Cadmium Blue Orange Medium

This particular mixture is an especially desirable combination for the yellow-orange/blue complementary axis.

Cobalt Cadmium Titanium
Blue + Orange + White
Medium

The soft greys obvious in this tint show why this combination is so valuable for painting.

Phthalo Cadmium Titanium Green + Red Medium + White (Blue Shade)

This is another complementary combination that deviates from neutral grey but is useful in painting.

WATER, DISTANCE AND NEUTRALS

Two landscapes solve the problem of establishing distance and painting water with neutralised colours. Each creates an entirely different mood.

Bedruthan Steps Paul Geraghty

This painting reveals a great expanse of space, in contrast to the close intimacy of the following painting. Higher-chroma colours appear at the bottom of the canvas nearest the viewer. The colours neutralise and lighten in value in a carefully controlled progression to the pale and indistinct horizon. Warm neutrals on the beach play against the cool neutrals of the water, but the overall colour temperature of the painting is unquestionably cool.

Time for Reflection Paul James

While many people would consider this a sombre or melancholy scene, the title implies a quietly reflective mood in tune with the season. With low-chroma colour, the strength of the painting lies in the control of values. We sense the quality of light on a fall evening with the sky reflected in the stream. The cooler neutrals in the far trees, which also have lightened in value, indicate distance.

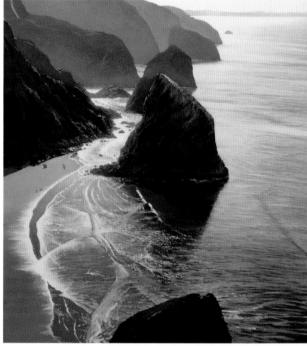

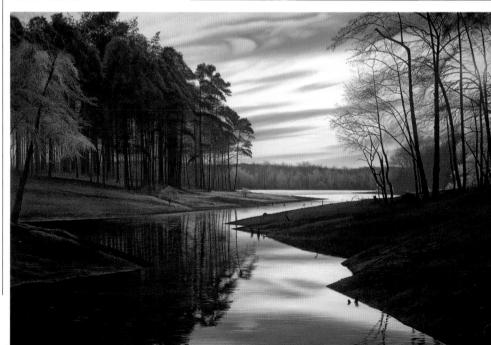

BRIGHT ACCENTS AND NEUTRALS

Carefully selected neutrals can make accents of bright colour really pop. The artists worked with neutrals in contrasting ways to make it happen in these two paintings.

Winter in Trafalgar Square Sera M. Knight
Painterly splashes of variegated neutrals are used for the majority
of this painting. The neutrals tend towards cool blues, which make
the bright red accents really catch the eye. Distance is implied with
warmer neutrals in the foreground dissipating to cooler neutrals
further back in the painting.

Moored at Portree Jim Woodman

Complementary blues and oranges provide the main palette for this painting. The blues are far more neutralised than in the painting at left and large areas are devoted to dark, sombre greys. Those brooding greys were laid over a layer of orange that can be seen in bits and pieces throughout the painting. Those orange accents bring the scene to life.

Winter's Embrace Daniel Smith

You nearly feel like shivering looking at the cool neutral greys in this painting. The few warm earthy neutrals in the animal fur only accentuate the overall cool temperature of this painting. No high-chroma colours have been used in this work either, but it completely contrasts with Hearthside on page 73.

COLOUR TEMPERATURE WITH NEUTRALS

With the use of neutrals, colour temperature can be established in your paintings. Compare the cool emphasis in *Winter's Embrace* below, with the warm emphasis in *Hearthside* on page 73. Both paintings effectively use neutrals to altogether different ends.

MIXING TRIADIC NEUTRAL GREYS

As explained in the Primary palette on pages 50–51, the three primary colours mix to an approximate neutral grey. Since the Sundell Colour Wheel is comprised of single-pigment paints, any three paints equally spaced around the wheel will also mix to an approximate neutral grey. Look at the intriguing variations in the following examples, all tinted with Titanium White.

Phthalo Cadmium Quinacridone Titanium Green (Blue + Orange + Violet + White Shade) Medium

Ultramarine Bismuth Cadmium Titanium Blue + Yellow + Red + White Medium

Phthalo Green Dioxazine Pyrrole Titanium (Yellow Shade) + Purple + Orange + White

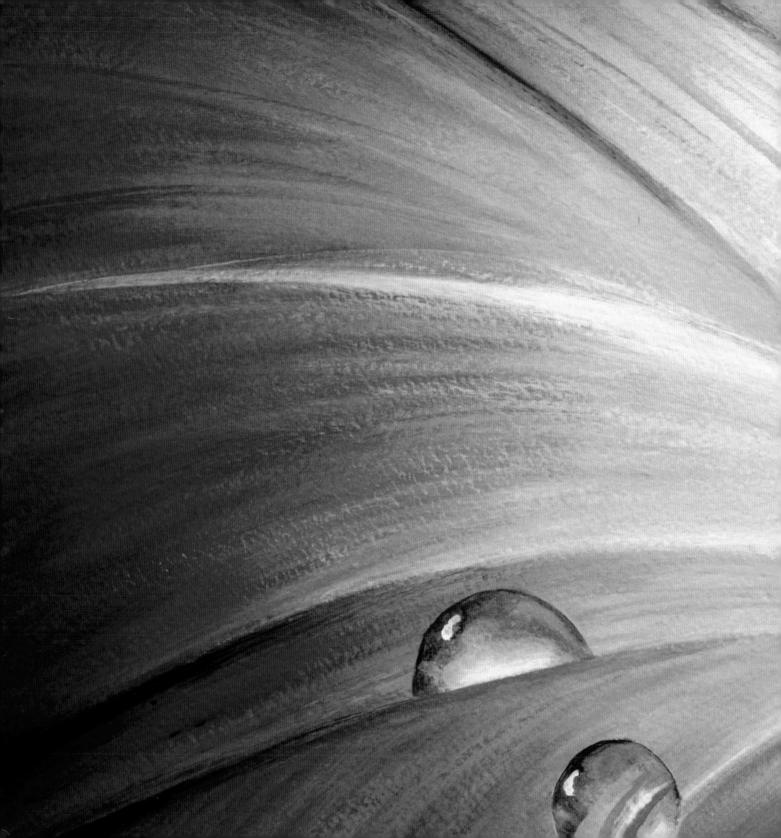

section 3 choosing pigments pigments for painting

The value of everything you have learnt about your materials and the aesthetics of using them comes alive in the application of that knowledge to a wide range of subject matter. This is when you can fully appreciate the solid foundation you have built for yourself. You are ready to create exceptional colour in acrylics as your inspired visions find their way into the paintings on your easel.

Choosing and using a colour scheme

Standing before the easel contemplating a pristine white canvas, the artist is faced with major decisions about how to proceed. What paints should be chosen for the palette? How should the subject be interpreted through those colour choices? What selections will help create the desired appearance and mood? Choosing a colour scheme is not necessarily a simple matter, although it greatly simplifies the painting decisions that follow. On the following pages, photographs of a number of painting subjects and potential colour schemes are analysed – try out the suggestions to hone your skills.

TEN STEPS FOR CHOOSING AND USING A COLOUR SCHEME

Identify the main colour of importance in the chosen subject.

Look at the other colours in the subject to see how they relate to that main colour on the Sundell Colour Wheel (see page 17).

When a pattern of colour relationships begins to emerge, determine which colour schemes include those particular relationships.

With one or more colour schemes under consideration, notice any colours in the subject that do not fit those colour schemes.

Evaluate how to alter those dissonant colours to bring them into alignment with your possible colour scheme choices.

Decide which of those colour schemes will work best for your interpretation of the subject you want to paint, keeping in mind the mood you want to create.

Using the chosen colour scheme, select the actual paints for those placements on the Sundell Colour Wheel.

Lay out your palette, leaving more space for the main colour and any other colours that will be used extensively.

Mix any combinations you will need, such as neutral mixtures, in large enough quantities to ensure that your colours remain consistent where they need to be.

Proceed to paint your interpretation of the subject.

EXERCISES IN CHOOSING COLOUR SCHEMES

Analagous colour scheme The colour scheme in the above photo of a squash and an apple can be easily resolved. Either the yellow-orange of the squash or the red of the apple can be considered the main colour. Looking at them on the colour wheel, an analogous palette becomes an obvious choice if we ignore the touches of green on the apple and squash stem. A widely spaced analogous palette of New Gamboge, Naphthol Red Medium and Quinacridone Violet could make a beautiful painting of the subject. This palette selection uses substitutes from page 17 for the yellow-orange and red placements on the Sundell Colour Wheel.

Naphthol Red Medium

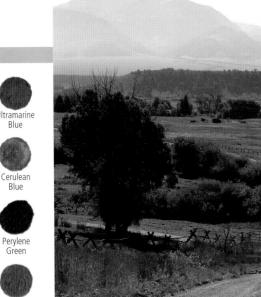

Chromium Oxide Green

Bismuth

Raw Umber

Raw Sienna

Permanent Green

Modified analogous colour scheme At a glance, the analogous colour scheme looks like a perfect choice for the landscape shown in the photo above. The blues and greens harmonise and blend beautifully. Noticing the hints of yellow or yellow-green in the flowers and meadow, we realise this might have to be an extended analogous palette. Ultramarine Blue, Cerulean Blue, Perylene Green, Chromium Oxide Green and Bismuth Yellow could work well for this purpose.

Unfortunately, those colours due not lend themselves to a naturalistic rendering of the road or jack fence. Still, the harmony of the analogous colour scheme speaks to us in the landscape, while the road and fence add to the composition. One solution is to modify the analogous colour scheme by adding Raw Umber and Raw Sienna to the palette in order to accommodate the road and fence. Raw Umber could be useful for tree branches and modifying greens in deep shadow as well. In that case, the dark Perylene Green would not be as necessary, and perhaps Permanent Green could be selected in its place.

Sometimes the perfect choice is not so perfect after all, but can still be used with a simple adjustment, since the look of the finished painting is more important than arbitrarily staying within rigid guidelines. After all, the use of a colour scheme is meant to enhance the interpretation in paint of our chosen subject, not hinder it.

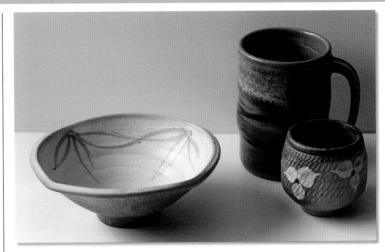

Complementary colour scheme Rich, earthy orange hues greet our eyes in this photo. The pale teal blue on the tall mug speaks of a complementary relationship to the earthy orange. An interesting palette for this subject could be the choice of Quinacridone Burnt Orange for the red-orange placement on the Sundell Colour Wheel and the choice of Cobalt Teal for its complement.

For a somewhat different look, the colours could shift to Quinacridone Gold for the yellow-orange placement on the colour wheel and Cobalt Blue for the complement in the blue placement on the wheel.

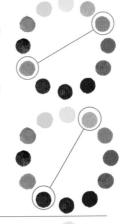

Burnt Orange

Cobalt Teal

Ouinacridone Gold

Cobalt

Quinacridone Magenta

Rich Green Gold

Titanium White

Tetradic colour scheme To paint the neutralised greens in the mug and cup shown in the photo, the palette could be extended to the tetradic colour scheme, adding Quinacridone Magenta and Rich Green Gold for the magenta and yellow-green placements. This would create a tetradic colour scheme when added to either of the previously mentioned complements, a rectangular one with the Quinacridone Burnt Orange and Cobalt Teal pair, and a square one with Quinacridone Gold and Cobalt Blue

Titanium White is included in all the palettes below

Cadmium Orange Medium

Cobalt Blue

Phthalo Green (Blue Shade)

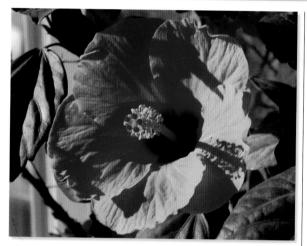

Tetradic colour scheme 1 Yelloworange is clearly the main colour in this photo of a hibiscus. The stamen shows a little red as well. The tetradic palette is the most limited one that will produce yellow-orange, red, neutralised green and a neutral grev. Cadmium Orange Medium mixes with its complement, Cobalt Blue, to make a soft grey, while Cadmium Red combines with Phthalo Green (Blue Shade) to create a neutralised green for the leaves.

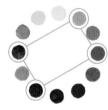

Ouinacridone Rose

Chromium Oxide Green

Tetradic colour scheme 2 An alternate tetradic colour scheme could use Cadmium Orange Medium with the Cobalt Blue complement, but shift to Ouinacridone Rose for the colours in the flower. Its complement, Chromium Oxide Green, would mix neutral greens.

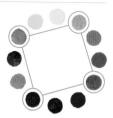

Quinacridone Violet

Bismuth Yellow

Tertiary colour scheme The first tetradic colour scheme could be expanded to a tertiary colour scheme by adding the complementary pair of Quinacridone Violet and Bismuth Yellow. This would enhance the shadows, particularly in the flower itself.

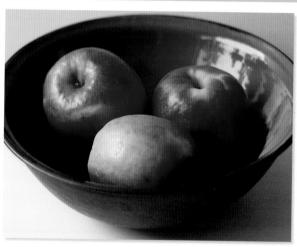

Split-complement colour scheme 1 The above photo poses some challenges for selecting a colour scheme. Red is the main colour. It relates to the yellow and yellow-orange in the apples well enough, but the turquoisegreen interior of the bowl is a little jarring. Cobalt Turquoise would be the nearest paint match, and it does not complement red but does complement the red-orange placement on the colour wheel. Shifting the apples to more of a red-orange and omitting the yellow and yellow-green in the apples could make a workable split-complement palette of Cadmium Orange Medium, Pyrrole Orange, Cadmium Red Deep and Cobalt Turquoise.

Titanium White is included in both the palettes below

Cadmium Orange Medium

Pyrrole Orange

Cadmium Red Deen

Cobalt Turquoise

Split-complement colour scheme 2

Another approach could be taken. If rosier apples are painted, a different potential split-complement palette is revealed. Shifting the deep turquoisegreen interior of the bowl to a green or yellow-green, a palette of Quinacridone Rose, Pervlene Green, Phthalo Green (Yellow Shade) and Bismuth Yellow becomes a lively option.

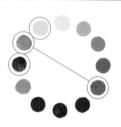

Perylene Green

Phthalo Green (Yellow Shade)

Bismuth Yellow

Titanium white is included in both the palettes below

Two pairs of complements

Low-chroma earth colours and neutrals abound in this image. The most striking contrast arises from the muted orange leaves that are complementary to the muted blue-grey rocks. Cadmium Orange Medium complementing Ultramarine Blue would provide a great starting point for this painting. The soft neutral greys made possible by mixing those two paints would be extremely effective.

However, adding a second complementary pair of colours would create more interest. The largest rock has a faintly purplish hue, so Dioxazine Purple with a yellow complement to neutralise it makes an appealing option. Choosing Cadmium Yellow Medium for that yellow would provide a more opaque colour to work against the powerful tinting strength of Dioxazine Purple. Tints of Cadmium Yellow could be used for small accents in the leaves.

Cadmium Orange Medium

Ultramarine Blue

Dioxazine Purple

Cadmium Yellow Medium

Split-complement colour scheme 1

Choosing a split-complement palette could be effective for this image. Looking at the list of substitute colours for the colour positions on the Sundell Colour Wheel (see page 17) is helpful in selecting such a palette.

Can you see how using Yellow Ochre, Ouinacridone Gold, and Ouinacridone Burnt Orange with a complement of Cobalt Blue would work? The luscious neutrals from mixing Cobalt Blue with those colours could make a lovely background of rocks and earth with lively leaves painted in the quinacridone colours.

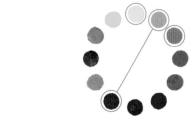

Titanium white is

included in both the

palettes below

Burnt Orange

Cobalt Blue

Split-complement colour scheme 2

An earthier variation of the previous split-complement palette could be selected. Yellow Ochre, Raw Sienna and Burnt Umber could be used with a complementary Ultramarine Blue. A guieter painting would result, as none of the vibrant and semi-transparent guinacridones would be present.

Raw Sienna

Burnt Umber

Ultramarine Blue

Neutral colour scheme

For further exploration, refer to Neutrals and earth tones on pages 72-75. You could also choose to use triadic neutrals to create the background and rocks for this painting. Another option would be to use Raw Umber to reduce chroma in Ultramarine Blue or Cobalt Blue in the painting instead of mixing with the complementary orange colour. Learning to create a variety of lovely neutrals leads to more interesting interpretations of subjects like this one.

Light, shade and shadow

Understanding light and how it works with shadows and shade is essential for painting the illusion of threedimensional forms on a two-dimensional surface.

Look for the source and angle of the light falling across the subject; the shadow automatically falls in the opposite direction. Getting this established correctly in a painting is the first step for a beginning artist. But the interplay of light and colour in shadows is more complex than this. The artist must learn to see what really happens to light in a shadow to create rich paintings that breathe with life and vitality.

Steelhead Flies (detail) Bern Sundell Here, shadow defines the form of the flv. Shadows and highlights were painted on the hook and body of the fly to indicate their shapes, but the shadow lying on the table shows us the hook arching upward, so we immediately understand the form of the flv.

CREATING A SHADOW USING A COMPLEMENTARY COLOUR

A shadow, first and foremost, is an area of reduced light. Reduced light results in neutralised colours, so mixing a colour with its complement creates a neutral for painting the shadow (see Complementary palette, pages 56-57).

Cadmium

Chromium

Titanium

Yellow Ochre

2 Paint the shadow of the pepper falling on the table with less white and more Indanthrone Blue in the mixture. establishing a cooler tone for the shadow.

3 Paint the shadows with a mixture of Chromium Oxide Green and Cadmium Red Medium. green and red being complements on the Sundell Colour Wheel.

Chromium Oxide Green and Cadmium Red mix, as the pepper reflects some of its colour into the shadow. This blends into the rest of the shadow, leaving the darkest area where the pepper touches the table.

1 Paint the table with a mixture

of Yellow Ochre,

Titanium White in a

slightly uneven blend

to give a livelier look

to the colour.

Choosing a colour scheme

Bowl of Eggs by Bern Sundell was painted with a modified tetradic colour scheme (see Tetradic colour palette, page 60). His colour scheme is of blue and orange complements paired with purple and yellow complements as the dominant palette for the painting. By emphasising the cool blues, he created a painting with a cool, breezy, moonlit feel. Compare this with the exercise on the opposite page.

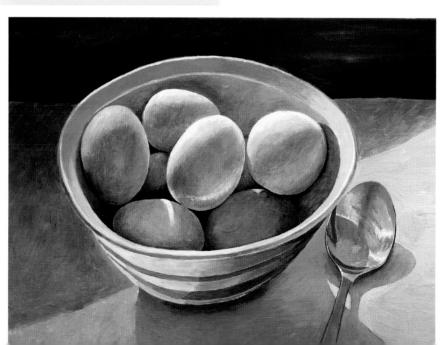

Main palette

Prism Violet

Cadmium Orange Medium

Cadmium Yellow Light

Titanium White

Ultramarine Blue

Additional palette Cadmium Red Medium Cobalt Teal Raw Umber Cerulean Blue Yellow Ochre

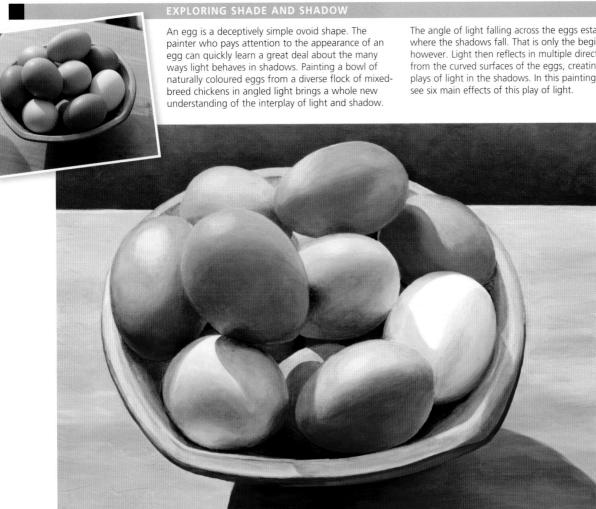

Anthraquinone

Cadmium Orange Deep

Cadmium Orange Medium

Quinacridone Rose

Raw Sienna

Raw Umber

Titanium White

Ultramarine Blue

Ultramarine Violet

Yellow Ochre

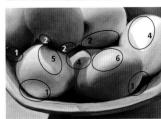

- 1 Light can be observed reflecting from the inside of the bowl onto the eggs, making lighter areas within the shadows. These appear as soft glows of light.
- 2 Similar to the reflections from the bowl, the eggs themselves reflect back onto each other. Consequently, you can see the colour of the light teal egg reflected onto the pinkish magenta egg, a bright brown onto the same pinkish magenta egg and brown onto a light
- 3 The curving shape of an egg makes a soft, diffuse shadow edge where the light falls across it, gently descending into the shadow on that egg.
- 4 When the shadow of one egg falls across another egg, a hard edge is seen on the shadow lying on the second egg. That edge results from the abrupt cut-off of light hitting the second egg. When two eggs cast shadows on a third egg, an interesting light shape can occur between the separate shadows.
- 5 Where one egg touches another egg, very little light can enter, so this is the darkest shadow area. It gradually blends with the curve of the egg into parts of the shadow that receive more reflected light. These soft modulations of shade are important to notice.
- 6 The bright highlight where the light directly strikes the surface of the egg also has diffused edges, once again due to the curving surface of the egg.

Backgrounds

A background sounds like a simple element that can be added at the end after the important part is painted. However, the hapless artist who tries to add a background as an afterthought often makes the appalling discovery that nothing works. Such backgrounds have ruined many promising paintings. Let's explore some colour strategies to help your backgrounds properly emphasise the main subject.

CHOOSING BACKGROUND COLOURS

Here are eight strategies for choosing effective background colours.

Use colour harmony to integrate the background with the main subject. Choose analogous colours or even the same hues used in the subject.

Use complementary colours to sharply contrast with the main subject. The complementary background may be partially neutralised as needed.

Neutral colours in the background make the main subject sparkle. Alternatively, they can make the main subject appear more substantial.

Adjust values to make the background recede. Neutralising the chroma simultaneously enhances this effect.

Use light reversals to sharply accent a main subject. Dark values opposing light values create powerful contrasts.

Create a supporting background pattern for a more stylised appearance. Use colours in that pattern to accent the subject using a suitable colour scheme.

A solid-colour background puts the focus squarely on the subject. If the subject is luminous, avoid a white background because it will kill the luminosity.

Creatively combine these strategies to paint backgrounds uniquely suited to your subject matter. Remember, the objective is to paint a background that draws attention to the main subject.

ANALYSING BACKGROUNDS IN PAINTINGS

Analysing backgrounds in different paintings develops your ability to plan effective backgrounds for your own paintings. Practise identifying the strategies used in paintings that attract you. Identifying failed strategies also helps, but right now let's focus on some good examples to see what works.

A Quiet Morning Paul Geraghty

Strategy number four makes the background recede into the distance. We sense a gentle morning fog in this lovely painting. Sharp contrasts in value in the foreground unobtrusively fade into those subdued wooded hills behind the harbour. The chroma of the colours decreases along with the loss of those contrasting values. This background beautifully sets the scene for the boats.

LIGHT REVERSALS

These two paintings both use strategy number five but in totally opposite ways. Either way, these light reversals really work. This is a good example of how any strategy can be used to create altogether different looks

Sun Struck Daniel Smith

This painting is a study in values first and foremost. The low-chroma colours are quietly understated. A subtle play between warm and cool colours can be seen in the bluish sheen against the warm browns on the elk's head and antlers, while the background also has a slight bluish undertone contrasting with the warm foreground. The visual emphasis is focused on values in this painting, with deep darkness forming a backdrop for the wary bull illuminated by a stray beam of sunlight.

Windy Kids Jennifer Bowman

Powerful contrasts in both value and hue make this background indispensable to the main subject of the painting. The dark blue sky finds complementary orange hues in the raincoats and beach, showing the full impact of strategy number two. Furthermore, if one uses the additive colour complements, the yellows in the raincoats and reflections in the wet beach serve equally well as complements to the blue sky, increasing the visual effect. This artist did not neglect value, applying strategy number five with a dark background and light main subject.

Untitled Frederick G. Denvs

The main trees are the darkest part of the painting, silhouetted against the blazing radiance of the background. Drenched in light, colours are brighter in this work, especially in the areas nearest the light source. Despite the brighter colours than used in Sun Struck (see left), contrasting values are still the backbone of this painting. It is an excellent example of how light reversal can be used with striking results.

PATTERNED BACKGROUNDS

Geometric patterned backgrounds that are similar in structure establish the shared commonality of this pair of paintings in their application of strategy number six. The composition and geometric patterns themselves are almost alike, but the colour choices bear no resemblance to each other.

Paint Horse Carrie Wild

Neutrals characterise the palette in this painting. Rectangular shapes dominate the background and are loosely painted. Notice the contrast between warm and cool background colours, echoing the play of warm and cool in the horse. The cool grey behind the horse pushes the subject forward. On the right, the dark rectangle introduces an element of strategy number five as well. The brighter whites in the horse make it stand out, vet it remains integrated with the background.

Hello Robin Pedrero

The colourful palette chosen for this painting obscures the similarity of the composition and geometric pattern to the horse painting. The loosely painted washes of colour glow behind the dark bird, showing the use of strategy number five. Upon closer examination we see that the colour choices follow strategy number one by using similar hues in the background and main subject. Another contrast appears in the way the background blue is lower chroma than the tiny blue foreground flowers, but the background oranges are distinctly brighter than the rusty orange in the bird.

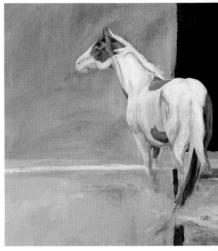

are handled in the paintings you see, noticing what strategies make them action is useless. Feel successful. Observe any flaws and think of what strategy might have solved treatments in your the difficulty. Observe everything around you in daily life to find unexpected inspirations for backgrounds in your paintings.

Observe how backgrounds Apply what you observe in your own paintings. Observation without free to experiment with different background own work. Be alert to what works and what does not.

Practise your skills to improve them. Using your own failed paintings to learn what really works is part of succeeding in your art. Regard your paintings as one long creative continuum so that any failed painting is only a stepping stone to greater understanding and power in your paintings.

Skies and clouds

Skies lift our spirits with their everchanging displays of clouds and light. Clouds dance and move across the sky, sometimes with gentle grace and other times with powerful menacing storms. Clouds catch the light, scattering beams across the waiting landscape or turning the sky molten with sunset colours. A sure way to engage your viewer is to capture the radiance of a sky in your painting.

Skies and clouds can usually be painted with a simple palette emphasising blues, grevs and white. Complementary colours can be mixed to create a variety of greys for the sky. bringing a liveliness that is altogether missing if you settle for those dead neutral greys you can buy in tubes and jars.

For sunrise or sunset, the palette expands to include reds, vellows and oranges in particular. Night skies pose different challenges. Instead of Cerulean Blue, Ultramarine Blue or Cobalt Blue – paints that are suited to brighter skies – deeper indigo blues are needed. Indanthrone Blue works

especially well for a night sky because the pigment is so powerful it can be painted in a range that goes nearly to black.

In most cases, painting the sky first is advantageous. This allows the blends in the sky to be smoothly painted across the entire area and any tree branches or other forms in front of the sky to be added later. Trying to paint a smooth blend in 'hopscotch' patches seen through tree branches is a thankless task and frequently gives a poor result. Let your painting process be as graceful as the skies you paint and your paintings will become a source of delight.

EXAMPLE OF PAINTING A SKY

For this painting a simple palette was selected, including Cerulean Blue, Titanium White, Cobalt Blue, Cadmium Orange Medium, Quinacridone Burnt Orange, Quinacridone Gold, Raw Umber, Ultramarine Blue and Ultramarine Violet.

Cerulean

Cobalt Blue

Medium

Ouinacridone Burnt Orange Orange

Ouinacridone

Ultramarine

Violet

1 Blocking in Block the painting in using Cerulean Blue in the cloudless parts of the sky and tints of a mixture of Cobalt Blue and Cadmium Orange Medium for the greys in the clouds. Paint the distant mountains in tints of Ultramarine Blue and Ultramarine Violet. Establish the foreground with tints of Raw Umber and Quinacridone Gold.

2 Build up detail Apply pale tints of Quinacridone Gold in portions of the clouds, leaving a slight yellow glow. Add tints of Ultramarine Violet to some of the grey areas of the clouds. Embellish the mountains and foreground slightly in their original colours.

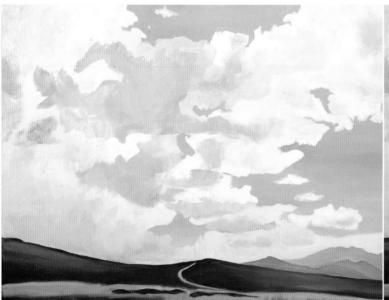

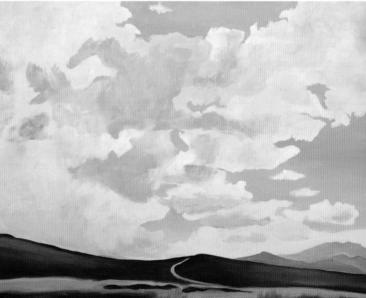

GREYS FROM COMPLEMENTS

When pigments mix they absorb light, so they behave differently from light itself (see page 9). Pigments also vary wildly in hue, chroma and value, so any two pigments may not mix exactly as we would predict from their placement on the Sundell Colour Wheel, which organises them by general hue categories. The prediction from a pigment mixing wheel is that opposite colours – complements – will mix to a neutral grey. In real life this varies, so testing your own collection of paints will be revealing.

Select all of the possible complementary pairs from your own palette and mix them, tinting with Titanium White, to see how they behave. You will discover a rich trove of possible greys that let you match the mood and intensity of any sky you wish to paint. This gives you great power for your sky paintings. You may find it helpful to review Neutrals and earth tones on pages 72–73 or Mixing colour wet-into-wet on pages 42–43.

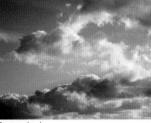

Cirrus clouds

Cumulus clouds

Stratus clouds

TYPES OF CLOUDS

While a meteorologist is concerned with the altitude of clouds and the specific types of clouds characteristic of each change in altitude, artists are more interested in the visual appearance of the clouds they wish to paint.

Clouds are grouped into three broad categories:

- Cirrus clouds are the highest in the atmosphere, thin wispy white clouds with feathery curves and swirls.
- Cumulus clouds are the puffball type of cloud, or when rising into stormy drama, those towering thunderheads. They typically have a flat bottom and

are dark grey in colour. The water mass in these clouds forms shadows within them.

• Stratus clouds are lower-lying flat cloud layers that include fog. They tend to be white or grey in colour.

The three categories of clouds readily intermingle in the sky, since they are water droplets drifting and mixing in the air, refracting and reflecting light while moving with the wind. This adds to the delightful variety possible in your paintings. Learn to observe the shapes, colours and play of light in the skies to improve your own cloud paintings.

- **3 Consider the values** Work up the varying values in the sky with tinted mixtures of Cobalt Blue and Cadmium Orange Medium for the cloud greys. Controlling these values correctly is vital for the success of the painting. Notice that the forms of the cumulus clouds are becoming more recognizable and distinct. Since the clouds in the upper part of the sky are nearer to us, we are almost underneath their flat bottoms and they appear sprawled against the sky. As the clouds move to the distant horizon, those flat bottoms step away from us, becoming more obvious to our eyes.
- 4 The finished painting In the finished sky, some of the grey mixtures created with the Cobalt Blue and Cadmium Orange Medium complements emphasise one or the other complement. The towering cumulus cloud on the left rising from the horizon to the top of the painting has more Cadmium Orange Medium in it, while some of the clouds moving into the distance have more Cobalt Blue. Notice the refinement of values in the distant clouds, which gradually become lighter as they move away from us in the painting. Leaving subtle tints of Quinacridone Gold and Ultramarine Violet in the clouds keeps them integrated with the land in the painting because it also uses those same pigments.

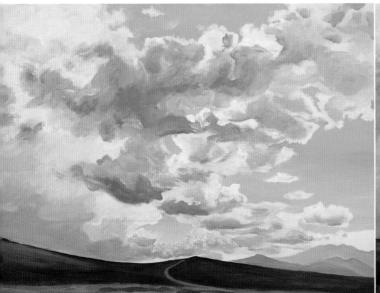

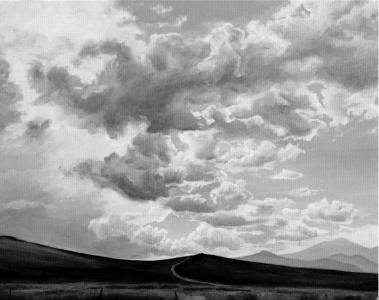

Gallery: Skies and clouds

Painting skies is exhilarating. The vastness of space in the sky above us, the dancing shapes of the clouds and the myriad transparencies of light lure us to the paintbox. From serene washes of gentle colour to turbulent choppy clouds threatening storms and lightning, skies give free range to all our emotions.

Colour contrasts abound in clouds colliding with light. Sunrise and sunset express this most dramatically but in midday towering cumulus clouds provide their own share of sky drama. Watching our ever-changing skies is an endless inspiration for paintings.

Changing Light Paul Geraghty

A range of blues and greys dominates this painting, but this range has a lively look because of the complementary warm yellows and oranges in the sky. Lavenders and even subtle greens crept into these clouds to add a sparkling richness. Strong value contrasts emphasise the light rays beaming through these great clouds. Skies always need something to hold them up, and this watery vista with islands and a lighthouse does the job beautifully. The quiet blue-greys of the water lead us towards the horizon and we see a startling and brightly lit cyan edge of water catching those beams of light from the radiant sky, and once again we are in the clouds...

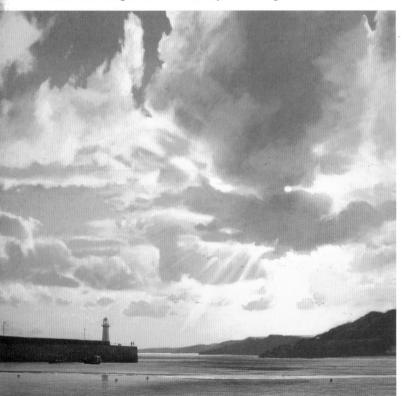

Main palette Cobalt Blue, Titanium White, Payne's Grey and Cadmium Red

Other key colours Cadmium Orange and Cadmium Yellow

Main palette

Ultramarine Blue, Phthalo Blue (Red Shade), Phthalo Blue (Green Shade) and Payne's Grey

Other key colours Yellow Ochre, Naphthol Red, Mars Black, and Titanium White

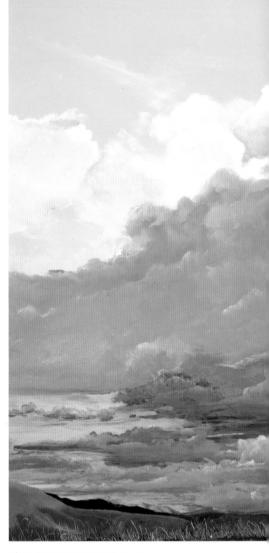

Fiery Sunset Warren Strouse

The tiniest sliver of land supports the artist's vision of piles of cumulus clouds. Yet this slice of land shows grasses and hills receding to the horizon with greens complementary to the sunset above it. Sometimes a little does a lot. The sky soars with colour, light Cerulean Blue at the top, fluffy brightly lit clouds catching yellows, oranges and even pale tints of red, all atop a streaming mass of shadowed clouds. Deep in these rumbling clouds of dark blues, purples and glowing patches of orange and red, the setting sun blazes fiery red-orange into the horizon. Broad areas of peaceful colour at the top change into turbulent and combative complements at the horizon. Smaller areas of both brighter and darker complementary colours add intensity to the lower part of this sky.

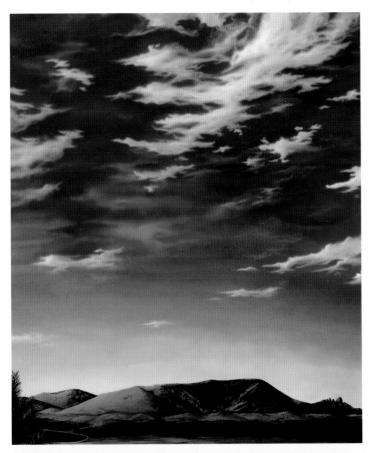

Sleeping Giant Alan Snell

This sky here relies on a smooth rosy golden glow at the horizon to support its turbulent cloud wisps dancing higher up. The highest cirrus clouds sing with golden and red-orange glazes of colour against the intense deep blues. Values provide drama, with such a dark blue in the upper sky and shadowed deep greens in the close foreground trees. The horizon is not soft and indistinct, but sharply delineated against the sky with its own dark values. The land between the far mountain and foreground trees briefly reflects the rosy sky in a muted, neutralised way.

Main palette

Ultramarine Blue, Phthalocyanine Blue, Cobalt Blue and Titanium White

Other key colours

Cadmium Yellow, Raw Sienna, Naphthol Red and Ivory Black

New Dawn Jason Sacran

This sky is not painted with soft wash-like blends, but with rather choppy brushstrokes that impart a different mood to the colours on the canvas. In the detail from the middle of the painting (see right), you can see how this handling of colour differs from some of the other skies shown here. Compare the approach with Sleeping Giant (see above), which uses a similar palette. The manner in which colour is applied can affect emotion as much as the colour itself.

Main palette

Ultramarine Blue, Cobalt Blue, Titanium White, Cadmium Yellow Light, Cadmium Orange, Cadmium Red Medium and Alizarin Crimson Hue

Other key colours

Titanium White, Viridian Green and Ivory Black

Water scenes

Painting a scene with water brings a sudden realisation: we never actually paint water. Water is a clear, colourless substance, not something intrinsically paintable. What we paint instead is how light moves through water or how it reflects from water. Thinking about it in this way allows us to create the illusion of water in our paintings.

Painting water requires an understanding of how light interacts with it. If the surface of water is rippled, the reflections break up because they are reflecting at all different angles and in different directions. If the surface of the water is smooth, we see almost perfectly mirrored reflections.

Light can move through water and illuminate what lies underneath. Certain distortions characterise the underwater view, so those must be taken into account as well when painting. Light may become more diffuse when moving through water, so edges are not as sharply defined and detail may disappear.

Become alert to the changes in light, reflections and shadows with water scenes. The more you observe, the more you will recognise what is important in painting water.

ANALYSING DIFFERENT ASPECTS OF PAINTING WATER

Examining October Reflections will reveal many important points about painting water. If you understand these points you can apply them to your own paintings of water scenes. Let's look at several details and see what visually interesting factors we can discover.

The water around rocks

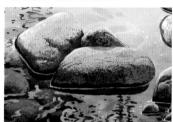

At the edge of a partially submerged rock where it emerges from the river, a silvery highlight appears. These highlights are bright white in the sun but bluish in the shadowed areas. They follow the form of the rocks and result from the slight movement of water lapping up against them. Notice the darker Raw Umber colour of the rocks slightly above the water line. It is wet because of that lapping motion, and the dry rock above it is lighter in colour.

Colour changes

As we continue to explore the shadowy underwater world in the painting, we notice colour changes below the surface of the water. The central leaf is painted with a slight bluish haze where it lies underwater. The rocks are softened with a glaze of bluish paint as well. The dark shadows next to the upper rocks in this detail are a clue to what is happening. A faint sheen of light is ever-so-slightly reflecting from the water, leaving a bluish tinge to what we see through that sheen. Nearest the larger rocks, their shadows on the water interrupt even that slight sheen and are considerably darker.

HOW LIGHT MOVES THROUGH WATER

Light rays bend when they enter water. This is called refraction and the amount of the bend is called the index of refraction. This photo shows a perfectly straight bamboo skewer in a glass of

straight bamboo skewer in a glass of water. Notice how drastically the angle changes where it enters the water. This is because the light moves at a different angle in water than in air, so we see the illusion of a bend in the straight bamboo skewer.

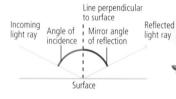

Another angle of great interest to the artist is the angle of incidence, the angle between the incoming light ray and the line perpendicular to the surface it will hit. The light reflects at the same angle away from that perpendicular line, meaning the light coming in at a certain angle will reflect at that exact same angle going away from the surface. We will only see those reflections that are angled so they come to our eyes. This is why water ripples mostly appear to be

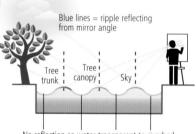

No reflection so water transparent to riverbed

horizontal, as those are the angles at which we see the reflected light.

Ripples are visible to us mostly as horizontal coloured shapes, since they break the reflecting surface of water. We no longer see the sky reflected where we have a ripple. Instead, we see into the water where nothing is

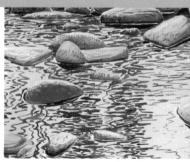

reflecting from the surface. So ripples are painted as shadows allowing us to see into the water. To accomplish this, the artist painted all the underwater rocks and allowed them to dry. Then he painted the sky reflections over the underwater rocks in rippling shapes.

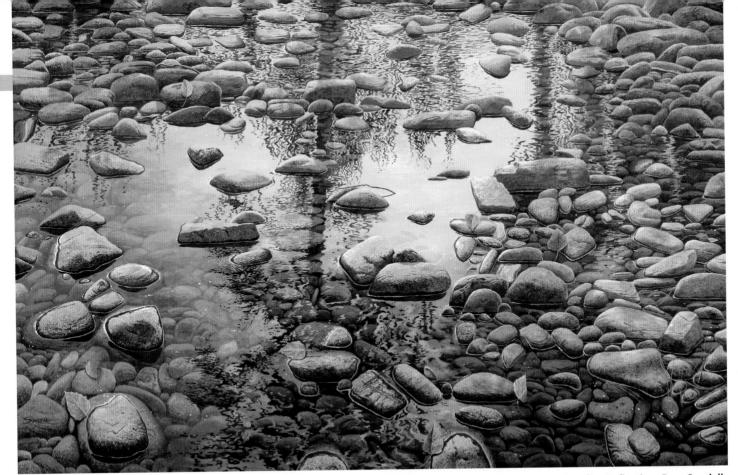

The complete illusion of water

A slight bluish sheen on fairly still water gives the sense of a watery surface. The deeper shadow areas hold a darker blue. The centre stone appears lighter underwater on the left edge where it is not so shadowed. The shimmering highlights around the rocks enhance the visual impression of a water surface. Lapping water leaves dark, wet rings around the water line of the rocks. A few floating white bubbles also add to the illusion of a distinct water surface.

The secrets of shadows

Looking further into shadows on water, in this detail we see part of the shadow of a tree trunk that falls across the middle of the painting. A shadow cannot reflect light from the surface, so we peer below the water surface to the underlying rocks. Since the rocks are shadowed, the colours are low key, dark, and rich, but the shapes are somewhat indistinct.

Broad areas of shadow

The tree shadows include broad areas of shadow in some parts of the painting because of the foliage on the trees. In this detail we see such an area. Only a few glimmers of blue haze show the sky colour, a dapple of light penetrating the foliage and reflecting from the water. Mostly we see shadowed rocks lying in the water, painted in low-key earth tones.

October Reflections Bern Sundell

This tranquil scene of river rocks and water in the fall shows many different aspects of light and water interacting. Some areas are still and calm while others are moving with ripples. Shadows of trees interrupt the reflections of sky and partially submerged rocks rise above fully submerged rocks. The strongest value contrasts lie in the foreground. Detail diminishes as the eye moves to the top of the painting, the most distant part of the scene.

Colour palette

Cerulean Blue, Ultramarine Blue, Raw Umber, Yellow Ochre, Raw Sienna, Cadmium Yellow Medium, Cadmium Orange Medium, Cadmium Red Medium and Titanium White.

Gallery: Water scenes

Sometimes water is smooth and serene, other times wild and violent, but it always brings powerful expressions of emotion. Painting water can be like painting pure colour. It is really painting what surrounds water, lies under water or lies above water, but as translated through the motion and depth of water. Illusions held in water make beautiful paintings.

Great Wave Paul Geraghty

This stunning wave is an excellent example of an analogous colour scheme of blues and greens. Values are somewhat muted with a little white drawing our eye to the curl of the wave rising from its dark edge. Colours blend fairly smoothly in the lower frothy areas and shift into graduated streaks of green going from dark to light. The frothy mass at the top is choppily painted in contrast to the smooth wash of the sky in the upper left. Notice how the low-chroma hues in most of the painting change to higher-chroma hues near the whitest area.

Main palette

Ultramarine Blue, Phthalo Blue (Red Shade), Phthalo Blue (Green Shade), Phthalo Green (Yellow Shade), Cobalt Green and Light Turquoise

Other key colours

Light Violet, Anthraquinone Blue, Carbon Black and Titanium White

Sea and Rock Paul Geraghty

Water is painted in this scene with low-chroma neutrals. Everything in the painting is muted, yet the painting is flushed with light. Careful handling of values creates this effect. Notice the brighter area in the middle of the distant sky, a brightness glancing off the surface of the water all the way onto the wet sand where the last wave retreats. This central radiance accented by the dark shadows of rocks and waves is what creates a strong sense of light in a painting of neutralised colours.

Main palette

Burnt Sienna, Burnt Umber, Permanent Maroon, Red Oxide, Yellow Ochre and Ultramarine Blue

Other key colours Violet Oxide, Naphthol

Violet Oxide, Naphtho Red (Medium), Mars Black, and Titanium White

Tranquility Paul Geraghty

Notice the temperature of the colour in this painting. Soft low-chroma blues, blue-greys and violet-blues dominate. A small amount of yellow and red orange provide a necessary but rather muted contrast. Most of the colour we see in this painting is cool in temperature. The brighter sky shows as a lower-chroma reflected watery sheen in the foreground, emphasising that coolness. Varied horizontal bands of colour provide the composition for this painting.

Main palette

Ultramarine Blue, Phthalo Blue (Red Shade), Anthraquinone Blue, Yellow Ochre and Cadmium Orange

Other key colours

Cerulean Blue, Violet Oxide, Cadmium Yellow, Carbon Black and Titanium White

Grand Opening Day Jennifer Bowman

A simple palette and an unusual point of view combine here to create a striking painting. Blues, turquoises and cyans in highly abstracted patches of colour result in water that shows the movement of this craft. Yellow greens pull the rowing figures into harmony with the water while the yellow-oranges add a zing of complementary contrast. Dark and light values create the structure of the painting.

Main palette

Phthalo Blue, Cadmium Orange and Cadmium Red Light

Other key colours

Rich Green Gold, Cadmium Yellow, Dioxazine Purple and Titanium White

End of the Day Paul James

The colour temperature in this painting runs much warmer than Tranquility (see above) due to the strong yellows, oranges and red-oranges dominating the palette. Even the dark blue crashing wave has brighter and redder (warmer) mixtures in the middle where the sun hits it. Low-chroma blues provide a complement to the dominant higher-chroma oranges and de-emphasise the coolness intrinsic to blue. Values are executed with much higher contrasts in this painting and the water is powerfully enlivened with high-chroma reflections of the hues in the sky.

Titanium White, Ivory Black, Mars Black, Burnt Umber, Burnt Sienna, Raw Umber, Cadmium Yellow, Cadmium Orange, Cobalt Turquoise, Yellow Ochre and Lemon Yellow

Other key colours

Cadmium Red, Cadmium Red Deep, Deep Violet, Phthalo Green, Ultramarine Blue, Pale Olive Green and Hooker's Green

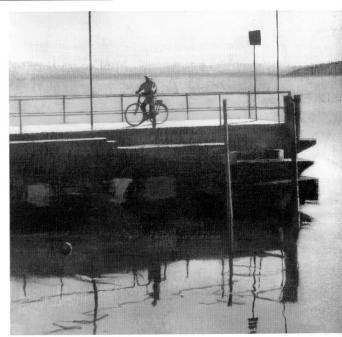

Untitled Peter Nardini

This painting is composed primarily of blues with a hint of warm browns for contrast. The strongest contrast is provided by the dark values of the pier against the lighter values of the water and sky. The water holds all the colour of the sky with a few wavy dark reflections. The figure on the bicycle is painted in the same hues found in the sky and pier.

Main palette
Cadmium Orange,
Phthalo Blue,
Cadmium Red, Primary
Yellow, Titanium
White and Black

Buildings

Buildings are our shelter from the elements, our safety and our protection. They are our homes. the businesses we visit, places of both work and play, and they come in astonishingly diverse forms. A building can be a simple log structure or a soaring architectural display of space-age materials. Painting a building evokes the human spirit in a different way to other subject matter.

However unique buildings may be as expressions of the human spirit. they fortunately can be painted using all the principles of colour in acrylics discussed in this book. Buildings can be rendered in whatever colour schemes appeal to the artist. They can be integrated with colour into their surroundings in the painting.

Moods can be evoked at will through changes in the colour palette. So take another look at that rustic barn or gleaming neon-lit café and see what interests you about the colour in the building.

Is it the way light and shadow fall across the walls? Is it the way light reflects from the ground into some of those shadows? Is it the mood created by dimly perceived interior worlds? What matters most to you when you look at the building? Can you translate that quality of mood into a colour scheme that expresses it clearly?

In these ways, a building can be painted like any other subject matter. Just observe colour and the play of light. Interpret the mood you wish to convey with a colour scheme that inspires you, and pick up your brushes.

WEATHERED WOOD AND SHADOWS

Stage 1 The canvas primed

with gesso tinted with Raw

Sienna on page 30 provides a good coloured ground for

beginning this painting. All

the areas that look rather like

Yellow Ochre are the primed

The palette chosen for the

painting emphasises purple

canvas left untouched at

this stage.

introspection.

In this example, a weathered barbershop from a ghost town is shown. The ramshackle structure departs from strict perspective rules due to the decay of time. It displays interesting architectural elements and long, slanting shadows along with the worn wood.

palette includes

Purple

Ouinacridone Burnt Orange

Raw Umber

Yellow

Cadmium Orange Medium

- 1 Apply a tint of a mixture of Cobalt Blue and Cadmium Orange Medium to start the boardwalk in front of the building. Do not attempt to indicate individual boards in this area as yet.
- 2 Paint the bench and step up to the door in a lighter tint of this same mixture. Use the same mixture on the inset panels in the stand for the barber pole and the left window frame.
- **3** At this stage, turn your attention to painting the purple shadows. Use Dioxazine Purple, Indanthrone Blue and varying amounts of Titanium

White for tinting to establish the shadow patterns across the coloured ground of the canvas.

- 4 In the lower left corner the shadows are the deepest, and Titanium White is not needed.
- 5 Paint Raw Umber in the dark recesses of the windows with tints of Indanthrone Blue where the sky reflects from the glass.
- 6 Paint a few weathered boards with a darker grey version of the Cobalt Blue and Cadmium Orange Medium mixture.

2

- 7 Delineate the barber pole with Indanthrone Blue, Quinacridone Burnt Orange and pale tints of the Cobalt Blue and Cadmium Orange Medium mixture.
- 8 Use a little Chromium Oxide Green with Raw Umber to lay in the first leaves above the window and in the upper-right corner.

Indanthrone

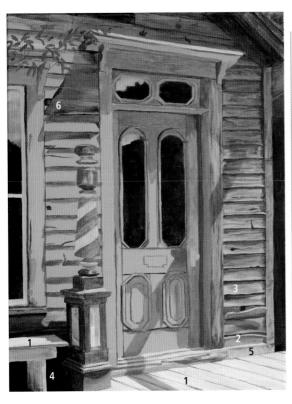

Stage 2 After the underpainting has dried, coat the entire painting with Regular Gel Medium using a flat hog-bristle brush. The brushstrokes should follow the direction of the wood grain in each board to provide a suitable wood grain texture to take the next layer of paint.

- 1 Once dried, complete the boardwalk in front of the building, using varying tints of the Cobalt Blue and Cadmium Orange Medium grey mixture. Refine further the step, bench, and other areas using this mixture.
- 2 Starting at the bottom right, unevenly apply glazes of colour to each board, working with three boards at a time. You could allow the glazes to dry between coats but could also work them wet-into-wet.
- 3 Allow some of the coloured ground of the primed canvas to remain. Lightly skim the brush across the top of the gel texture every so often to leave paint in a natural-looking woodgrain appearance.
- 4 Create the darkest shadows using Raw Umber mixed with Dioxazine Purple. Apply varying mixtures of Quinacridone Burnt Umber and Yellow Ochre, sometimes tinted with Titanium White, unevenly to the boards.
- 5 The building has greyer weathering on the boards where snow accumulated in winter, so apply the grey mixture of Cobalt Blue and Cadmium Orange Medium over some of the other glaze layers.
- **6** In the shadowed areas, add tints of Dioxazine Purple with a little Indanthrone Blue in uneven glazes. Notice how the previously harsh purple shadows now begin to look natural to the building.

Stage 3 After a little more work establishing a solid balance of values around the door, paint the door itself. Use more tints of Yellow Ochre in the door to show that the wood is weathered differently.

The contrast of the smoother boards of the door with the rougher texture of the siding is useful as the values of the door can be brought into balance with the rest of the painting. Use darker strokes of Dioxazine Purple and Raw Umber in some of the darkest shadows to add more emphasis to the door.

1 All of the windows have been left untouched since the first layer of paint, but they need to look as though they have glass in them. Paint slightly tinted mixtures of Indanthrone Blue and Raw Umber over the Raw Umber parts of the windows. The slightly paler areas give the impression of slight reflection from glass. Adjust the sky reflections in the glass further.

2 With the door, windows and walls completed, finish the barber pole with strong shadows and a few highlights to make it more dimensional. Scrape a little Raw Umber vertically onto the pole to show the weathering more accurately.

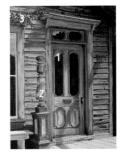

3 Paint the foliage with neutralised greens using Chromium Oxide Green, Raw Umber and sometimes a little Titanium White. With the boards behind the foliage in their finished state, paint branches across them to support the leaves.

Gallery: Buildings

Buildings are such an important part of our lives it is no wonder we love to paint them. Their geometric shapes create exciting patterns of light and shade. Those hard-edged shapes contrast well with foliage. Different artists see different possibilities in painting them, so let's look at a few examples.

Steps John Sprakes

This painting emphasises the geometry of the shapes in its composition, but in an altogether different manner than China Camp from Bluff (see left). The colour scheme is a modified split complementary with cyans, blues and violets opposing the low-chroma yellow-orange. A few extremely low-chroma greens and a complementary low-chroma red were added to this colour scheme. The play of colour in the geometric shapes provides the main interest, rather than the shapes themselves. Notice the modulations of colour in the shadows and how they quietly create interest with the lighter parts of the stairs.

China Camp from Bluff Kathleen Elsey

The abstracted geometric pattern of the group of buildings provides the main interest here. Colour is actually subordinated to the composition of this painting. The red and green hues are of medium chroma but still offer a complementary contrast. A low-chroma but high-value yellow beach exists as a geometric element. The rest of the painting is executed mainly in neutrals with some dark values for contrast.

Main palette

Titanium White, Chrome Yellow, Cobalt Blue, Ultramarine Blue, Cadmium Red and Alizarin Crimson

Other key colours

Aqua Green, Brilliant Purple, Blue Violet, Magenta and Phthalocyanine Blue

Main palette

Hansa Yellow Light, Cadmium Yellow Dark, Alizarin Crimson Hue, Cadmium Red Medium, Cerulean Blue Deep, Ultramarine Blue, Yellow Ochre and Green Gold

Other key colours

Raw Umber, Jenkins Green, Dioxazine Purple and Titanium White

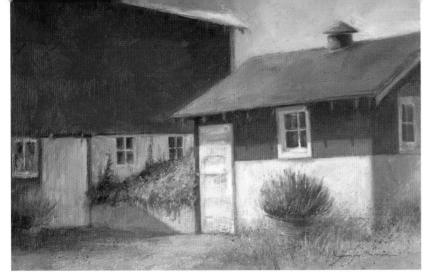

Barn Jennifer Bowman

High-chroma colours come into play here with an intensely bright cyan sky and vivid reds, greens and yellows in the barn and flowers. The green is a little more subdued in chroma than the yellows and reds, so it works well with the shadows on the walls of the barn. Purples appear in the shadows on the walls, darker near the eaves of the red wall areas, and almost a bright violet on the white walls and door. We feel the effect of reflected light on the walls with this colour handling.

View of Spring Barbara Louise Pence

The play of light across the geometric shapes draws the eye to this painting. At a glance, the red and green complements make this look like a simple complementary painting. However, the wall is painted a low-chroma yellow neutralised with a purple in the light and a low-chroma purple neutralised with yellow in the shadow. This makes it a straightforward tetradic colour scheme, except for the blue in the window and some of the shadows.

Main palette

Main palette

Napthol Crimson, Cadmium

Red, Titanium White, Olive

Green and Hooker's Green

Other key colours Phthalo Blue, Dioxazine Purple

and Cadmium Yellow

Ultramarine Blue, Transparent Burnt Sienna, Dioxizine Purple, Yellow Ochre, Sap Green and Titanium White

Other key colours

Alizarin Crimson Hue

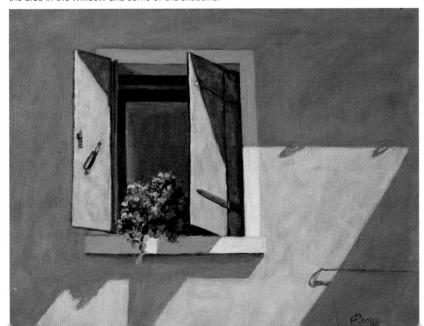

Main palette

Azo Yellow Medium, Hansa Yellow Light, Cadmium Red Light, Alizarin Crimson Hue, Ultramarine Blue, Phthalo Blue Green, Phthalo Turquoise, Dioxazine Purple and Titanium White

Other key colours

Cadmium Orange, Cobalt Blue, Cerulean Blue, Quinacridone Violet, Opera Rose and Quinacridone Nickel Azo Gold

Venice Glow Lou O'Keefe

Colours are exaggerated here with high-key blues, yellows and violets splashing down from the top centre of the painting. The lower-key blues and greens of the water change the mood of those high-key colours. Neutral shadows on the left are offset by vibrant complementary red walls and green shutters on the right. The artist achieved a glowing look with this combination of colours.

Plant life

Plants come in a bewildering variety of forms. Paintings just of the leaves could easily fill a book with all their variety of shapes and colours. Those colours also change with the seasons, the bright freshness of spring leading to deeper greens of summer and then the blazing colours of fall. Seeds and flowers add interesting elements and myriad artistic complications of their own. Painting plants can easily occupy an artist for a lifetime.

When painting plants, earth tones and bright floral colours are easier to mange than naturalistic greens. Unfortunately, many beginning painters find almost an infinite number of ways to make greens shriek in their paintings. To avoid this awful fate, learn to control chroma and value in your greens.

Vivid high-key and high-chroma greens do occur in nature, but more often as sparkling accents rather than as the dominant green of the plant. By reducing chroma, partially neutralising the green, the colour often integrates far more naturally into your painting.

Reducing value in the greens is another method to make the plants you paint look more lifelike. Shadows locate a plant in space and give it dimension, so those darker values for the shadows bring the plant into a more realistic focus.

Control the paint mixtures carefully to establish the range of colour to be found in a plant. The leaves often have subtle gradations of colour that blend softly. Veins may interrupt this, but they still must integrate with the smoother sections of the leaf. Really look at the plants you paint and learn to understand what you see. That will make painting the appropriate greens go from a frustrating struggle into a playful exercise.

The following two paintings explore different characteristics of green leaves and light. For leaves painted in a range of greyed blue-greens to more intense yellow-greens, see the cabbage leaves in Analogous colour palette on pages 54-55.

Green Light

Chromium Oxide

Medium

Hansa Yellow

Raw Umber

Yellow Ochre

Carbon Black

Titanium White

CHROMA, VALUE AND NATURALISTIC GREENS: A COMPARISON

The two painting sequences on this page and opposite use the same palette to mix very different greens. This demonstrates the great difference that results from changing chroma and value in the greens: on this page the greens are intense and heavy; opposite they are lighter and fresher.

Geranium Leaves Stage 1 Begin by establishing placement of the leaves and the overall value structure in full colour.

- 1 Paint the background with varying tints of Raw Umber mixed with a very small amount of Carbon Black. Paint the deep shadows in the leaves with Chromium Oxide Green mixed with a little Raw Umber.
- 2 Mix several variations of Permanent Green Light with Hansa Yellow Medium and tint them with Titanium White as

needed. Use these tinted mixtures for the brightest leaf areas. Blend slightly with the shadow colours in the leaves.

3 Paint the main stalk of the geranium plant with Raw Umber and a little Chromium Oxide Green. A tint of Yellow Ochre with a little Raw Umber works well for the dried husks on the stalk.

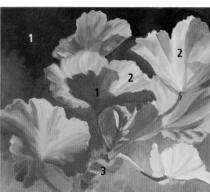

Stage 2 Paint the background, leaves, stalks and dried husks using the same basic mixtures as before.

1 Define the leaves with more of the Permanent Green Light to blend between the shadows of Chromium Oxide Green mixed with Raw Umber and the highlighted areas of Permanent Green Light with Hansa Yellow Medium tinted with Titanium White.

2 Add more definition in the values of the stems.

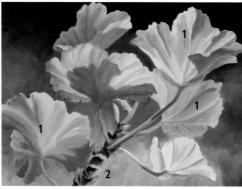

Stage 3 Continue refining the leaves, stems and stalks with the mixtures previously used. Carefully adjust the values to make the powerful lighting evident.

- 1 Add Titanium White highlights in varying widths on the leaf edges.
- 2 Make the highlights the most brilliant on the central leaf with the large shadow to maximise the value contrast and keep the eye from wandering off the edges of the painting.

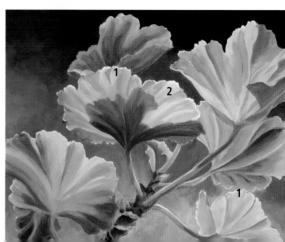

Same palette, with extra colours for the flowers

Cadmium Orange Medium

Nasturtium Leaves Stage 1 Paint the background in tints of Raw Umber with a small amount of Carbon Black added.

- 1 Most of the flowerpots can be painted with tints of Carbon Black, sometimes with a little Raw Umber added. The two earthy brown pots use a mixture of Raw Umber and Pyrrole Orange tinted with Titanium White.
- 2 Paint the darkest leaf areas with Chromium Oxide Green and Raw Umber.
- Stage 2 Continue developing the leaves and background with the previous mixtures used.
- 1 Carefully blend the greens in the leaves. They are not backlit so the drastic value contrasts in the individual geranium leaves opposite are not a factor. Instead we see soft gradations of colour. Softly blend tints of Chromium Oxide Green and Raw Umber on the left leaf.
- 2 The next leaf moving right uses tints of Permanent Green Light with a little Hansa Yellow Medium and a minute amount of Raw Umber.
- 3 The back of the big leaf on the right shows blends of the same mixture but with some areas where either the Hansa Yellow Medium is more pronounced, or where the Permanent Green Light is more pronounced. Add more veins in the leaves, taking care with their blends as well.

- 4 Indicate the main veins with pale tints of Hansa Yellow Medium or the Chromium Oxide Green and Raw Umber mixtures.
- 5 Establish the flower with Pyrrole Orange in the darkest areas and tints of Cadmium Orange Medium in the lighter areas. Blend them into each other as needed.

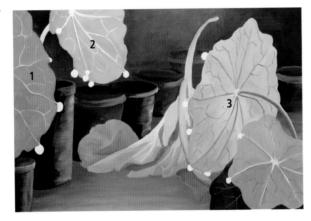

Notice how the geranium leaves show strong value and chroma contrasts. The harsh lighting makes brilliant high-key and high-chroma areas alongside dark shadows within the same leaf.

Using the same palette for mixing the greens, the nasturtium leaves display soft blends and delicate colour transitions. This lighting falls softly across the leaves, showing less value and chroma contrast.

1 Adjust the values in the flower and add a thin layer of Chromium Oxide Green and Raw Umber to the uppermost tip. Refine the veins of the leaves so they take on a delicate appearance.

2 To complete the painting, add colour to the dewdrops. These delightful round droplets form overnight in the greenhouse and capture myriad reflections. The dewdrops all display green mixtures, tints of Raw Umber and Titanium White.

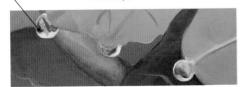

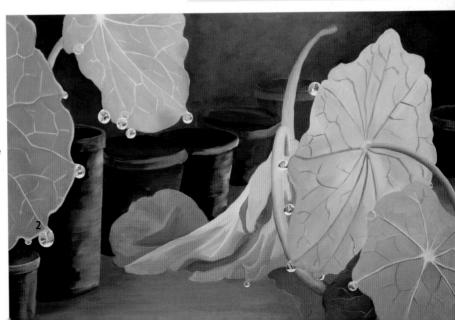

Gallery: Plant life

Plants with their leaves, seeds, fruit and flowers bring beauty to the lands we inhabit. Rhythms of the season are revealed as they grow through their life cycles. Gardens and open spaces overflowing with plants of every description engage artists with an ongoing source of multi-coloured inspiration.

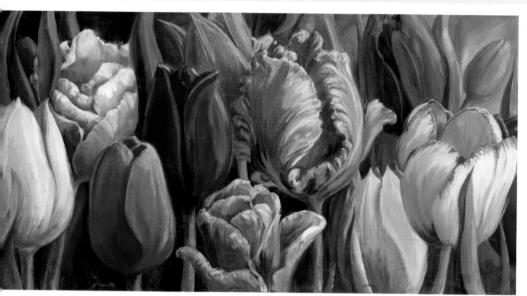

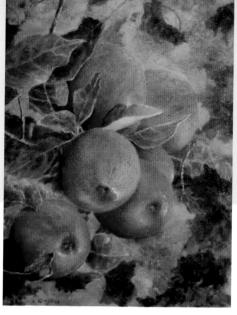

Apples Divine Elizabeth Crabtree

The colour scheme is readily identifiable here – a straightforward example of complementary colours. The variegated reds of the apples work well with the opposing green hues of the leaves. The foliage has a good range of values and natural-looking greens, making a pleasing painting.

Main palette

Cadmium Red Medium. Cadmium Orange, Crimson Red Translucent. Payne's Grev, Olive Green Light and Olive Green Deep

Other key colours

Burnt Sienna. Yellow Ochre Cadmium Yellow. Titanium White and Zinc White

Cadmium Orange, Cadmium Red Light, Cadmium Yellow and Titanium White

Other key colours

Phthalo Blue, Dioxazine Purple. Olive Green, Forest Green, Sap Green and Hooker's Green

Tulips Jennifer Bowman

A delightful array of colour greets us in these tulips. Complementary pairs of red and green along with yellow and purple accentuate the vibrant appearance of the tulips. The diverse types shown in the flowers allow some to be painted in smoother blends and others in more dramatically variegated fashion. The artist favoured warm lights and cool darks in this painting to generate a three-dimensional illusion.

Main palette

Cadmium Yellow Medium. Dioxazine Purple, Hooker's Green, Naphthol Crimson, Titanium White and Phthalo Blue (Red Shade)

Other key colours

Jenkins Green, Cadmium Orange, Phthalo Blue (Green Shade), Phthalo Green and Cadmium Yellow Dark

Dunn Ranch Pamela Ohnemus

This vista of flowers provides a backdrop for the daisies in the foreground, their vellow petals fluttering in the breeze. Several flowers have lost their petals completely. Aside from the Cerulean Blue sky with blue-violet clouds, yellows and greens dominate this painting, with a few small purple flowers to provide a complementary contrast to the yellows. The landscape is painted mainly in midrange values, keeping a lighter feeling than deep darks would offer.

Dancing with the Dew Lexi Sundell

This simple colour scheme uses bright cyans and purples against the yellows and yellow-oranges in the painting. A little green and blue completes the limited palette. Forty dewdrops reflect and refract light into their varied shadows on the petals. While the colours are mostly high key, strong value contrasts are present as well. This stylised interpretation of a dahlia expresses a sense of play through the unusual colour combination.

Main palette Cobalt Teal, Ultramarine Blue, Dioxazine Purple, Quinacridone Gold and Titanium White

Other key colours Cadmium Orange Medium, Chromium Oxide Green and Raw Umber

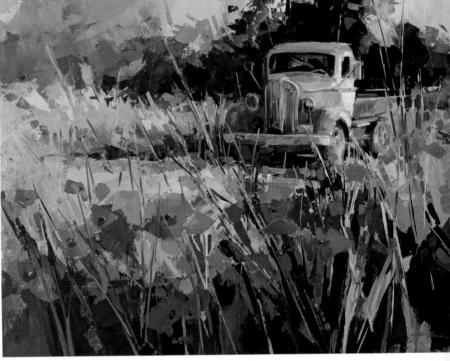

Main palette Cadmium Orange, Cadmium Red Light, Olive Green, Forest Green, Sap Green, Hooker's Green, Indian Yellow, Cadmium Yellow and Titanium White

Other key colours Phthalo Blue, Dioxazine Purple and Ivory Black

Out Standing in His Field Jennifer Bowman High-key and high-chroma colours laid horizontally across the middle of this painting give an open, cheery feeling to the painting. Painted with a full palette, the values are kept light but with enough strong darks to give structure and substance to the composition. The loosely painted broad strokes of colour were well chosen for the application of paint in this scene.

October Evening Pamela Ohnemus

Fall sets the stage for earth tones that are used to advantage in this painting. Strong value contrasts accent the brightly highlighted seed heads waving in the prairie wind against the dark backdrop of the land. The main interest of this painting is the rich range of earthy colours throughout these foreground grasses.

Main palette

Cadmium Yellow Medium, Dioxazine Purple, Phthalo Green, Naphthol Crimson, Titanium White and Phthalo Blue (Red Shade)

Other key colours Cadmium Orange, Phthalo Blue (Green Shade) and

Quinacridone Gold

Still life

Still-life painting is a beloved and longstanding tradition in art. The variety of shapes, colours and textures possible, along with the nuances of lighting, make still-life painting a challenging and enjoyable pursuit for the artist.

Still life requires a solid understanding of painting shapes of varied textures with convincing colour. Choosing suitable colour schemes to convey the desired mood for the objects in the painting is vital (see pages 46–49).

Fruit and flowers are often chosen as subjects for a still life. Prior to the advent of photography, artists painting from actual displays of fruit in the studio had difficulties if they did not paint rapidly, since the fruit and flowers would often rot and decay before the painting was completed.

A whole genre of still life known as vanitas arose in the sixteenth and seventeenth centuries, featuring this type of decay in paintings. To further emphasise the concept of the brevity of life, skulls and other elements were introduced.

The fact that acrylics dry rapidly eliminates the delay of waiting for paint to dry between layers as in oil painting. A high-quality painting of fruit or flowers is made possible without having to grapple with rotting fruit or wilting flowers.

Any combination of objects can be used as subjects for still-life painting. Be open to exploring your surroundings with an eye for interesting objects that can be combined in dramatic or unusual ways. Watch for lighting angles that enliven those subjects. Above all, have fun playing with the possibilities of still life.

Refine the outside of the cup and handle with another layer of paint, adding a small amount of Manganese Blue Hue in the middle of the cup.

Paint the interior of the cup with more of the mixture used on the body of the cup. Use a darker mixture of Manganese Blue Hue, Raw Umber and Carbon Black for the shadow, blending it smoothly into the interior of the cup.

STILL-LIFE TEXTURES

Raw Umber

Ultramarine Blue

Manganese Blue Hue

Yellow Ochre

Carbon Black

Titanium White

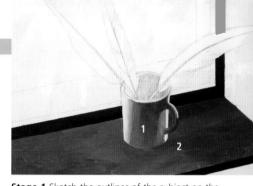

Stage 1 Sketch the outlines of the subject on the canvas. Paint varying tints of Carbon Black mixed with Ultramarine Blue in the darkest geometric forms of the wall, shelf edge and window frame.

1 Use lighter tints of the Carbon Black and Ultramarine Blue mixture with more Ultramarine Blue for the cup, establishing the dark shadow in the middle of the cup and handle.

2 Apply tints of varying mixtures of Raw Umber and Yellow Ochre on the shelf.

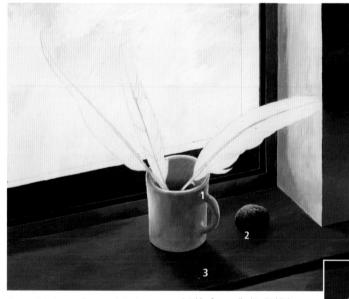

Stage 2 Paint a mixture of Carbon Black and Ultramarine Blue in the rest of the window frame. Paint a pale tint of this mixture in the window area and the lighted wall on the right side of the window.

- **1** Add a few small white highlights to the cup.
- 2 Paint the rock with a stippled texture made with tints of Carbon Black, Raw Umber and Yellow Ochre in a variety of combinations.
- 3 Add another layer of the mixture previously used on the shelf. Paint shadows on the shelf with a thin layer of Carbon Black and Raw Umber.

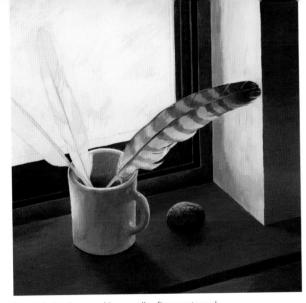

Stage 3 Continue making small refinements and adjustments on the shelf, wall, window and cup, and start to paint the striped feather.

1 Delicately paint the striped feather with soft blends of Raw Umber, a tiny amount of Carbon Black and Titanium White.

2 Allow a few separations in the feather to show, but do not make any coarse brushstrokes so that the soft feather contrasts with the stippled texture of the rock and the hard, smooth surfaces surrounding it.

Stage 4 Paint the two brown feathers with tints of Raw Umber mixed with a small amount of Carbon Black. Notice that these feathers have more pronounced separations than the striped feather. However, they are still delicate and softly blended, so avoid coarse brushstrokes and harsh colour transitions

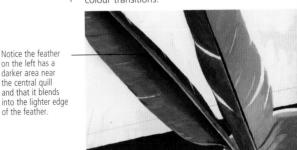

Stage 5 Add the missing details of the window frame with the mixtures previously used for the window frame. Use loose, painterly strokes to complete the window itself, which shows glare from the light, obscuring the scene beyond. Varying tints of Carbon Black mixed with Ultramarine Blue serve this purpose well.

> Notice how the feathers in the cup appear to occupy space. The textures of the feathers contrast with the hard, reflective surface of the cup. and the roughness of the rock.

Even the smooth surface of the window contrasts with the duller smooth surface of the shelf and the slight texture of the wall. The angled light and contrasting textures make this still-life painting anything but dull despite the understated low-chroma palette used.

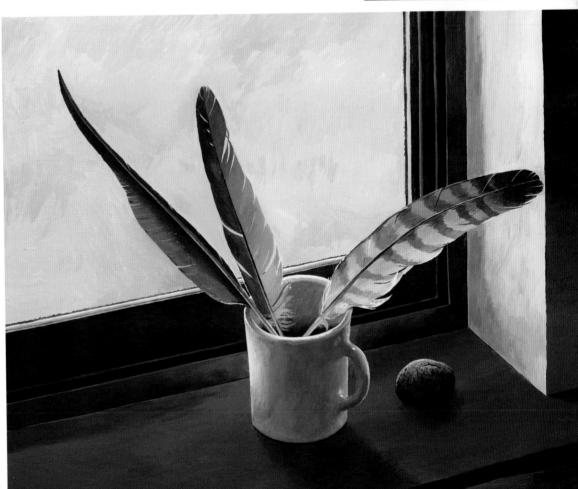

Notice the feather

on the left has a darker area near

the central guill

of the feather.

and that it blends

Gallery: Still life

Still-life painting opens up a tremendous variety of options beyond the traditional fruit-in-a-bowl concept. Learning to observe, to see everything with fresh eyes. can lead to unusual and interesting paintings. Still-life subjects can be so varied that they abound with opportunities to freely play with colour.

Constellation Lorena Kloosterboer

Marbles glow with scintillating colours and the light moving through them creates lively shadows as well. A tinted ground of light grey gesso forms the background that enhances the bright colours used in these marbles.

Main palette

Payne's Grey, Titanium White, Cadmium Red Cadmium Yellow. Cobalt Blue and Cadmium Orange

Other key colours Burnt Umber, Brilliant Light Green (Phthalo Green variation), Burnt Sienna and Cerulean Blue

Multiple layers of thin glazes were applied to create the glowing play of colour shown in this detail from the painting. Precise control with acrylics can develop a rich and beautiful appearance.

Rainbow of Buoys Lou O'Keefe

Of course, opaque subjects can also be painted in lively colour as these buoys demonstrate. Outlining them in black and applying the paint loosely in patches of broken colour gives an almost stained-glass radiance to this painting. Softened and irregular highlights contribute to the look, which would not be nearly as radiant if most of the colours were low chroma instead of the high-chroma ones chosen here.

Alizarin Crimson Hue, Ultramarine Blue, Phthalo Blue Green. Phthalo Turquoise, Dioxazine Purple and Titanium White

Other key colours

Cadmium Orange, Cobalt Blue, Cerulean Blue, Quinacridone Violet, Opera Rose and Quinacridone Nickel Azo Gold

Sunshine Sonata Lorena Kloosterboer

An unusual point of view establishes drama in this painting, accentuated by the diagonal placement of the faceted crystal vase. Both glass and water refract light, distorting the stems and flowers in arresting colour patterns. The colours chosen harmonise well, with blues blending into greens that in turn blend into yellows. Everything was painted with tight control in multiple thin glaze layers. Mid-range values predominate but a few strong darks and white highlights bring additional visual impact to the subject.

Main palette

Titanium White, Cobalt Blue, Cadmium Yellow, Lemon Yellow, Brilliant Yellow Green (Phthalo Green variation) and Sap Green

Other key colours

Pale Olive, Phthalo Green and Hooker's Green

By the Window Rosina Flower

An interesting approach to painting flower bouquets is shown in this loose and abstracted still life. Softly blurred edges with plenty of white added to the yellow background tints establish a look suffused with light. Light violet across the foreground is a fitting complement to the yellow. Bright splashes of blue and magenta continue the light and airy look with only the foliage adding darker values to the painting.

Sew What? Joseph Krawczyk

Complete understatement can be used to create a powerful image. In this painting all bright, high-chroma colours have vanished, leaving only a subdued red spool and its equally subdued complementary green spool as the focal point. Warm browns with a hint of golden light are used in the chair and basket. The suggestion of an extremely neutralised green floor disappears into intense dark shadow. This colour handling establishes a softly introspective mood.

Main palette

Black, Burnt Umber, Cerulean Blue, Burnt Sienna, Raw Sienna, Naples Yellow, Yellow Oxide, Burnt Umber, Cadmium Red and Light Green

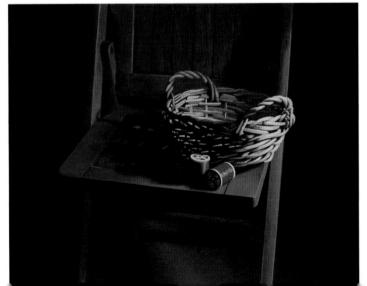

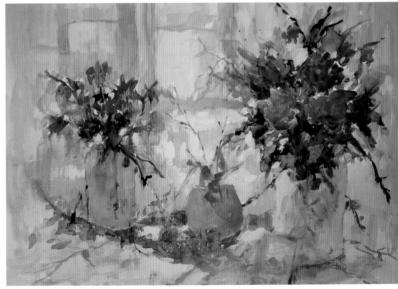

Main palette

Quinacridone Magenta, Lemon Yellow, Dioxazine Purple, Titanium White. Ultramarine Blue and Cadmium Red

Other key colours

Cobalt Blue, Titanium White, Cadmium Yellow and Yellow Ochre

Animals

Animals are engaging subjects for the artist, offering live personalities combined with colourful fur, feathers, scales and other textures so delicious to paint. Eyes command attention, and the light falling across the animal can evoke any mood you want to create

In truth, painting animals is not really different from painting any other subject. Appropriate colour schemes have to be selected, the source of light has to be understood and visually communicated, and the chroma, hue and values of the painting have to be properly rendered. Texture is a component that is helpful in creating surface contrasts, such as the difference between the smooth skin of a nose and the roughness of fur.

With any living creature, in most cases the eyes are of crucial importance in a painting. We automatically gravitate towards eyes, looking into them wherever possible. Inviting the viewer into the eyes of your animal subject is an excellent way of getting and holding their attention.

Eyes pose a particular challenge in that light falls across them, creating shadows, the surface is moist, and the colours in the eye have to be integrated into the rest of the painting to be convincing. Most of the time, eyes look lifeless until just the right highlights are added, making the animal suddenly 'see' and engage the viewer.

PAINTING A BLACK DOG

Painting black fur effectively requires the artist to stop making assumptions and actually look at colour. If a black dog is painted entirely in black, a cartoon silhouette results. As you know from the section on colour temperature (see page 70), black can be either cool or warm. The dog in this example has predominantly cool black fur, so the colours are selected accordingly. Ironically, considerably more Titanium White than Carbon Black has been used to paint this black dog.

Indanthron Blue

Raw

Quinacridone

Yellow Ochre

Carbo

Quinacridone Gold

Titanium White

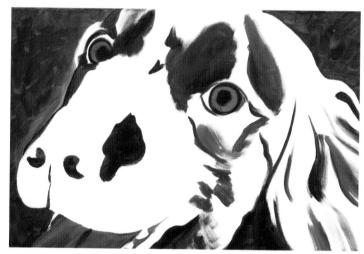

1 Paint the background with Yellow Ochre and Raw Umber. Indanthrone Blue should mark the deepest shadows, and use more of the Yellow Ochre and Raw Umber mixture in the eyes. Apply a little Quinacridone Rose with Raw Umber to the tongue.

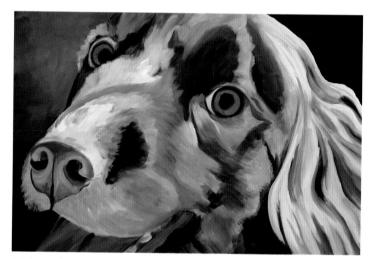

2 Paint varying mixtures of Indanthrone Blue, Raw Umber and Titanium White over the background. Paint the rest of the fur and nose in tints of Indanthrone Blue. Paint the mouth with more Quinacridone Rose. After the paint is dry, apply a layer of Regular Gel Medium to the fur with a stiff hog-bristle brush, making texture following the direction of the hair.

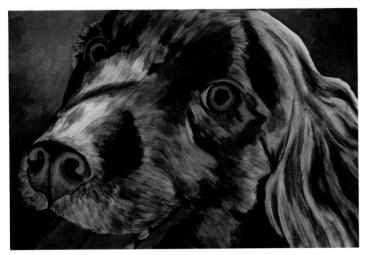

3 Once the Regular Gel Medium is dry, paint varying tints of Raw Umber and Indanthrone Blue over the fur, allowing the gel texture to help create the illusion of hair. Use the same mixture for the nose, which remains smooth. Add Quinacridone Gold to the eyes. Reduce the values in the mouth to throw it more into shadow. After drying, apply another layer of Regular Gel Medium to the fur to increase and vary the texture.

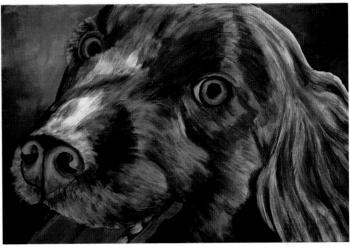

4 Work on the fur, adding more tints of Raw Umber. At this point, the fur could be completed by using Indanthrone Blue and Raw Umber only, without the use of black paint at all, but in this example, the author chose to use a little Carbon Black in step 5 to intensify the value contrasts. Add a final layer of Regular Gel Medium texture to the fur before proceeding to that next step.

The highlight on the nostril area is not a bright white but is instead blended into the dark shadows to show a continuity of form and show the texture of the skin on the nose.

5 Add a tiny amount of Carbon Black to the deepest shadows in the dark areas of the eye, recesses in the depth of the nostrils and the darkest shadows in the fur. Add highlights in Titanium White. Notice how the highlights in the eyes bring the happy playfulness of the dog to life.

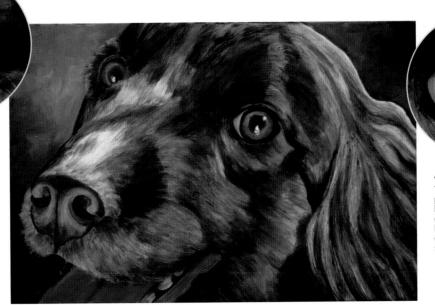

The highlights in the eye are painted with Titanium White, but not with hard-edged splats of white. Instead they are blended to show the diffuse edge of a highlight on the wet surface of the eye.

Gallery: Animals

Animals present the artist with the challenges of painting fur and feathers in a convincing way. Even with that under control, unless the creature is seen at a distance, the eyes still have to be painted in a manner that properly conveys the spirit of the animal. Notice the many variations possible in painting fur, feathers and eyes.

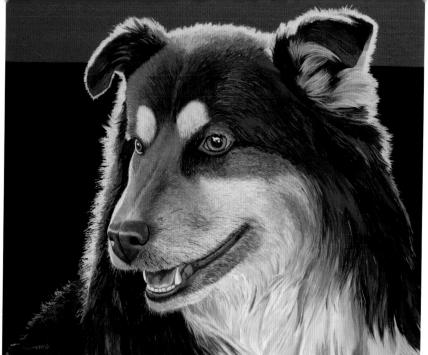

Main palette

Raw Umber, Carbon Black, Dioxazine Purple, Cobalt Turquoise, Cobalt Teal, Cadmium Yellow Medium and Titanium White

Other key colours

Cadmium Orange Medium, Cadmium Red Medium and Manganese Blue Hue

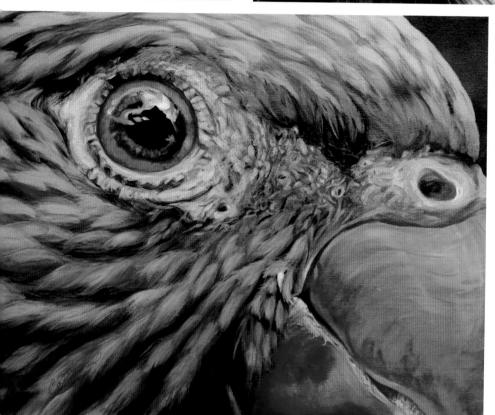

Colorplay Bern Sundell

In contrast to Ginger (see opposite) this dog is painted with realistic detail but with higher-chroma colours that startle with their unexpectedness. Turquoise greens complement the small but intense red areas and the softer yellow backlighting complements purples in the fur. Notice the eyes once again. The painting of Ginger has softly rendered eyes in keeping with the quiet colours in that painting, whereas these eyes are sharply delineated with white highlights against black pupils. These white highlights create quite a spark of life in this dog.

Loki Carol Anna Fullerton-Samsel

In order to provide strong contrast, the artist first underpainted the feathers with black before adding the other colours. Notice the lively look of the eye, in part achieved by the use of strongest value contrasts in the painting. Placing the white highlights correctly in the eye is critical in the process of making the eye radiate the spirit of the animal. Oranges in the beak and eye were chosen to complement the blues in the feathers while pale lilac highlights in the feathers complement the yellows at the nostrils. High-chroma colours are enhanced by proximity with lowerchroma colours, and high-chroma colours dominate this painting.

Main palette

Ultramarine Blue, Phthalocyanine Blue, Cobalt Blue, Yellow Oxide, Cadmium Yellow Medium and Cadmium Red Medium

Other key colours

Ouinacridone Red. Phthalocyanine Green. Burnt Umber, Raw Sienna and Hansa Yellow Light

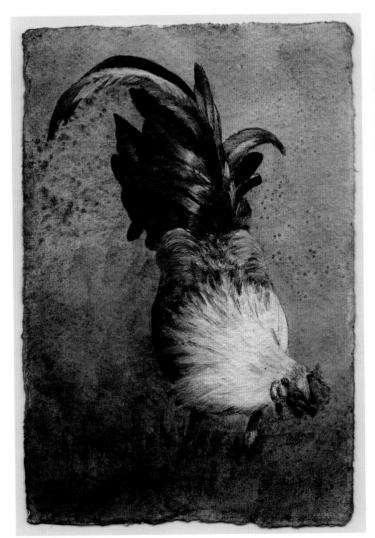

Portrait of Posh Paul James

An exploration of the varied textures of fur and nose skin led to this richly painted bovine. Cadmium Yellow, Orange and Red mixtures were adjusted with siennas, umbers and ochres. The artist deftly handled Burnt Sienna without creating an unpleasant chalky pink, a common occurrence when Burnt Sienna mixes with white. Subtle touches of violet, turquoise and blue add life to the animal. Notice the deep black in the eyes and nose, yet the small highlights placed in the cow's eyes bring out the spirit of this animal effectively. Strong value contrasts are used in this painting.

Main palette

Titanium White, Ivory Black, Mars Black, Burnt Umber, Burnt Sienna, Raw Umber, Cadmium Orange, Yellow Ochre, Lemon Yellow and Cadmium Yellow Deep

Other key colours

Cadmium Red, Cadmium Red Deep, Deep Violet, Cobalt Turquoise and Ultramarine Blue

Main palette Ultramarine Blue, Burnt Sienna, Titanium White, Hansa Yellow and Ouinacridone Red

Rooster Kiana Fecteau

The feathers of this bird were painted in a completely different manner than the feathers in Loki. The choice of watercolour paper as substrate allowed soft washes of colour. Subdued low-chroma colours were chosen, even for the comb and wattles of the bird. Value contrasts in the tail feathers were used to effectively indicate the iridescence of those feathers. Near-whites in the neck and shoulders of the bird contrast with the blacks of the tail, adding emphasis to the rooster.

Ginger Barbara Louise Pence

The fur in this dog was painted altogether differently than the cow (see above right). Burnt Umber and Raw Sienna were neutralised with Dioxazine Purple. The white fur has a considerable amount of blues and purples for the shadows as well as a few greens. These complements of blue versus orange and purple versus yellow are applied in fairly low-chroma glazes made with matt medium. Matt medium is made matt by the inclusion of Titanium White particles to opacify the acrylic emulsion. This further subdues the colour while adding richness by using multiple layers of semi-transparent glazes.

Main palette

Transparent Burnt Umber, Raw Sienna, Dioxazine Purple, Yellow Ochre, Sap Green and Titanium White

Other key colours Ultramarine Blue and Alizarin Crimson Hue

Landscapes and trees

Landscapes challenge the artist to create the illusion of depth, of distance, in the painting. Since so many landscapes have green foliage, they also challenge the artist to develop skill in handling natural-looking green mixtures.

By adhering to simple principles, a complex painting that shows different layers of distance can be painted. Correct selection of the palette goes a long way to creating an effective landscape painting, so choose your colour scheme with care.

A major concern is that of values. Value contrasts are more extreme in the foreground at the bottom of the painting and diminish gradually into the distance, where they lose both strong dark values and brilliant highlights.

The next principle to keep in mind is that a bluish haze can be seen in far distant areas of the landscape due to the atmosphere of the Earth. This bluish haze diminishes and colours gradually become higher chroma as they approach the foreground.

HANDLING VALUES IN A LANDSCAPE PAINTING

Cerulean

Green Light

Ultramarine

Precise handling of values is vital to the success of a landscape painting. Values communicate distance and establish the positional relationships between different areas and objects in the landscape.

The reference photo for this painting from page 79 in Choosing and using a colour scheme is shown converted to grayscale. If the reference photo you are working with has excessively darkened shadows when converted to grayscale (as this one did originally), the loss of detail can be problematic. This photo was lightened in Photoshop to restore the detail, but it is good practice to properly observe the landscape (or take a 'mental' picture) when you are taking the photo, since a camera's dynamic range is the range of values it can display in a photo and this range typically is not as extensive as our own eyes can perceive.

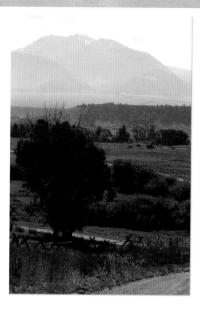

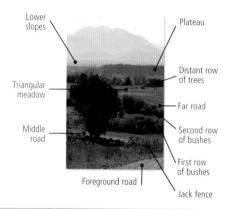

Different parts of the painting are labelled for easy reference in the following painting stages.

MIXING BLUES AND YELLOWS TO MAKE GREEN

Mixing blue and yellow paints to make green can be a viable option in landscape painting. As always, you must be able to reduce chroma in the mixtures to use them effectively. Painting mixtures directly onto heavy watercolour paper can quickly reveal the potentials of different palette combinations.

Hansa Yellow Medium blends into Phthalo Blue (Green Shade), Both of these pigments are high-chroma, semitransparent colours. The blue is so powerful it takes a lot of the yellow to change it into this attractive green.

Permanent Red blends into a green made from Hansa Yellow Medium and Phthalo Blue (Green Shade). As the complement of the mixed green, Permanent Red can be used to reduce chroma in the green.

Cadmium Yellow Medium makes a more subdued green mixed into Ultramarine Blue. Cadmium Yellow Medium is an opaque paint and Ultramarine Blue is semi-transparent.

Quinacridone Crimson is used to reduce chroma in the green mixed at left. Although Quinacridone Crimson is a complement to the green, the blend is reddish in appearance. It is useful to test different complements, as the pigments do not always behave in the ways suggested by colour theory

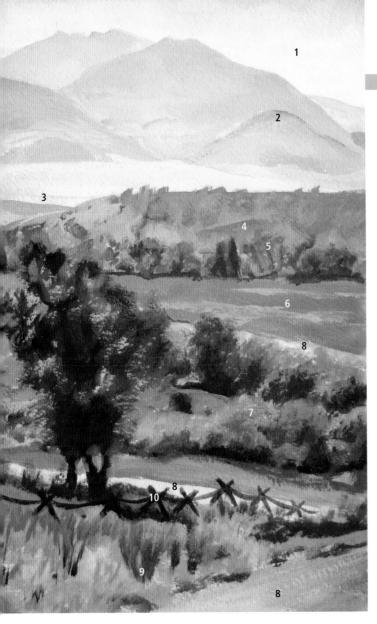

Stage 1 Paint the entire surface of the watercolour paper to roughly establish the placement and general colour of the areas of the painting.

- **1** Start at the top with Cerulean Blue and plenty of Titanium White for the sky.
- **2** Paint the mountain shapes with tints of Ultramarine Blue.
- **3** Add small touches of tinted mixtures of Ultramarine Blue and Chromium Oxide Green, making it quite pale on the lower slopes of the mountains.
- **4** Darker tints of Chromium Oxide Green and Ultramarine Blue create the plateau. Add a tint of a little Raw Sienna in the lighter areas of the plateau.
- **5** With the distant row of trees introduce a little Raw Umber into the varying mixtures of Chromium Oxide Green, Ultramarine Blue and Raw Sienna and Titanium White.
- **6** Paint the triangular meadow primarily with tints of Permanent Green Light, Chromium Oxide Green and Raw Sienna with a small amount of Bismuth Yellow.
- 7 Use more of these mixtures for the rows of bushes and grassy areas between the middle and far roads and the tall foreground tree. Add Raw Umber with Ultramarine Blue for the shadows.
- **8** Paint the middle and far roads with tints of Raw Sienna. Paint the foreground road with varying mixtures of Raw Sienna, Raw Umber and Titanium White.
- **9** Add the weeds and grasses in the foreground with more of the tinted mixtures of Chromium Oxide Green, Permanent Green Light, Raw Sienna, Raw Umber and Bismuth Yellow.
- 10 Paint the jack fence with Raw Umber.

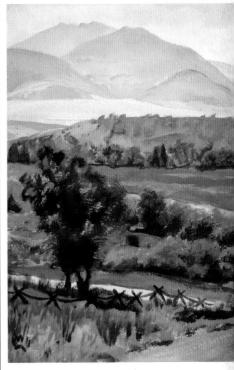

Stage 1 (grayscale) The first stage of the painting involves covering the entire surface with paint, roughly establishing the placement of different objects and areas of the landscape. Value relationships are incorrect but future layers of paint will correct and refine them. The main thing is to cover the glaring white of the paper or canvas so it no longer distracts the eye.

Cerulean Blue is opaque and combines with Hansa Yellow Medium to make a fairly low-chroma green mixture. This can be useful in landscape paintings.

A yellow-green mixed from Hansa Yellow Medium and Cerulean Blue is modified by Quinacridone Rose. Quinacridone Rose is the complement for yellow-green, which should create a neutral, but this is a more earthy than grey neutral.

The Hansa Yellow Medium and Cerulean Blue mixture has been blended with Raw Sienna. Notice how this pigment modifies the green in an earthy way that can settle naturally into a landscape painting.

A different earthy mixture results from blending Raw Umber into the green made from Hansa Yellow Medium and Raw Umber. This combination also could fit very well into a landscape painting.

Yellow Ochre has been blended into Ultramarine Blue to make a low-chroma green differing in appearance from the other mixtures shown here. For landscape painting, modifying green mixtures with any of the earthy pigments can be useful in creating a natural look.

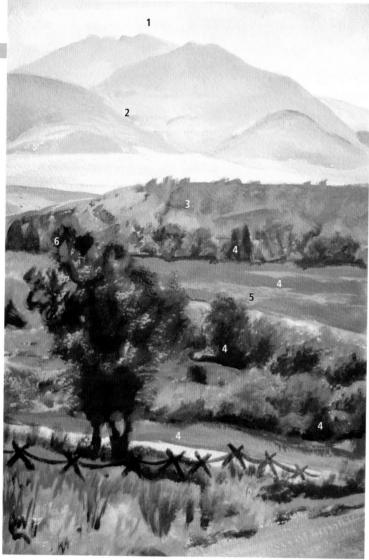

Stage 2 Now that the colours in the painting are roughly established, refining can begin.

- 1 Repaint the sky, making whiter clouds behind the mountains to add a little more contrast.
- 2 Define the shapes of the mountain shadows with tints of Ultramarine Blue and Chromium Oxide Green to create more interest in them.
- 3 Continue using the previous mixtures in the plateau but add more tints of Raw Sienna to the exposed dirt to lighten the look of it. Be sure to either
- mix a little Ultramarine Blue into these tints or glaze over them to keep the atmospheric look of blue in the distance. The Raw Sienna brings it closer to the viewer than the distant mountains, but it is far enough away to still need some blue.
- 4 The far row of trees, both rows of bushes and the meadow and grassy areas need serious repainting. Use Raw Umber with Ultramarine Blue for the darkest shadows and carefully decrease their darkness the further away in the landscape they appear. Use more Raw Sienna in the far row of trees than the two rows of bushes to reduce chroma in the greens. This also adds to the illusion of distance.
- 5 Add more Bismuth Yellow and Raw Sienna to the green mixtures in the triangular meadow as it is too dark in value. Take care to create a progression of lower-chroma greens in the distance to more vivid greens nearer the viewer. Using more Bismuth Yellow and Permanent Green Light nearer the viewer enhances this effect. A 'bad hair day' paintbrush helps stipple the foliage in the bushes and the tall foreground tree.
- **6** The tall tree needs repainting with more Chromium Oxide Green and a little Permanent Green Light to make the foliage more variegated and interesting.

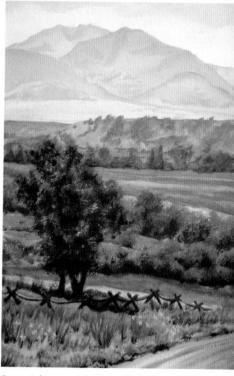

Stage 2 (gravscale) Creating distance in the different parts of this extensive landscape is based on the principle that the strongest value contrasts will be nearest the viewer and diminish as they recede into the distance. This means the strongest darks and lights must be created in the foreground, although this may be done in multiple stages or layers of paint. More distant parts of the painting should be lighter in value but also lack brilliant highlights. Adjustments in this step of the painting include

lightening the values of the plateau and graduating the values from the first row of bushes to the distant row of trees so the landscape appears to steadily recede as the shadows become paler. Define the mountains with a little more contrast than the reference photo for visual interest. The lower slopes of the mountain are more brightly sunlit and lighter in value than the shadowed, more vertical. shapes of the mountains themselves.

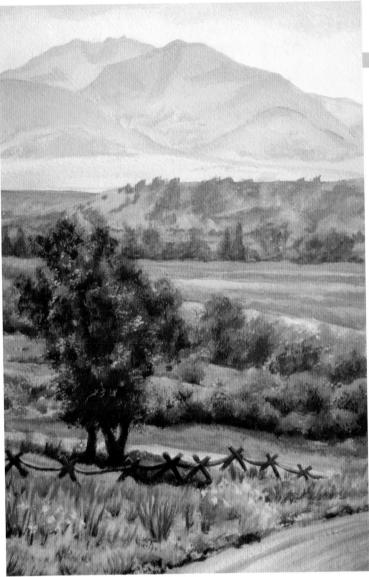

Stage 3 Continue to refine the details to complete the painting.

- 1 Refine the area just beyond the far row of trees before the plateau rises to imply additional meadows and shrubbery. Notice that the degree of detail gradually increases from the haziness of the distant mountains to the foreground. So, keep the detail beyond the row of trees a bit vague to assist in creating the sense of distance.
- **2** Paint pale tints of Bismuth Yellow across the triangular meadow to create the swathes of blooming mustard.

- **3** Refine the two rows of bushes and the grassy areas around them.
- **4** Adjust the middle road with a darker tint of Raw Sienna.
- **5** Paint the foreground road with more distinct indications of tire tracks, using more Titanium White in the brighter areas of the road.
- **6** Add more detail and more contrast in the weeds and grasses in the foreground.
- **7** Splashes of Bismuth Yellow make good flower accents to increase the illusion that the foreground is close to the viewer.

- 8 Repaint the jack fence, adding a little Raw Sienna to soften the dark Raw Umber cross braces and poles in the sunlit areas. A tint of Raw Sienna can be used for the highlights on them. Leave the cross braces and poles dark in the shadow of the tree.
- 9 Increasing the shadows and highlights in the foreground adds more contrast, bringing it closer to the viewer. By using only two green paints modified with Raw Sienna, Raw Umber and Ultramarine Blue, a harmonious landscape painting results. All the parts of the painting are naturally related to each other through colour, and colour itself is used to create an illusion of layers of distance moving backwards in the painting.

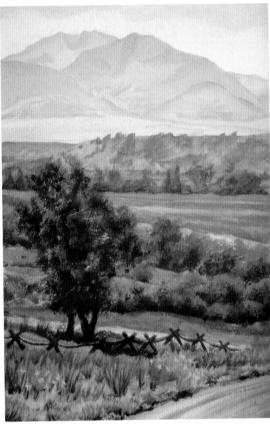

Stage 3 (grayscale)

Further refinements of value include adding lighter areas in the triangular meadow and continuing to adjust foliage in the trees and bushes. The tall tree in the foreground must be darker than the other bushes and trees as they recede from the viewer, but the tree needs more detail in the foliage than the original photo reference. Define the jack fence with highlights in the sunny areas, lightening the overly dark cross braces and poles in the process. Leave them darker without highlights in the shadow of the tree. Notice that the jack fence is slightly lighter in value where it disappears down the hillside. Darken the values in the middle road, as it remained far too bright in the previous stage. Add lighter values to the foreground road. The weeds along this road must have pronounced value contrasts with some strong shadows and brighter highlights in order to be convincing to the eye.

Gallery: Landscapes and trees

Painting landscapes poses all manner of challenges. The ever-changing skies, seasonal colour changes in trees and other plants across the land, the shapes of the land itself, how it reflects in water, and the way light slants across the scene may all have to be integrated into a finished work of art. Learning how to see the way colour can communicate all these factors is an art in itself.

A landscape always starts with light. What are the qualities of the light? Is it early or late in the day with softly slanting rays leaving great shadows? Is it burning midday with great intensity? Is it summer, winter or another season? Each season brings its own qualities of light.

Nothing kills a painting faster than internal contradictions in how the shadows fall, so consider the direction of the path of light. Really look at the light and know how it works with the landscape and trees you wish to paint.

The more northerly and more southerly hemispheres register strong colour changes with the seasons. Yet, even as one moves nearer the equator, changes in light through the seasons can still be seen and understood.

Incorporating trees into a landscape requires an understanding of the structure of trees and how that structure catches the light. With deciduous trees, the appearance changes dramatically when the leaves change colour in fall and even more when they are gone in the winter. How do the trees fit with the rest of the landscape?

Throughout this process, great attention must be given to the handling of value and chroma. Landscapes usually show distance, which is most easily communicated by value changes and chroma changes. Understanding them makes a big difference.

Fractured Landscape Jennifer Bowman

This artist dispensed with almost all detail in order to explore vibrant colour in the landscape. Blues are complemented with splashes of bright orange. Duller reds in the trees of the upper background complement in a quieter way the medium-chroma greens of the foreground. The greens give way to lively patches of yellow-greens and yellow-oranges. Tiny hits of purple accent those masses of yellow mixtures. This painting is simply a beautiful dance through the palette.

Main palette Indian Yellow, Cadmium Yellow, Rich Green Gold, Alizarin Crimson Hue and Titanium White

Other key colours Cadmium Red Light, Phthalo Blue and Cadmium Orange

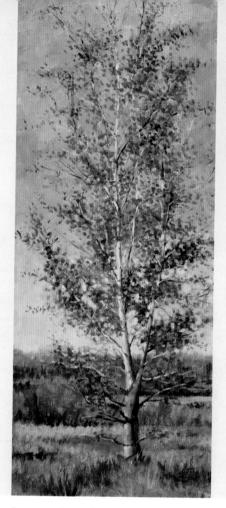

Sycamore Jason Sacran

When graced with leaves the apparent form of the tree changes, with masses of foliage altering the shape. The structure of the trunk and branches is still present, complete with their expected shadow patterns. Some artists prefer to paint the entire branching structure before adding leaves. The sunlight has to highlight the leaves in a manner that fits with the shadows on the trunk and branches of the tree as well.

Main palette Ultramarine Blue, Viridian Green, Hooker's Green, Cadmium Orange Medium and Titanium White

Other key colours Cadmium Yellow Light, Alizarin Crimson Hue and Ivory Black

Summer Park Frederick G. Denys

In groupings of trees, foliage intermingles with lost and found edges so that it may not be immediately obvious which leaves belong to which tree. The trees themselves alter the light as well. Notice the dappled light falling through the leaves across the foreground trees, the grass and the path. The brightly lit areas on the trunks of the foreground trees change in hue, chroma and value. A naturalistic handling of the varied greens of the foliage provides much of the beauty of this painting, along with the strong value contrasts.

Straying Sheep Joe Hush

When the leaves have fallen, the branching structure of a tree is clearly revealed. The tree grows in a fractal pattern, taking the shape of the trunk with its branching arms into increasingly smaller and more delicate versions until the twigs are lace against the sky. Notice how the large tree on the right of this painting is shadowed on the right sides of the trunks and branches and illuminated on the left with lighter values.

Main palette

Permanent Green, Chromium Oxide Green, Green Gold, Ultramarine Violet, Burnt Umber, Raw Umber and Titanium White

Other key colours

Quinacridone Burnt Orange, Cadmium Yellow Medium and Carbon Black

Main palette

Cerulean Blue, Ultramarine Blue, Burnt Sienna, Raw Sienna, Chromium Oxide Green. Perylene Green and Titanium White

Other key colours

Raw Umber, Cadmium Red Deep and Green Gold

Mountain Waterfall Frederick G. Denys

Notice how the small sliver of sky across the top and the large shadow across the middle of this painting create the impression that we are deep in a canyon. The palette in this painting is that of fall with earthy tones and rich orangegolds. In the foreground are high-chroma aspens with strong value contrasts. Some of the individual branches and leaves are visible. As the eye moves upwards through the painting, the mountain moves up and away into the distance. Shadowy silhouettes of conifers mark their presence without much detail. The colourful aspen trees become colourful masses instead of individual trees and then disappear altogether. The conifers continue into the far distance until they are mere dabs of a paintbrush.

Ultramarine Blue. Yellow Ochre, Cadmium Yellow Light, Burnt Umber, Ouinacridone Burnt Orange and Titanium White

Other key colours Buff Titanium, Raw

Umber, Olive Green and Carbon Black

Landscapes do not necessarily have deciduous trees and flat meadows. This dramatic desert scene features a purple-hued mountain looming beyond a ridge covered with desert scrub. Darkest values are found in the foreground and in the silhouette of the tall cactus. This imposing saguaro is further emphasised by a sunburst of white light streaming through the pale sky. The warm earthy browns and subdued greens of the ridge are backlit with highlights around the shrubs and small cacti. Careful attention in using values that express the direction of light contribute to the impact of this painting.

Main palette

Cerulean Blue, Ultramarine Violet, Ultramarine Blue, Burnt Sienna, Carbon Black and Titanium White

Other key colours

Cadmium Yellow Light and Cadmium Yellow Medium

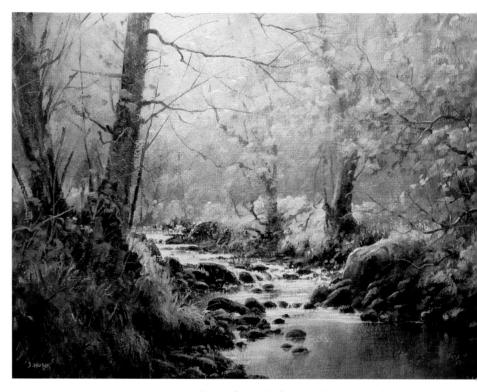

Main palette

Titanium White, Ultramarine Blue, Cadmium Red, Burnt Sienna, Raw Sienna and Cadmium Lemon

Other key colours

Red Iron Oxide, Yellow Ochre and Cadmium Yellow

First Colour - Holystone Burn Joe Hush

The yellow-green of emerging spring leaves sets the mood for this impressionistic painting. The palette is simple – greens and earthy browns with a little blue-grey. Darker values in the rocks and trees nearest the viewer establish distance. The soft blue-greys and less-defined tree trunks and leaves blend into that distance. A much paler blue-grey is used to paint the sparkling water of the creek, drawing us into the middle of the scene. No white highlights are used, keeping a soft glowing look to the painting.

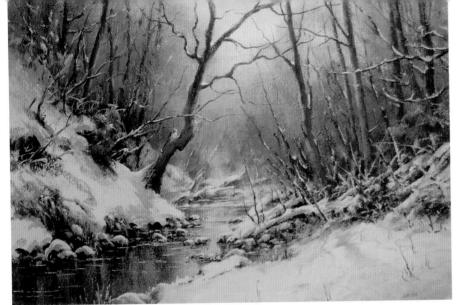

Winter Trees Joe Hush

The palette in this impressionistic painting is a simple one, mixing a few paints into neutralised purples and yellows, oranges and earthy browns. The sharply outlined trees in the foreground of the painting recede into diffuse clouds of muted purple woods in the distance. The subtle reflection of the orange and yellow sky in the creek and the last orange highlights from the setting sun are not enough to warm this snowy scene. The snow itself is luminous, with pale yellow in the brighter areas and subdued purples in the shadows – complements that impart a subtle vibrancy. No pure whites are used, which creates a soft landscape.

Retired Jason Sacran

A setting summer sun illuminates the left side of the woods beyond the meadow. The golden orange glow spreads across grasses, diminishing in strength as it approaches the old tractor on the left. Neutrals visually indicate the age of the retired vehicle. Except for the glow from the setting sun, the painting is characterised by neutralised colours with only a few slightly brighter greens in the foreground.

Main palette

Cadmium Yellow Light, Cadmium Orange, Cadmium Red Medium, Alizarin Crimson Hue, Viridian Green and Ivory Black

Other key colours

Titanium White, Yellow Ochre and Ultramarine Blue

Main palette

Titanium White, Ultramarine Blue, Cadmium Red, Red Iron Oxide, Burnt Sienna, Raw Sienna and Cadmium Yellow

Other key colours

Alizarin Crimson Hue, Hooker's Green, Phthalo Blue and Ivory Black

Main palette

Indian Yellow.

Cadmium Yellow,

Dioxazine Purple

and Titanium White

Birches Jennifer Bowman

This lively fall painting is lush with warm yellows, oranges and reds. With a full palette in use, the complementary purples, blues and greens increase the brightly vibrant effect. High-chroma hues are used with very few neutralised colours. Plenty of white adds brilliant highlights. Notice the relaxed and casual brushwork in the detail and how it adds to the overall sense of freedom with colour.

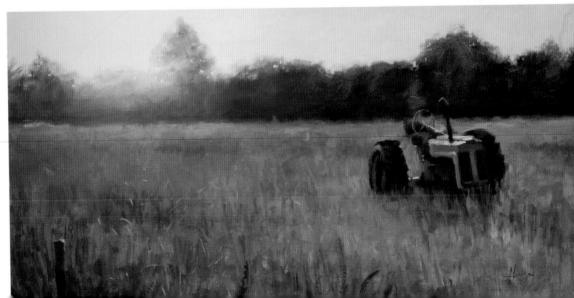

Portraits and figurative painting

The human form in movement and stillness pervades our memories, our present and our future. Indelibly inscribed in our minds are the faces and gestures of those we know well. Painting the human figure naturally resonates deeply in our beings. Bringing this impulse into colourful expression can be a challenge, but an immensely satisfying one.

Figurative painting can initially be more difficult than painting, say, a teacup or tree. Correct proportions may elude the artist and skin colour can be baffling. In order to help you work out what colours to use to paint skin tones, observe the skin of everyone you meet during the day and look for colour. Start identifying as many hues as you can and you will be startled at the wide variety of colours you see.

Palette choices for skin colours should harmonise with the entire palette for the painting. One set of paints for skin colours may be chosen for a painting using cool colours and another set altogether for a painting of the same person using warm colours.

Painting sample swatches on heavy watercolour paper can help you understand how to use your paint choices effectively. Experiment with as many combinations as you can imagine for skin colours with a wide variety of paints so you become comfortable using your entire palette as needed.

EXAMPLE OF A CASUAL PORTRAIT

A relaxed portrait of a man in a battered hat is the subject of this casual portrait. A limited palette emphasising earth tones conveys the outdoorsy nature of the man and the setting.

Stage 1 Paint the shadows of the shingles with Raw Umber. Mix Raw Umber and Chromium Oxide Green and loosely indicate the shadows in the hat and jacket.

- 1 Mix Raw Umber, a little Carbon Black and a little Titanium White to indicate the beard and moustache.
- 2 Use Raw Umber for the glasses and mouth.
- **3** Mix varying tints of Raw Umber, Yellow Ochre and Raw Sienna and block in the shirt.

Stage 2 Paint the shingles with tints of Raw Sienna. Add tints of varying combinations of Raw Sienna and Yellow Ochre with a little Raw Umber. Add a few areas of Raw Umber with Carbon Black and a little Titanium White.

- 1 Combine Chromium Oxide Green with Raw Umber and Yellow Ochre in varying tints for the hat and jacket.
- **2** Paint the hat band in tints of Raw Umber.
- **3** Rough in the eyebrows and beard with tints of Raw Umber mixed with a little Carbon Black.

4 Establish the skin tones with mixtures of Raw Sienna with a little Yellow Ochre and Raw Umber in varying tints.

Raw

Chromium Oxide Green

Yellow Ochre

Cadmium Orange Medium

n Quinacridone

Quinacridon Rose

Titanium

White

ISSUES IN PORTRAIT PAINTING

Prior to the widespread use of the camera, portraits were valued as the only way to capture and preserve the likeness of an individual. These ranged from elaborate, full-figure portraits to small, simple paintings.

Expression: Sitting for a formal portrait was a tedious business for the subject. A relaxed, unsmiling face became standard in portraiture because a smile quickly turned into a painful grimace during a prolonged sitting.

Teeth: Current arguments against smiles that show the teeth in a portrait revolve around the problems of painting the teeth themselves. Painting white teeth in

shadow without making them look stained can be challenging. Precisely defining each tooth adds too much intensity to the teeth if the shadow values are painted too dark. However, the mouth is a highly expressive part of the face. Saying the teeth should not be painted because it is hard to get the colour right is about the same as saying portraits should be painted with the subject's eyes closed because it is hard to get the whites of the eyes right. Developing a delicate handling of shadowed tints is a much better solution to this problem.

Scale: The issue of scale also has to be considered. We are so responsive to the human image that scale is more important in figurative and portrait painting

than other forms of painting. As a quick rule of thumb, life-size or smaller works quite well but painting someone larger than life-size provokes unexpected problems. If the image is only slightly larger than life-size, we find it makes us strangely uncomfortable because we are so accustomed to human beings around us. Once the figure is substantially larger than life-size, we can relax with the image.

Stage 3 Add a little Raw Umber to a mixture of Cadmium Orange Medium and Raw Sienna. Apply varying tints of this mixture to parts of the shingles.

- **1** Add more Raw Umber and Carbon Black to the shadows of the shingles.
- 2 Apply a mixture of Chromium Oxide Green, Raw Umber and Carbon Black to create the deepest shadows in the hat and jacket.
- 3 Work with varying combinations of Chromium Oxide Green and Raw Umber to paint the hat and jacket. Tint these combinations as needed to create the lighter areas.
- **4** Refine the shirt with the colours previously used.
- **5** Add Quinacridone Rose to some of the mixtures used previously for the skin and define the features further.

Stage 4 Continue refining the features with the mixtures previously used. Notice that subtle differences in the features are essential to capturing the essence of the person. Here, one eye squints a little more than the other and the mouth opens a little more on one side than the other.

- **1** Add highlights to the cheeks, nose and lower lip.
- **2** Repaint the glasses with Raw Umber mixed with a little Carbon Black.
- 3 Paint the beard and moustache with pale tints of Raw Umber and Carbon Black mixtures for the highlighted hair and with darker mixtures for the shadows.

Gallery: Portraits and figurative painting

Everything you know about colour in acrylics can be applied to painting the human form. Learning to observe nuances of light and shadow, the play of colour in skin tones and the range of values in your subject will go a long way towards creating powerful paintings of the human form. Portraits and figurative painting allow diverse palette choices and styles of painting, as we can see in the following examples.

Main palette

Nickel Azo Yellow, Quinacridone Burnt Orange, Quinacridone Gold, Raw Umber, Dioxazine Purple and Titanium White

Other key colours

Ultramarine Blue, Cadmium Red Medium and Cadmium Orange Medium

Peruvian Woman Lexi Sundell

This fairly low-chroma palette was built upon two pairs of complements; purple with yellow as the main pair and blue with orange as a lesser accent pair. The skin tones were painted in tinted glazes of Nickel Azo Yellow, Quinacridone Burnt Orange, Quinacridone Gold, Cadmium Red Medium, Raw Umber and Dioxazine Purple. A pale tint of Nickel Azo Yellow was used for highlights in the face and Dioxazine Purple was used in the darkest shadow areas. Notice how the highlights in the eyes bring them to life. Strong value contrasts characterise this painting.

Tying the Shoelaces Sera M. Knight Values in this softly impressionistic painting are kept in the mid-range. Purple and yellow are the main complements with blue and orange as a less-used pair of complements. The figure is painted with slightly more definition than the tutu. The silvery luminance in this painting arises from the combination of pastel colours and the loosely brushed radiating white areas. Layers of colour are painted with the freely applied brushstrokes only partially covering previous layers. For example, the high-key Cobalt Teal in the skirt mostly covered the underlying purple and was itself partially painted over with white. A sparkling airy look results.

Main palette

Dioxazine Purple, Cerulean Blue, Cadmium Yellow Deep, Cobalt Teal and Titanium White

Other key colours

Alizarin Crimson Hue and Cadmium Red Medium

Yellow Gown Linda McCord In this painting, we see precision and clearly defined edges in most areas, using a limited palette prominently featuring neutrals. The warm skin tones and pinkish grey in the background combine with the exaggerated yellow of the hair to add warmth to the painting. The neutralised green in the mirror softly frames the girl's face. Notice how the highlights on the gown are painted to give the impression of a shiny and slightly

Main palette Cadmium Yellow, Dioxazine Purple, Hooker's Green and Titanium White

stiff fabric.

Other key colours Cerulean Blue and Cadmium Red Light

Strings Linda McCord

The strong red in this background blends into dark shadows, giving a rich look to this scene of a man playing a harp. The dark values in the background allow the figure to be the main interest in the painting. Lighter values in the white shirt, hair and reflections in the glasses keep our attention focused on him. Soft blues and purple shadows in the shirt soften the look of the fabric – a fitting accompaniment to harp music.

Main palette

Quinacridone Burnt Orange, Cadmium Red, Cadmium Yellow Light, Phthalo Blue and Titanium White

Other key colours

Cerulean Blue and Dioxazine Purple

Paints and brushes

Choosing the right paints and brushes is important for the acrylic painter. The most wonderful paint in the world will give poor results if applied with poorquality, incorrectly shaped or incorrectly sized brushes. Conversely, poor-quality paints are no help with even the best brushes carefully chosen for the painting. So how do you know what to buy?

PAINT CHOICES

Acrylics are available in fluid and heavy-body format. Before buying either, know how you want to use them. Review pages 20–23 if you are not sure. Choose paints that work well for the way you want to paint.

Remember to buy high-quality acrylic paints, because student-grade paints are usually inferior in both pigment quality and pigment density. Student-grade paints only look like a bargain until you actually try to use them.

The Sundell Colour Wheel is a good painter's palette (see page 17). You could begin with those paints and a few earth colours, such as Raw Umber and Yellow Ochre, plus Titanium White and Carbon Black. It is wise to spend time getting comfortable using a basic palette to avoid overwhelming confusion with too many paints at first. Adding more paint choices later when you are ready to expand your palette is easy with the table of substitutes on page 17.

PAINT QUANTITIES

Quantity of paint becomes a question after you have decided on either fluid or heavy-body acrylics and the makeup of your palette. Paints are sold in sizes from 60-ml (2-ounce) tubes to 3.7-L (1-gallon) cans. Running out of paint in the middle of a painting is annoying, but so is finding half a jar of dried-up paint.

Unless you are starting with paintings several feet wide, buying 60-ml (2-ounce) tubes is a good starting point. A larger tube of Titanium White can be a prudent choice, as it is used almost constantly to make tints with the other paints. As you become familiar with how much paint you use, larger quantities of other colours might be useful.

Jars of paint can be an economical choice when larger quantities of paint are needed than tubes can provide. They are not as easily portable if you want to paint en plein air, that is, outdoors on location.

THE SECRETS OF THE PAINT LABEL

Hidden away on the label of quality acrylic paint is the answer to most of your questions, thanks to the ASTM, the American Society for Testing and Materials. The best manufacturers honour ASTM standards even though the law does not force them to do so. Information listing the generic name, common name and colour index number of the pigment or pigments is placed on the label so you can make sense of your paint choices. You can also find lightfastness ratings on the paint label or manufacturer websites, allowing you to select paints highly rated for longevity.

A tube of Ultramarine Violet

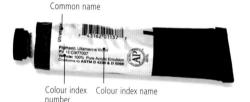

Sometimes the common name on the label is perfectly straightforward, such as on this tube of Ultramarine Violet.

Common name or manufacturer's name:Ultramarine Violet

Colour index generic name: Ultramarine Violet **Colour index number:** PV15 (P = pigment; V = violet; 15) = exact chemical composition of the pigment

A tube of Green Gold

Sometimes the common name has nothing to do with the generic name. Different manufacturers may use the same common name for different pigments altogether. The same pigment might also be used with different common names, so it pays to be observant. Looking carefully at the label, you can see that this particular tube of paint combines three different pigments.

Common name or manufacturer's name: Green Gold Colour index generic name: Nickel Azo Yellow + Arylide Yellow + Phthalo Green

Colour index number: PY150 + PY3 + PG36

MEDIUMS AND VARNISHES

Along with your paints, you will need to purchase any mediums, varnishes or other special products you wish to use in your paintings. A regular semi-gloss gel medium is a good general-purpose choice. Matt and glossy options can be used if preferred. Review the Pigment properties section if you are unsure of your needs (see page 18).

Varnish protects the surface of the dried acrylic film so that it will not suffer from embedded dust and dirt as time passes. It also gives an even reflective surface for your painting. Some paints, such as Anthraquinone Red, are naturally glossier than other paints because of the way the pigment behaves in the acrylic emulsion. Such variations disappear under matt, satin or gloss varnishes.

A plain paper plate serves as a functional palette. An apron and a Sta-Wet palette

SMALL BUT ESSENTIAL EQUIPMENT

Palettes are constantly in use and deserve proper consideration when furnishing your studio. As with everything else, choices abound. Let's look at the simplest and the most luxurious solutions for palettes.

A plain paper plate serves as a functional and budget-friendly palette. Saving paint for later use on it is difficult, but a piece of plastic wrap will suffice for a short time. Styrene plates stay stiffer than plates, which absorb more moisture. Spray your paints on the plate regularly with a fine mist from a spray bottle to delay them crusting into an unmanageable mess. Once they inevitably turn into that crusty mess, throw the plate away and start with another one. Apron and Sta-Wet palette: You may not want the apron but you will love the Sta-Wet palette. Hidden by the lid is a flat sponge and a palette paper on top of the sponge. The wet sponge holds moisture that wicks up through the paper, keeping your paint on the paper moist and ready to use. As long as the sponge is kept wet, paints can last for a couple of weeks in this palette. If you don't want to create the waste of discarded paper plates, skip all the other palette choices and buy this one. Your disposition and paintings will both improve because you won't be fighting with the paint on your palette any more.

CARE OF UNUSED PAINTS

Lids get stuck on both tubes and jars. Keeping both the lids and the threaded area on the container clean solves the problem before it happens. If a lid does get stuck, use a pair of pliers to remove the cap.

Jars are a bigger problem. They arrive in shipment with paint all over the underside of the lid. If this is not scraped away and the lid cleaned on first opening, the lid most likely will be stuck the second time you try to open the jar.

In that case, place the outside edge of the lid against a solid workbench or tabletop, without the jar itself touching anything. Give the opposite side of the lid a sharp whack with a mallet to break the dried paint bond. Do not hit the jar with the mallet. A few whacks quickly allow the lid to open easily. The lid rarely breaks in this process, but it can happen, so keeping the lid clean is the best practice.

Freezing fresh acrylic paints ruins them. They also dry out quickly if stored in the direct blast of a furnace. Spraying a light mist of water inside the jar before closing helps prevent premature drying.

RRIISHES

Brushes are available in a staggering array of shapes, sizes and kinds of bristles. The good news is that you do not necessarily have to buy the most expensive brushes for high-quality results.

Synthetic Taklon brushes offered by many manufacturers can be both economical and enjoyable to use with acrylics. Heavy-body acrylics require a brush with a good spring to it, which Taklon provides. The bristles are also easy to clean.

Hog-bristle brushes are especially useful if the texture of a brush stroke is desired. These bristles are coarser than Taklon but also have a good springiness. If a hog-bristle brush is used to apply a layer of gel medium, it will be more difficult to clean than a Taklon brush. Small sable or squirrel round brushes made for watercolours can be used, although they have a much weaker spring to them. After flow release is added to the paint, these little pointed brushes can be helpful for painting small details such as tiny highlights. Synthetic substitutes for sable and squirrel can also serve you well.

Flats and rounds are the most useful brushes for acrylic painting. With an assortment of sizes in these two shapes, you can paint anything you want.

BRUSH CLEANING

Acrylic paint dries quickly and can easily ruin brushes. If you are using multiple brushes for different colour mixtures, leave the ones you are not immediately using in a container of water so they do not harden before you get back to them.

Soap and water works just fine for cleaning your brushes when you are finished painting. Gently work the soapy water into the bristles without bending them so hard that you wreck the brush. Continue rinsing until the water runs clear. White Taklon brushes will stain, but this is not detrimental.

Plain gel medium is the most difficult to clean because you cannot see it and you cannot really feel it during cleaning, so extra care is required.

SAFETY ISSUES

Acrylic paints are reasonably safe in studio work as long as you paint with them properly. For example, never put the brush in your mouth as a handy place to hold it for a moment. Do not allow your pets to drink the waste water in your containers. Use some common sense in handling your paints:

- If possible, let the waste water from paint brushes evaporate until the paint suspended in it becomes a thin dry crust and then dispose of it. Disposal of dried paint is much less of an environmental problem than liquid paint.
- If you need to sand a painting, keep in mind the fact that pigments such as the cadmiums are most hazardous when airborne and inhaled. Wear a respirator and sand in a well-ventilated area. Thoroughly clean the work area afterwards.
- If you have cuts on your hands, wear plastic gloves until the cuts heal to prevent any problematic pigments in your paint from being absorbed.
- While acrylic paints generally have fewer toxicity problems than many other paints, they may still affect people who have extra sensitivity to chemicals. Paint manufacturer websites offer more detailed information on specific paint pigments or other products. Some varnishes require particularly careful handling no matter what your level of chemical sensitivity. If in doubt about a product, look up the Material Safety Data Sheet (MSDS) and handle it accordingly.

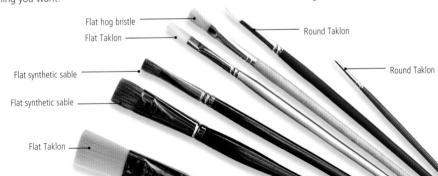

Canvas and other substrates

Since it is impossible to paint with acrylics without a substrate to receive our colourfully inspired brushstrokes, let's consider the options available. As water media, acrylics can be used on watercolour paper but can also be used on canvas and boards like oils. So how do you choose the best substrate for your work?

An understanding of papermaking enables you to choose an appropriate paper substrate more effectively. Paper is made by pounding pulp from various plant fibres. Wood contains cellulose that decays rapidly by yellowing and becoming brittle, as we see in newspapers. Cotton and flax do not contain cellulose and make a far more archival paper.

The pulp is beaten in a water solution and the entangled fibres are poured into a mould frame, a framework with a large screen the size of the intended sheet of paper. After the water drains away through the screen, the wet sheet is pressed to flatten it while squeezing out remaining water.

The sheet can be dried with or without heat. Heat drying makes a paper that is less likely to dry flat after rewetting because it needs the same application of heat and pressure to regain its original flatness. Sheets dried without heat can be worked with

plenty of water until they buckle. Drying them pressed flat under weights makes them readily go back to their original flatness in the studio.

Sizing refers to starches, gelatins and other materials added to paper to alter its ability to absorb water, surface smoothness and other characteristics. Some sizing materials acidify the paper, increasing the speed of decay.

Sizing can be added to the waterborne pulp, and this is called internal sizing as it is distributed throughout the paper. Sizing can also be added to the finished sheet, in which case it is called surface sizing.

Purchasing an acid-free paper containing no cellulose is the best choice for longevity of your artwork. Making your own paper can be an enjoyable process but is too involved and time consuming for most artists more interested in painting than papermaking.

Assorted cut pieces of watercolour paper show the difference between bright white and natural paper, the natural paper being the darker sheet on the right. A deckle edge remains along the bottom of the sheet on the left.

WATERCOLOUR PAPER

Watercolour papers have attractive ragged edges called deckle edges. They are so named because the ragged edges form along the deckle frame that surrounds the screen and are a natural part of papermaking.

The worst choice you can make in buying watercolour paper is to select thin, cheaply made paper. It receives paint horribly and handles even worse.

Instead, buy 638 gsm (300 lb) paper by a quality manufacturer and you will be astounded at the difference. The heavy paper takes water media beautifully, resists buckling and is a delight to use. You also can choose from varying amounts of surface texture depending on your painting preferences.

BOARDS

Boards are available in a wide range of types. Some are primed with gesso and others are covered with canvas. Board materials can be as simple as a form of cardboard with canvas glued over it to elaborately cradled hardwoods.

Cradled boards have a framework around the edge on the back. Nicely finished cradled boards do not have to be framed, although they can be.

Masonite is a common pressboard in use, but it is not considered archival. Particle board is similarly short on longevity. Wood tands to acid decay over

not considered archival. **Particle board** is similarly short on longevity. **Wood** tends to acid decay over time, with birch being the least susceptible. Birch is chosen for most archival works and still needs to be sealed with a varnish on the sides not primed with gesso.

CANVAS

Canvas is a well-loved substrate, with its varied textures, thicknesses and longstanding traditions of use. Canvas is usually made from either cotton or linen, although new synthetic fibres such as polyflax are also available. Canvas can be purchased stretched or unstretched, primed or unprimed and in sheets and rolls.

Cotton is less costly than linen and, perhaps surprisingly, is considered to be as long lived as linen canvas when properly primed. Cotton duck is more tightly woven than plain cotton. A loosely woven canvas is cheaper and gives a coarser surface that often is not desirable. Cotton canvas thickness is rated on a scale of 1 to 10 with 1 being the thickest. **Linen** is considered the gold standard of canvas due to its smooth, tight weave and stiffness. Buy linen that is primed with gesso, which makes a good ground for acrylics.

Polyflax is a synthetic material that can be used alone or blended with cotton to make canvas. Polyflax is stronger than cotton and is an excellent choice when painting large canvases that exceed 3 m (6 feet) in any direction.

Pre-stretched canvas

Pre-stretched canvases can be purchased in a multitude of sizes and qualities. Typically the canvas has the standard minimum of two coats of gesso, but you may want to add additional coats to prepare the surface to your liking. If you prefer, you can simply start painting on the canvas instead.

This corner of a pre-stretched canvas shows the folded corner of the canvas on the outside edge. Pre-stretched canvases come in varying quality levels. The example shown is an inexpensive canvas with coarse weave, casually rather than carefully stretched.

The back of the same commercially prepared canvas shows the spline that sets the canvas edge into a recessed groove to hold it in place. Staples are used only to secure the corners on this canvas.

Tools for stretching canvas

Stretching your own canvases is a simple process. Instead of a commercial spline to hold the canvas in place, staples are used along the back edge of the stretcher bars and they hold the canvas more securely than the splines do. Begin in the middle of each side and work your way out to the corners for a smooth stretch, going round and round the canvas from side to side to keep it even.

After assembling the stretcher frame, use stretching pliers to pull the canvas as you staple your canvas onto the back of the bars. They are inexpensive but effective for pulling the amount of tension you need. Remember to tension pre-primed canvases to the finished tautness you want. Raw canvases have to be left partially slack because gesso will tighten them as it dries. In large canvases this can actually crack stretcher bars if the raw canvas is stretched too tight.

Pictured right are two kinds of staplers. On the lower right is an ordinary workshop stapler that works well. For larger canvases in particular, the commercial upholstery stapler directly to the right is a good option. Connected to a hose on an air compressor with 90–100 psi (6–7 bar) pressure, it makes the process as easy as can be.

CARE AND SHIPPING OF STRETCHED CANVAS PAINTINGS

Paint surfaces should never touch each other because acrylic paint remains slightly absorbent and sticky when dried. You do not want your paintings sticking to each other, causing mutual ruin. Varnish does not offer enough protection to enable them to be stored touching each other.

Occasionally a canvas painting may be dented by accident or improper handling. Spraying the back of the canvas with a clean mist of water and rubbing it with an equally clean hand is usually enough to smooth the dent. After drying, the canvas will again be taut and smooth.

Shipping acrylic canvases can be done by wrapping them in 8 mil plastic sheeting, such as is used for a dust sheet in house painting. Cut 5-cm (2-inch)

thick polystyrene sheeting to size and secure it tightly on the front and back with plenty of clear packing tape to prevent rubbing. Cut additional sections of the polystyrene to proper size for the side edges and tape that tightly in place. Repeat the process with sheets of extra-heavy cardboard for the front, back and side edges. Use approximately an entire roll of clear packaging tape per package and this process will protect your painting, as well as avoid having to purchase costly pre-made painting crates.

If shipping extremely large canvases, it is more cost effective to carefully remove the canvas from the stretcher frame and ship it rolled in a tube. The best procedure is to roll the thoroughly dry canvas painted side outwards (so as not to crush or crumple the paint

film) with a sheet of 8 mil plastic sheeting over the face of the painting. Let the plastic film extend long enough to encircle the roll past the canvas end.

Heavy-duty cardboard tubes can be obtained at builder's yards; they are designed to use as forms for pouring concrete. One of these makes a really stout container for your painting. Roll the canvas as described around a small-diameter tube and insert it inside a larger tube that allows a 5-cm (2-inch) clearance all around for polystyrene peanuts. Add wooden ends and the painting is well protected for shipping. A good-quality frame shop can re-stretch the canvas on new stretcher bars at the destination.

Index

acrylics 6-7 changing acrylic colours 24 fluid acrylics 20-21 heavy-body acrylics 20-21 how darkening in drying affects value 68 luminescent acrylics 26-29 opaque acrylics 24, 25 preserving work 22, 23, 32 semi-transparent acrylics 24-25 texture 36-37 wash properties 34-35 additive colour 9 Alizarin Crimson (Hue) 10, 22 American Society for Testing and Materials (ASTM) 122 analogous colour palette 54 loose analogous palette 54 using 54-55 analogous colour schemes 47, 78, 79 animals 106-107 gallery 108-109 painting a black dog 106-107 aprons 122 automobile industry 22

backgrounds 84-85 analysing backgrounds in painting 84-85 choosing background colours 84 light reversals 84-85 observe, apply, practise 85 patterned backgrounds 85 backlighting 66 Bartleson-Brenneman effect 8

blends 66 blues 13, 17 blue and purple colour study 13 mixing blues and vellows to make green 110-111 neutrals 72 boards 23, 124 Bowman, Jennifer Autumn Heron 61 Barn 97 Birches 117 Electric Casev 23 Fractured Landscape 114 Grand Opening Day 93 Out Standing in His Field 101 Tulips 100 Windy Kids 85 Briggs, Shaughn New Zealand Paua 28 brushes 36, 122, 123 brush cleaning 123 buildings 94-95 gallery 96-97 weathered wood and shadows 94-95 Burnt Sienna 73

C

canvas 23, 124 care and shipping of stretched canvas paintings 125 cotton canvas 124 linen canvas 124 polyflax canvas 124 pre-stretched canvas 125 tools for stretching canvas 125 care and shipping of stretched canvas paintings 125 Carter, Carol A View Worthy of the Climb 61 Morning on the Arno 35 changing acrylic colours 24 chroma 8, 16, 17, 68 chroma, value and naturalistic greens 98-99 high chroma 9 low chroma 9 ways of reducing chroma 9 clouds 86-87 gallery 88-89 arevs from complements 87

types of clouds 87

additive colour 9 avoiding muddy colour 15 changing acrylic colours 24 chroma 8, 9, 16, 17, 68 colour groups 10-13 colour temperature 70-71 cool colours 67, 70, 71 high-key colour 58, 64-65 hue 8, 9, 16, 17, 68 iuxtaposition of warm and cool colours 67 low-key 59, 64-65 luminosity in colour 66-67 mixing two colours with a tint 43 mixing with layers and glazes 44-45 primary colours 40 secondary colours 40 subtractive colour 9, 50 tertiary colours 40 value 8-9, 16, 66, 68 warm colours 67, 70, 71 colour schemes 38, 46 analogous colour scheme 47, 78 choosing and using 78,82 complementary colour scheme 46, 79 five reasons to use colour schemes 46-47 modified analogous colour scheme 79 monochromatic colour scheme 46 neutral colour scheme 81 primary colour scheme 48 six-colour scheme 47 split-complementary colour scheme 48, 80-81 tertiary colour scheme 49 tetradic colour scheme 49. 79,80 colour wheels 16-17 colour wheels with just three primaries 51 mixing in steps around the colour wheel 15

see Sundell Colour Wheel

complementary colour

schemes 46, 79

complementary palette 56

cautionary note 57

complementaries 56

characteristics of

five reasons to use complementary colours 57 red and green complements 56 using different kinds of complements 57 vellow and blue-violet complementaries 57 cool colours 67, 70, 71 cotton canvas 124 Crabtree, Elizabeth Apples Divine 100 Variations on a Theme 70 Crackle Paste 31 Crackle Paste and palette knife 36-37 cradled boards 124

D

Daniel Smith 10 Denvs. Frederick G. Desert Light 116 Desert Song 65 Mountain Waterfall 115 Sudden Snow 66 Summer Park 115 Untitled 85 distance 74 drying extenders 32-33 duochrome acrylic paints 27 usina 29

E

earth tones 17, 72-75 Burnt Sienna 73 mixing earth tones 73 Neutrals Colour Wheel 72 Elsey, Kathleen China Camp from Bluff 96 environmental factors 23

Fecteau, Kiana Fluff 51 Rooster 109 figurative painting 118-121 fine lines 32 flat brushes 123 flow release 32 Flower, Rosina By the Window 105 fluid acrylics using in a painting 20-21 fugitive paints 10

Fullerton-Samsel, Carol Anna

Loki 108

gel mediums 30, 31, 122 layers and glazes 44-45 texture 36-37 Geraghty, Paul A Quiet Morning 84 Bedruthan Steps 74 Changing Light 88 Great Wave 92 Meor Light 67 Sea and Rock 92 Tranquility 93 aesso 30 glazes 44-45, 67 gold and silver iridescent paints 26 Golden Artist Colors 10 Open range 32 grevs 50-51, 75, 87 grayscale 111, 112, 113 greens 12, 17 chroma, value and naturalistic greens 98-99 green colour study 12 mixing blues and yellows to make green 110-111 neutrals 72 arounds 30, 31

high chroma 9 high-key colour 58, 64-65 comparing high-key, lowkey and full-key colour 58 highlights 67 hog-bristle brushes 123 hue 8, 9, 16, 68 Hush, Joe First Colour - Holystone Burn 116 Romantic Woodland 71 Straying Sheep 115 The Last Strays 66 Winter Trees 117

Heavy Gel Medium 31

using in a painting 20-21

heavy-body acrylics

inorganic pigments 10 interference acrylic paints 26 using 29 iridescent acrylic paints 27 silver and gold 26 using 29

J

James, Paul Barn Owl 69

End of the Day 93 Portrait of Posh 109 Time for Reflection 74 juxtaposition of warm and cool colours 67

Kloosterboer, Lorena Arigato 70 Constellation 104 Sunshine Sonata 105 Knight, Sera M. Misty Day 67 Tving the Shoelaces 120 Winter in Trafalgar Square 75 Kovich, Loren Green Frenzy 35 Krawczyk, Joseph Butterfly Chair 6 Floored Light 65 Hearthside 73 Sew What? 105 Shifting the Light 69 Krizek, Donna

White Roses 69 landscapes and trees 110–113 gallery 114-117 mixing blues and yellows to make green 110-111 lavers 44-45, 67 light 8, 9, 16 how light moves through water 90 light reversals 84-85 light source 66 light, shade and shadow 82-83 reflected light 67 linen canvas 124 low chroma 9 low-key colour 59, 64-65 comparing high-key, lowkey and full-key colour 58 luminescent acrylics 26-27 disadvantages 27

MacEvoy, Bruce 16, 71 magentas 10

using 28-29

luminosity in colour 66-67

nine methods for painting

luminous colour 66-67

Masonite 124 Material Safety Data Sheet (MSDS) 123 McCord, Linda Floor Play 35 Strings 121 Yellow Gown 121 mediums see ael mediums mixing paints 14 avoiding muddy colour 15 experimental mixing 14 five principles of mixing 14 mixing fundamentals 14 mixing in steps around the colour wheel 15 mixing multiple pigments 14 mixing primaries 40 mixing three pigments 42-43 mixing two colours with a tint 43 mixing two pigments 42 six-colour palette 40, 41 tinting strength 14 twelve-colour palette 40 ways to practise mixing 15 wet-into-wet 42 monochromatic colour schemes 46 mood 38 cool full key 59

cool low key 59

warm high key 58

low-key limited palette 59

warm low key 58 MSA (Mineral Spirits Acrylic) 31 Munsell, Albert Henry 16 Nardini, Peter Untitled 93 neutrals 17, 72-75 accenting bright colour 67 bright accents and neutrals 75 choosing complements for painting neutrals 59 greys from complements 87 mixing neutral grevs 50-51, 75 mixing neutrals 41 neutral colour scheme 81 Neutrals Colour Wheel 72 neutrals from complements 74 water, distance and

neutrals 74

newsprint 23 Newton, Isaac 16

0 O'Keefe, Lou Lamborghini Spider 22 Rainbow of Buovs 104 Venice Glow 97 Winter Warmth 67 Ohnemus, Pamela Dunn Ranch 100 October Evening 101 opaque acrylics 24 opaque and semi-transparent acrylics together 25 opaque over semitransparent 24 semi-transparent over opaque 24 oranges 11, 17 red and orange colour study 11 organic pigments 10

paints 10-13, 17, 122 basic mixing 14-15 care of unused paints 123 paint choices 122 paint quantities 122 secrets of the paint label 122 palette knives 36 Crackle Paste and palette knife 36-37 palettes 40, 123 analogous colour palette 54-55 arranging palette 41 complementary palette 56-57 neutrals 41 palette care 41 primary palette 40, 50-51 six-colour palette 40, 41, 52-53 split-complementary palette 58-59 tertiary palette 62-63 tetradic colour palette 60-61 paper paper plates 40, 123 understanding

papermaking 124

34. 124

watercolour paper 23,

S sable brushes 123 Sacran, Jason Pence. Barbara Louise safety issues 123 secondary colours 40 View of Spring 97 Self-levelling Gel 31 semi-transparent acrylics 24 establishing pigment mixing three pigments mixing two pigments 42 pigment availability 22 pigment permanence pigment properties 19 chroma, value and naturalistic greens example of casual portrait pre-stretched canvas 125 primary palette 40, 50 colour wheels with just three primaries 51 mixing neutral greys primary palette and subtractive colour 50 why use only three blue and purple colour

New Dawn 89

Svcamore 114

Retired 117

particle board 124

pearlescent acrylic

paints 26

usina 29

Pedrero, Robert

Hello 85

Ginger 109

pigments 10, 16, 17

value 68

42-43

22-23

plant life 98-99

98-99

pliers 125

gallery 100-101

polyflax canvas 124

portraits 118-119

118-119

gallery 120-121

issues in portrait

painting 119

primary colours 40

primary colour

schemes 48

50-51.75

primaries? 50

red and orange colour

purples 13, 17

reds 11, 17

refraction 90

Riley, Bridget

Arrest 2 9

round brushes 123

study 13

study 11

Regular Gel Medium 31

substrates 23

exploring transparency 25 opaque and semi-transparent acrylics together 25 opaque over semi-transparent 24 semi-transparent over opaque 24 shadow 82-83 exploring shade and shadow 83 using complementary colour 82 weathered wood and shadows 94-95 silver and gold iridescent paints 26 six-colour palette 40, 41, 52 building the six-colour palette 52 specialised usage 53 split-primary six-colour palette 52 six-colour schemes 47 skies 86-87 gallery 88-89 greys from complements 87 painting a sky 86-87 Smith, Daniel Sun Struck 84 Winter's Embrace 75 Snell, Alan Sleeping Giant 89 Soft Gel Medium 31 as varnish 32 split-complementary colour schemes 48, 80-81 split-complementary palette 58 choosing complements for painting neutrals 59 mood 58-59 Sprakes, John Steps 96 Sprakes, Patrick The Two Red Chairs 56 squirrel brushes 123 Sta-Wet palettes 32, 40, 123

SUNDELL COLOUR WHEEL

The author's colour wheel is designed to provide a reliable tool for the artist seeking exceptional colour in acrylics. A chart is included below showing suitable substitutes for each of the 12 colour positions on the wheel. This makes exploring alternate paints less daunting, since you know where they fit into an established framework.

The pigment numbers are also given with the paint name in the wheel and on the chart.

Paints that are convenience mixtures of multiple pigments are included in some colour categories. They are placed at the end of the list after the single-pigment choices. You can readily identify them by the multiple pigment numbers following a paint name.

The Sundell Colour Wheel and substitute paint listing can also be found on page 17.

12. Green-vellow 2. Yellow-orange 11. Yellow-green Hansa Yellow Cadmium **Bismuth** Medium Yellow Orange PY73 PY184 Medium PO20 Phthalo Green (Yellow Shade) 10. Green PG36 Phthalo Green In each colour-position pairing (Blue Shade) (e.g., green-yellow), the main colour is named second.

1. Yellow

Cadmium Red Medium PR108

Pyrrole

Orange

PO70

4. Red

3. Red-orange

9. Cvan Cobalt Teal PG50 Ultramarine Blue PR29

Ultramarine Violet PV15

7. Blue-violet

Ouinacridone 5. Magenta PV19

Quinacridone Violet PV19

6. Red-violet

1. Yellow

Cadmium Yellow Medium PY35 Hansa Yellow Deep PY65 Yellow Iron Oxide PY42 Nickel Azo Yellow PY150 Cadmium Yellow Medium Hue PY74 Primary Yellow PY3 PY73 PW6 Naples Yellow Hue PW6 PY42 PY83

2. Yellow-orange

Cadmium Yellow Deep PY35 New Gamboge PY153 Azo Yellow Deep PY65 Quinacridone Gold PO49 Cadmium Yellow Deep Hue PY184 PY74 PY65 Cadmium Orange Hue PO73 PY65 PY74

3. Red-orange Cadmium Orange Deep PY35 Perinone Orange PO43 Quinacridone Coral PR209 Quinacridone Burnt Orange PR206 Ouinacridone Burnt Scarlet PR206 Quinacridone Nickel Azo Gold PO48 Ouinacridone Sienna PO49 PR209

4. Red

Cadmium Red Dark PR108 Cadmium Red Deep PR108 Naphthol Red Light PR112 Naphthol Red Medium PR5 Permanent Red PR170 Pyrrole Red PR254 Pyrrole Red Dark PR264 Ouinacridone Red PV19 Pervlene Maroon PR179

5. Magenta

Primary Magenta PV19 Permanent Rose PV19 Anthraguinone Red PR177 Ouinacridone Crimson PR206 PR202 Quinacridone Magenta PR122

6. Red-violet

Cobalt Violet Hue PV19 PR122 PW4 PV23 Alizarin Crimson Hue PR122 PR206 PG7

7. Blue-violet

Dioxazine Purple PV23 Carbazole Violet PV23 Indanthrone Blue PB60 Permanent Violet Dark PB60 PR122 Prism Violet PV23 PW6 PR122

8. Blue

French Ultramarine Blue PB29 Phthalo Blue (Green Shade) PB15 Cobalt Blue PB28 Cobalt Blue Deep PB73 Anthraguinone Blue PB60 Cobalt Blue Hue PB29 PB15 PW6

9. Cyan

Cerulean Blue P36 Cerulean Blue Deep PB36 Cerulean Blue Chromium PB36 Cobalt Turquoise PB36 Primary Cyan PB15 PW6 Manganese Blue Hue PG15 PG7 PW6

10. Green

Cobalt Green PG26 Cobalt Green Deep PG26 Permanent Green Light PY3 PG7 Permanent Green PY3 PG7 Cascade Green PBr7 PB15

11. Yellow-green

Chromium Oxide Green PG17 Chromium Oxide Green Dark PG17 Green Gold PY150 PG36 PY3 Rich Green Gold PY129

12. Green-yellow Lemon Yellow PY175

Cadmium Yellow Light PY35 Hansa Yellow Light PY3 Cadmium Lemon PY35 Cadmium Yellow Light Hue PY184

- **Acrylic** A specific emulsion used as a binder for pigments to use them as paints.
- M Analogous palette Paints representing three or four adjacent hues on the colour wheel.
- **Chroma** The aspect of colour referring to the saturation or intensity of the colour; how bright or dull it appears.
- **Colour** The combination of hue, chroma and value as registered by the eve and interpreted by the brain.
- **Colour index number** Pigment code referring to a specific chemical composition.
- **Somplementary colour** The hue opposite another hue on the colour wheel, which may be represented by various paints in that hue.
- **Colour temperature** The relative warmth or coolness of a paint in relation to another paint on the colour wheel
- **Colour wheel** A spectrum of hues joined in a circle.
- Duochrome A form of luminescent acrylic paint showing two different colours, depending on viewing angle.
- Glaze To apply a thin layer of lighter paint over a darker colour to change the appearance, which is good for optical mixing of colours.
- **Hue** An aspect of colour that is a specific wavelength of light, such as red, orange, yellow, green, blue or violet.
- Interference A form of semi-transparent luminescent acrylic paint that is opalescent and shows its own

- complementary colour, depending on the value of the paint layer underneath it.
- **Iridescent** A form of luminescent acrylic paint showing pearlescent effects not dependent on the paint laver underneath it.
- Lightfastness Chemical stability of a pigment under long exposure to light.
- Luminescent acrylic Paints made with mica platelets, titanium dioxide and metallic oxides in an acrylic emulsion.
- Neutral colour A low-chroma colour that can be created by mixing complements.
- **Opaque** Completely obscures the view of anything underneath it.
- **Optical mixing** A method of applying paint over other dried paint layers so the colours combine visually.
- Palette mixing Combining paints directly while wet before applying them to the painting in a combined colour.
- **Permanence** Longevity or durability. Physical mixing Combining paints directly while wet, either on the palette or the painting surface.
- **Pigment** A chemical powder that is the component in paint producing the colour.
- Primary palette Paints representing the hues of magenta, cyan and yellow.
- **Saturation** Refers to the intensity of a colour, ranging from bright. full-strength chroma to a dull and diluted chroma.
- **Scumble** To apply a thin opaque coat of paint over a darker colour to soften or alter the darker colour.
- **Secondary colours** The hues of red-orange, blue-violet and yellow-

- green, which can be mixed from the primary palette.
- Substrate The painting surface, such as canvas, board or watercolour paper.
- Tertiary colours The hues of yellow-orange, red, red-violet, blue, green and yellow-green, which can be mixed from the primary palette and secondary colours.
- Tint White added to a colour. In this book, for convenience, tint means a mixture with Titanium White unless otherwise specified.
- Tinting strength The intensity of the pigment itself in a mixture.
- **Tone** A specific darkness or lightness that can be matched to a grayscale step in a range from white to black.
- Transparent Does not completely obscure the view of anything underneath it.
- Tuck A technique of darkening a corner or juncture where two adjacent shapes appear to touch.
- **Value** Relative lightness or darkness of a colour, its tone within a range from white to black, often a numbered scale.
- Value scale Most commonly an even, nine-step graduation from white at number one to black at number nine.
- **Wash** Paint diluted with water and applied to an absorbent substrate.

staplers 125 still life 102-103 gallery 104-105 textures 102-103 Strouse, Warren Fierv Sunset 88 substrates 23, 124-125 grounds 30, 31 subtractive colour 9 primary palette and subtractive colour 50 Sundell Colour Wheel 17. 78, 122 analogous colour palette 54 colour temperature 71 colour value 68 complementary palette 56, 57 high and low key colour 64 mixing colour 40-41 neutrals 72, 74, 75 primary palette 50, 51 six-colour palette 52, 53 tertiary palette 62 tetradic colour palette 60, 61 Sundell, Bern Artist Afternoon 61 Backvard Trout 52 Bahama Treasures 25 Bowl of Apples 62-63 Bowl of Eggs 82–83 Colorplay 108 October Reflections 90-91 River King 28 Royal Wulff 56 Steelhead Flies 65, 82 Sundell, Lexi Dancing with the Dew 101 Peruvian Woman 120 synthetic brushes 123 synthetic inorganic pigments 10 Taklon brushes 123 tertiary colours 40 tertiary colour schemes 49 tertiary palette 62 using 62-63 tetradic colour palette 60 comparing rectangular tetradic palettes 61 using the square tetradic palette 60 tetradic colour schemes 49. 79,80

gel layers 36-37 still life textures 102-103 versatility 37 tinting strength 14 tints 43 tools for stretching canvas 125

upholstery staplers 125

value 8-9, 16, 68 Bartleson-Brenneman effect 8 chroma, value and naturalistic greens 98-99 establishing pigment value 68 how darkening in drving affects value 68 value contrasts 66 value scale 68 values in paintings 69 Van Gogh, Vincent 22 varnishes 32, 122 violets 13 17 vision 8

W

warm colours 67, 70, 71 wash properties 34-35 controlled wash areas 34 freely applied washes 34 water scenes 74, 90-91 analysing different aspects of painting water 90-91 gallery 92-93 how light moves through water 90 watercolour paper 23, 34, 124 weathered wood and shadows 94-95 wet-into-wet 42

texture 36

Crackle Paste and palette

knife 36-37

Wild, Carrie Paint Horse 85 Winsor & Newton 10, 32 wood and shadows 94-95 wood board 124 Woodman, Jim Moored at Portree 75 Three Crofts 71 Warnish, Skye 60 workshop staplers 125

yellows 12, 17 mixing blues and yellows to make green 110–111

Acknowledgements

Quarto would like to thank the following artists, who are acknowledged beside their work:

Bowman, Jennifer, www.jenniferbowman.com, pp.4, 23, 61t, 85t, 93tl, 97tl, 100cl, 101tr,

© Bridget Riley 2012. All rights reserved, courtesy Karsten Schubert, London, p.9

Briggs, Shaugn, www.nz-art-work.com, p.28b

Carter, Carol, www.carol-carter.com, pp.35tr. 61bl Crabtree, Elizabeth, www.elizabethcrabtree.co.uk, pp.70, 100tr

Denys, Frederick G, www.frederickdenys.com, pp.65tr, 66cl, 85b, 114t, 115tl/tr, 116l

Elsey, Kathleen, www.elsey.com, p.96b

Facteau, Klana, www.kianafecteau.com, p.109tl

Flower, Rosina, www.rosinaflower.co.uk, p.105

Fullerton-Samsel, Carol Anna, p.108b

Geraghty, Paul, www.paulgeraghty.net, pp.67cr, p.74t, 84t, 88bl, 92t/b, 93tr

Hush, Joe, www.joehush.co.uk, pp.66t, 71t, 115bl, 116r, 117t

James, Paul, www.pauljamesart.com, pp.69tr, 74b, 93bl, 109tr

Kloosterboer, Lorena, www.art-lorena.com, pp.70t, 104cl, 105t

Knight, Sera M, www.seraknight.co.uk, pp.57tl, 67tl, 75cl, 120r

Kovich, Loren, AWS, www.lorenkovich.com, pp.35tl

Krawczyk, Joseph, http://krawczykstudio.com, pp.65cl, 69b, 73b, 105bl

Krizek, Donna, p.69cl

McCord, Linda, www.lindamccord.com, pp.35b, 121t/b

Nardini, Peter, www.peternardini.com, p.93b

O'Keefe, Lou, http://louokeefe.com, pp.22, 67tr, 97r, 104tr

Ohnemus, Pamela, www.pamohnemus.com, pp.100b, 101b

Pedrero, Robin Maria, www.gallery523.com, p.85cr

Pence, Barbara Louise, www.bpenceart.com, pp.97b, 109b

Sacran, Jason, www.jasonsacran.com, pp.89, 115br, 117b Smith, Daniel, www.danielsmithwildlife.com, pp75cl, p.84b

Snell, Alan, Helena, Montana, www.alansnell.com, p89

Sprakes. John, ROI RBA MAFA DA (Edin) – www.johnsprakes.com, pp.56br, 96t

Strouse, Warren, www.strouseandstrouse.com, p.88

Sundell, Bern, http://bernsundell.com, pp.18-19, 25, 28t, 38-39, 52, 56bl, 61br,

65br. 82t/b. 91. 108t

Sundell, Lexi, http://LexiSundell.com; http://PaintYourJoy.com

Wild, Carrie, www.carriewildart.com, p85tr

Woodman, Jim, www.jimwoodman.co.uk, pp.60b, 71b, 75tr

Quarto would like to thank Golden Artist Colors Inc. (www.goldenpaints.com), Daniel Smith Inc. (www.danielsmith.com) and Winsor & Newton (www.winsornewton.com) for supplying paint samples.

Quarto would also like to acknowledge the following: p.16 Bruce MacEvoy Artist's Color Wheel, www.handprint com/HP/WCL/cwheel06.pdf

All other images are the copyright of Quarto Publishing plc or Lexi Sundell. While every effort has been made to credit contributors, Quarto would like to apologise should there have been any omissions or errors – and would be pleased to make the appropriate correction for future editions of the book.